Plastics for
KINETIC ART

Plastics for KINETIC ART

by Nicholas Roukes

WATSON-GUPTILL PUBLICATIONS, NEW YORK

PITMAN PUBLISHING, LONDON

First published 1974 in the United States and Canada by Watson-Guptill Publications,
a division of Billboard Publications, Inc.,
One Astor Plaza, New York, N.Y. 10036

Published simultaneously in Great Britain by Sir Isaac Pitman & Sons. Ltd.,
39 Parker Street, Kingsway, London WC2B 5PB
ISBN 0–273–00813–7

Manufactured in U.S.A.

Library of Congress Cataloging in Publication Data
Roukes, Nicholas.
 Plastics for kinetic art.
 Bibliography: p.
 1. Kinetic art. 2. Plastics as art materials.
I. Title.
N6494.K5R68 702'.8 73–21607
ISBN 0–8230–4029–1

First Printing, 1974

To Diane

CONTENTS

PART 1. VISUAL KINETICS

PART 2. MECHANICAL KINETICS

PREFACE

"Who are you?" said the Caterpillar. This was not an encouraging opening for a conversation. Alice replied, rather shyly, "I—I hardly know, Sir, just at present—at least I know who I was when I got up this morning, but I think I must have changed several times since then."

Advice from a caterpillar,
Alice's Adventures in Wonderland,
by Lewis Carrol

Between yesterday, today, and tomorrow, there is probably only one thing we can definitely count on—and that's *change*.

Dynamic values, attitudes, and concepts, by their very nature, imply perpetual states of flux. Our planet earth and everything on it, including the peregrinating Homo sapien, is changing.

To the creative individual, the concept of change is fascinating—even obsessive. It implies an openness to experience, a tolerance of the unknown, and an insatiable urge to explore new horizons. Change is synonymous with the ongoing characteristics of life itself—the acknowledgment and response to this phenomemon is the recognition and application of our constantly expanding reflective consciousness.

We should not only abide by the inevitable laws of nature, but should also maintain an "openness," so that subjective intelligence can surface. Perhaps in this way we can "learn" from ourselves—and develop a Gestalt, or pattern of experiences, on which to hang our increasing knowledge of methods and materials.

In a recent interview Alvin Toffler, author of *Future Shock,* said that the key to understanding art does not lie in what artists think or do—it has to do with the new environment in which they find themselves. They, like the rest of society, are caught up in a great wave of revolutionary change. We must acknowledge the fact that the world is no longer moving on the tracks that were laid for it during the industrial revolution.

All art uses technology in some form. Science, technology, and art have always been close handmaidens; tools and technology are intrinsic components of a growing society—they are essential means of communication, self-expression, and social interaction.

Convivial Tools

Ivan Illich* describes convivial tools as those that offer the people who use them the greatest opportunity for creative expression, are easily used, do not restrain others from using them, do not impose obligation for their use, and allow the user to easily express his ideas in action. Illich cites the telephone as one such tool.

The convivial society is in control of its technology, and is not threatened by its mechanical Frankensteins. The anachronism of "social progress" is that as technological know-how expands, human facilities deteriorate. It would seem logical then to concur with Illich that in order to insure a convivial society of the future, technology should serve individuals, not "managers."

It must also be remembered that technology with all its seductive accouterments is not an end in itself, but simply a means by which the contemporary artist shapes his ideas and his identity.

The ability of the artist to "listen to his particular drummer," to infuse his special brand of subjective expression into the mechanics, methods, and materials of the seventies will serve as a great equalizer.

*Co-founder of the Center for Intercultural Documentation in Cuernavaca, Mexico (see Bibliography, p. 172).

Acknowledgments

I wish to express my thanks to the artists, engineers, galleries, and museums who contributed both materials and documentation for this book. Also, an appreciative thanks to the students and colleagues at the University of Calgary for their contributions. I am grateful to the publishers who allowed certain quotations from their books to be included in the text; to Nellie Bulechowsky, the correspondence secretary, and to typists Fran Quick and Corinne Lee for their assistance. Special thanks also to the editors at Watson-Guptill, Diane Hines and Jennifer Place, for their services in planning and editing this book.

Extra special thanks to Julie for counsel, compassionate understanding, and head-patting sympathy during the writing ordeal.

*"Have you more strange illusions, yet more mists,
Through which the weak eye may be led to error?"*

Beaumont and Fletcher,
The Hungry Courtier, *1607*

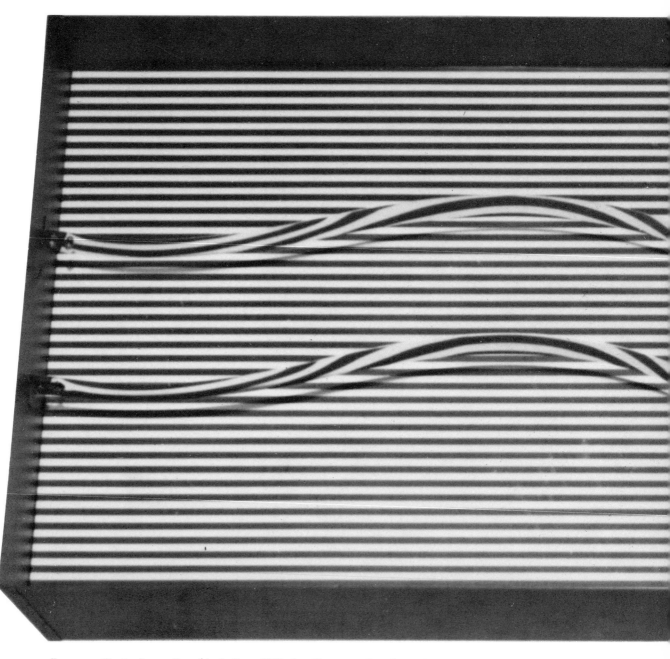

Formes en Contorsion sur Tramé *by Le Parc, 1969. Curvilinear acrylic rods installed over a field of parallel lines.*

PART 1 VISUAL KINETICS

Denise René Gallery, Paris.

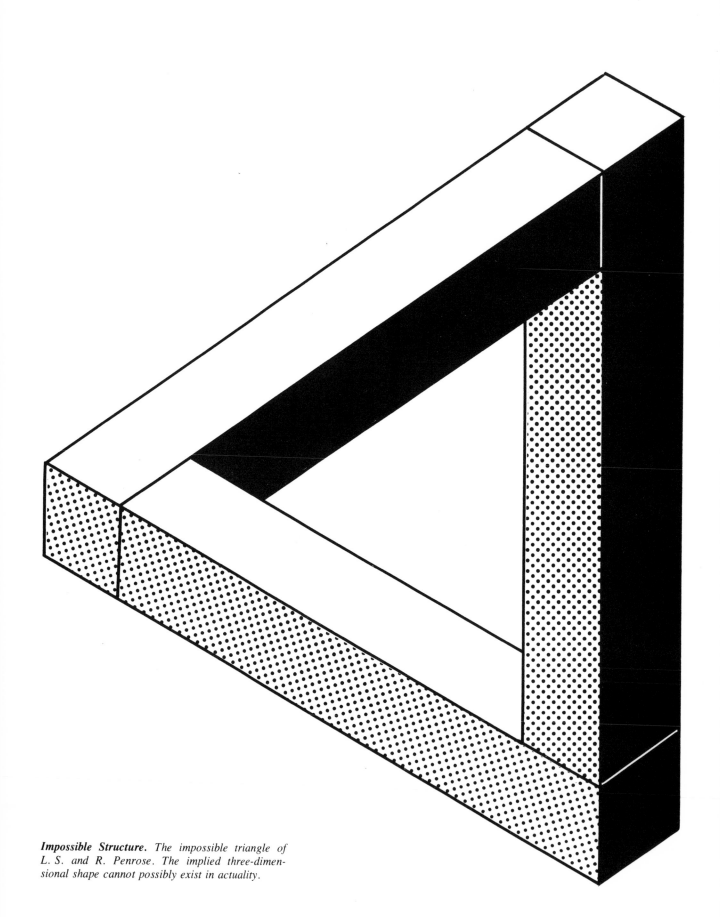

Impossible Structure. *The impossible triangle of L. S. and R. Penrose. The implied three-dimensional shape cannot possibly exist in actuality.*

INTRODUCTION

There is a special domain in the realm of kinetic art whereby motion is generated optically rather than mechanically. This type of movement relies on the work's structure and the inherent peculiarities of the retina for its effects. Using the materials that produce these visual effects can be an exciting area of involvement for the kinetic artist.

For the purposes of organization, I have divided the field of visual kinetics into three principal areas: *Virtual Movement, Movement Through Spectator Displacement (Transformation),* and *Actual Movement.*

Virtual Movement

Virtual motion is an illusion of movement that is nonexistent in physical terms. The art object itself is not kinetic; only the visual response to it. Motion is induced as the eye of the viewer is foiled in its futile attempts to reconcile conflicting visual data. Resultant retinal fatigue initiates ''motion''; the eye, in a sense, becomes the ''motor'' activating the work.

Visual perception varies greatly according to circumstance. When we speak of sensory illusion, we are not solely concerned with the fact that our senses are either adequate or inadequate to certain visual tasks, but that under varying conditions and among different viewers, the senses present differing and dramatically opposing sensations.

Visual Illusions. Illusions may also be described as visual deceptions. Consequently, all optical art forms are illusions, experienced when we perceive objects somewhat differently than they actually are, or when our eyes are fooled into presenting unstable or ambiguous data to the brain. These effects have to do with human quirks of visual perception, principally to the limitations of the physiological structure of the eyes and to the particular characteristics of binocular vision.

A study of the dynamics of visual perception and perceptual psychology can be a great help to the artist concerned with optical art. A few of the more authoritative books are *Eye and Brain* and *The Intelligent Eye,* both by R. L. Gregory, and the *Foundations of Cyclopean Perception,* by Bela Julez.

The diagrams throughout this introduction illustrate some of the optical illusions that have appeared in psychology texts for some time. Many contemporary artists have created works derived from these illusions.

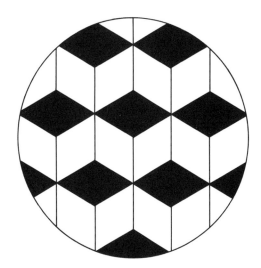

Triple Equivocal Figure. *The drawing may be perceived either as a flat design composed of black diamonds and parallel lines on a two-dimensional plane, or as a three-dimensional illusion of stacked cubes. Also, the cubes ''flip,'' with the black shapes becoming either the tops or bottoms of the cubes.*

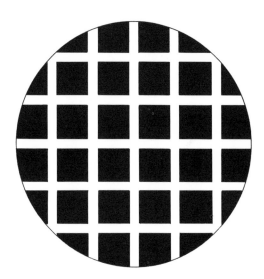

Illusory Shapes. *Gray shapes ''pop'' at the intersections of the white lines, but seem to vanish when an attempt is made to focus on them.*

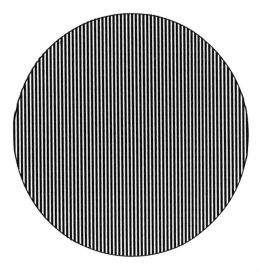

Parallel Lines, *closely spaced, generate powerful vibration fields, creating an "on-off" flicker. They also give false cues to the retinal cones, activating the perception of color (look at an imaginary point 6" behind the figure).*

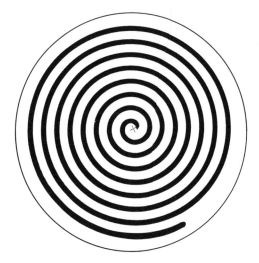

Archimedes Spiral. *When set in motion, the spiral produces sensations of swelling and contraction, and also creates an illusion of three-dimensional cone shapes. When the motion suddenly stops, the opposite effects are perceived as a result of after-motion phenomena.*

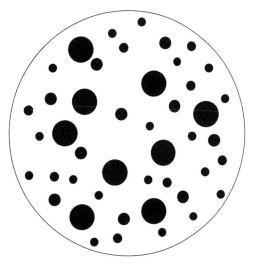

Afterimage. *This random dot pattern demonstrates how negative afterimages interrelate with positive black dots. The combined dot patterns create a kind of "choreography" as the eye chases the white dots. As the eye attempts to focus on a perceived white afterimage, it immediately vanishes.*

Visual Illusion. *This equivocal design "flips" from a two-dimensional kite design to a three-dimensional cube.*

Precursors. In 1965, an important art exhibition entitled the *Responsive Eye* was organized by the Museum of Modern Art in New York. The exhibition featured the work of contemporary artists concerned with visual illusions: Vasarely, Reinhardt, Liberman, Albers, Cruz-Diez, Riley, Morellet, Noland, Kelley, Poons, Anuszkiewicz, Oster, LeParc, Stella, Tadasky, Yvarali, and others. The show toured the United States for some time, and it triggered an enormous response to op art that affected not only artists and art students the world over, but industrial and commercial designers and manufacturers as well. Fabric designs with op motifs became fashionable, and book jackets, posters, and commercial art featured optical patterns.

Experimentally minded artists explored the characteristics of optical art long before 1965, however. The works of Van Gogh and Seurat are excellent examples of powerful fields of visual energy. Mondrian's *Boogie Woogie* ''pops'' with a musical beat. Duchamp's mind-boggling rotoreliefs were created in 1923. Cézanne, Delaunay, Picasso, Gris, Braque, Malevich, Klee, Kandinsky, Lissitsky, Balla, Boccioni, and Archipenko all made exceptional use of the peculiarities of optical perception.

Visual Canons. Optical art is concerned with what transpires in *front* of the picture plane, not behind it. This is an art calculated to communicate physically to the spectator through visual bombardment. Artists who find ways of generating optical kinetics are exercising powerful tools that tamper with or alter our normal perceptions. Simply put, the artist deliberately ''overloads'' our visual circuits with an input that is impossible to fully apprehend and cannot be controlled with the brain. Christopher Shurrock, a British artist, says, ''When such structural systems are combined, each system affects every other, and interactions result which are more than just the sum of the components.''

Joseph Albers categorizes optical phenomena in his book, *The Interaction of Color*. He describes effects such as bezold, after-image, simultaneous contrast, and optical anachronisms. Other writers describe phenomena such as persistence of vision, visual reversal, perceptual linkage, cyclopean perception, rivalry, distorting figures, and impossible forms. These are some of the ''tools'' that can be used to create visual kinetics—they result in art forms that pulse, quiver, snap, pop, flip, move, change, or otherwise accost the viewer.

Op art is not solely concerned with physiological perception, however. Strong psychic states are induced by sensory activation. Thus, optical designs serve to activate the physiological, ultimately triggering an emotional reaction or state of mind. Albers often referred to the mental activity ''behind the retina'' as an important aspect of op, or retinal art.

Dr. Gerald Oster states that the popularity of op art is quite natural in this age. It reminds us that man is basically an organism—with direct sensory interactions that at times may please, puzzle, or confuse him. Furthermore, making op art demands precision analogous to today's technology.

Cyclopean perception involves stereoscopic vision, and is

Illusion of a Fragmenting Line. *When a single line crosses a grating of parallel lines at angles of less than 45°, the line appears to break up.*

McKay Figure. *At first glance the McKay figure appears stable, but on prolonged concentration it becomes violently unstable. Strong moiré effects are induced by moving the design, because of the overlapping effect of the actual image with the fleeting afterimage.*

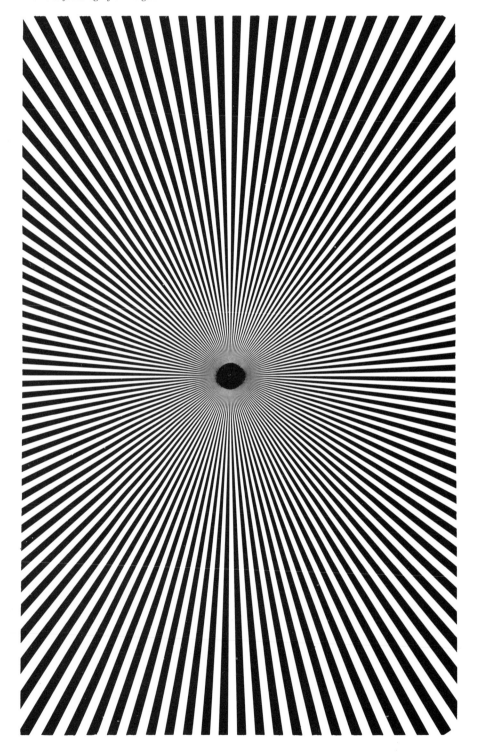

Shift Illusion. *Poggendorf's illusion demonstrates that when a line crosses a vertical bar at an angle greater than 45°, it misaligns itself. Which is the lower half of line A —line B or C?*

An Illusion of Depth. *The Edmunds Scientific Company.*

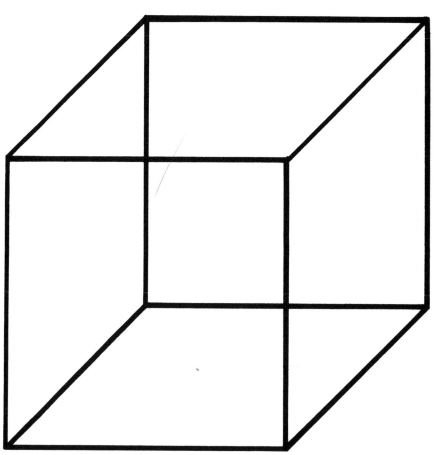

Equivocal Figure. *This skeleton cube "flips" from an above-right to a below-left eye level perceptual plane.*

described by Bela Julez in the following passage from the *Foundations of Cyclopean Perception:*

"The term 'cyclopean eye' was originally coined by Helmholtz to denote a hypothetical eye that was introduced by Hering in order to explain identical binocular directions. This hypothetical eye incorporates the two real eyes into a single entity (with two overlapping retinae) and lies midway between the two real eyes. It is literally the center of the cyclops, and the mythological allusion is very fitting since such an eye does not exist. I took the liberty of using 'cyclopean' in a more abstract and yet more concrete sense than is customary. While Hering's cyclopean eye is still an external eye and merely a geometrical concept, I use the same term to denote a central processing stage inside the brain having a concrete neuroanatomical existence."

Julez's book contains a remarkable collection of computer-generated patterns and red-green anaglyphs (mazelike structures capable of inducing three-dimensional perception). The anaglyphs, or stereograms, appear as formless textures when monocularly viewed. However, with the aid of a red-green viewer to induce stereoscopic vision (cyclopean perception), the designs undergo a remarkable transformation, separating into flat planes that seem to "float" above the surface of the paper.

Movement Through Spectator Displacement (Transformation)

Lissitsky, Agam, Cruz-Diez, Morellet, Yvarall, Vasarely, Sobrino, and artists in the original French research group (G.R.A.V.) initiated another type of "motion" in their work. Their art objects incorporate components that are not simultaneously visible to the viewer. They demand the viewer's movement for their total revelation. Yvrall, for example, painted parallel lines on a surface, then superimposed a vinyl cord construction slightly above them. As the spectator moves, an optical flicker, and a compositional change, occur in the work. Agam's "polyphonic" works incorporate three separate designs on corrugated surfaces, or

fins, placed at right angles to a base. The designs "flip" as the spectator passes from one side to another.

Some of Morellet's work involves a precise construction of parallel lines in three dimensions. As the spectator's view shifts, differing alignments of the three-dimensional forms create varying compositions. Vasarely's work in the fifties made use of transformation by superimposing parallel line designs drawn on two sheets of transparent plastic. The designs were related but slightly different in structure and were separated by a distance of about 2". As the spectator moves in front of the work, both visual transformation and a strong optical "on-off flicker" occur.

Sobrino's constructions of transparent smoke-violet acrylic produce varying compositions of shape and density as the spectator moves around the work. Cruz-Diez further integrates both light and pigmented color in his work, using grids made of transparent colored acrylic along with painted stripes. Costa and Soto program moiré effects into their transformable constructions.

Actual Movement

Kinetic art involving actual movement, (which will be discussed further in the second part of this book), has a history dating back to early civilization. Prehistoric and tribal cultures concerned with rites of magic and superstition utilized their bodies as instruments of communication. These rituals were enacted to accomplish specific aims: to get rid of evil spirits, guarantee successful hunts, insure fertility, and placate angry gods. Today's theater, dance, drama, and behavioral art are all continuations of kinetic body motion, although they have considerably different aims. The kinetic artist's media is *time*. In creating a work involving a series of unfolding events, the artist enters into the realm of the fourth dimension.

Other precursors to actual movement in kinetic art include objects such as wind-up clocks, statues, toys, marionettes, puppets, early cinema, theatrical projections, and machines.

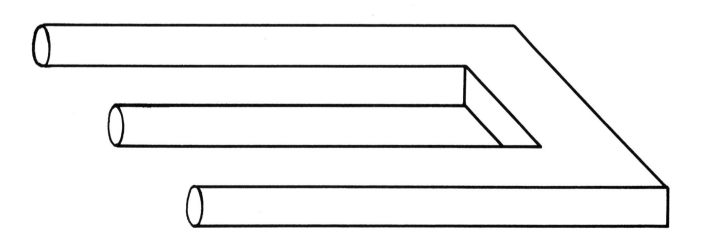

Impossible Figure. *Another structure that cannot possibly exist in actuality. The middle prong shifts, attempting to be in two places simultaneously.*

Square of Three —Yellow and Black by *Reginald Neal, 1964. Lithograph on acrylic paint and canvas. The New Jersey State Museum.*

MOIRÉ

Visual phenomenon involving line interference is called moiré (pronounced mwa-ray). You may have already experienced this illusion while looking out a window through overlapping folds of nylon curtains or through two metal window screens. The designs appearing on the surface of the materials are quite stunning and might be described as a "wood grain pattern" that tends to oscillate, depending on the viewer's movement. Moiré effects are also noticeable when passing two rows of fences, or a single row of fence posts interacting with their shadows. Even two superimposed pocket combs create this illusion. The effect is not only powerful, but quite attractive, and has led many artists to apply these same effects to their own art.

One such person, who happens to be a physicist as well as an artist, is Dr. Gerald Oster, professor of biophysics at Mt. Sinai Hospital in New York. He introduced moiré to the art world through his exhibits and extensive writing. Dr. Oster describes the moiré phenomena as occurring whenever two repetitive structures are overlayed with the elements "almost" superimposed. When two families of linear patterns are overlayed and lines cross at small angles, a *new* family of curves looms up—the moiré.

Derivation

The term moiré is from the French, meaning watered, as in watered or moiré silk—a design associated with the very expensive, shimmering, oriental fabric. This particular silk is woven with a pronounced parallel weave. As the translucent fabric is folded, the parallel cords move in and out of alignment, producing the attractive phenomena within the material. Any girl dressed in a two-ply summer kimono is guaranteed to attract some kind of attention—she is literally transformed into a walking kinetic objet d'art.

Wearing striped suits on television, however, is taboo for entertainers. The nature of the electronic grid system of television coupled with the striped suit design of the actor would create an optical razzle-dazzle that would be enough to "upstage" any performer.

Moiré has been used scientifically for close to a hundred years, first by Lord Raleigh to check the accuracy of diffraction gratings. Today, precision engineers and scientists employ moiré as an exacting means of measuring minute displacements, to study fields and flows, and for the solution of mathematical problems.

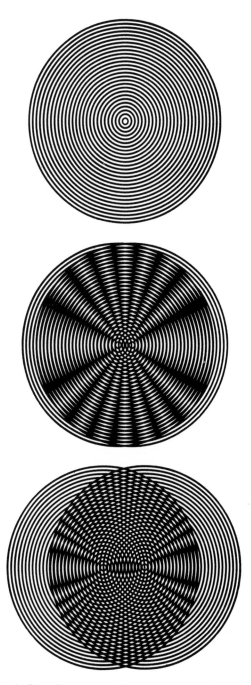

Concentric Ring Patterns. *The ring pattern shown creates "propeller" illusions when moved back and forth. When the same design is printed on clear acetate and superimposed over itself, the moiré designs shown at the bottom emerge.*

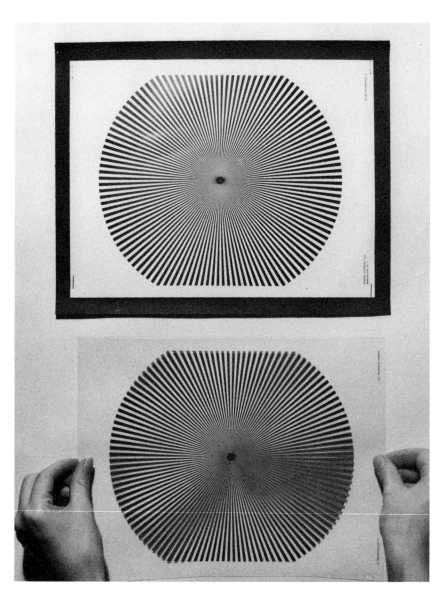

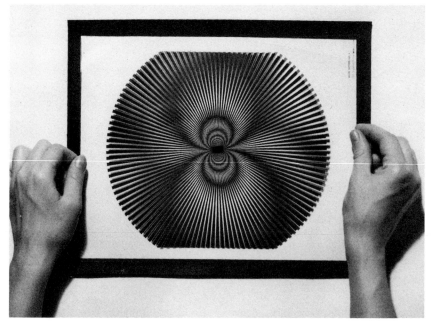

Radiating Lines are used to create this moiré effect. The designs shown consist of 120 black spokes within an 8″ circle. The spaces alternate equally between black and white, creating a figure of intense optical stimulation. The radiating line patterns are printed on 2 surfaces— clear acetate and glossy white paper. As the patterns are superimposed, an illusion of concentric rings emerges. Pattern #4, Edmunds Scientific Company.

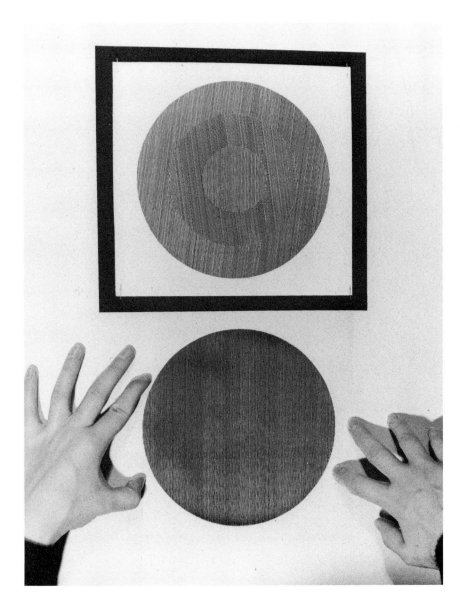

Moiré Illusions, created by Ludwig Wilding, are made by superimposing 2 dissimilar patterns. The middle pattern is composed of fine parallel lines, 40 lines to an inch, ruled on clear acetate. The pattern on the top is a similar design but is ruled on white paper and has two cuts made with a compass cutter. The inside circles are then shifted out of alignment and pasted on a backing sheet. When the patterns are superimposed, multiple illusions emerge. By turning the top design, a great number of successive illusions are produced.

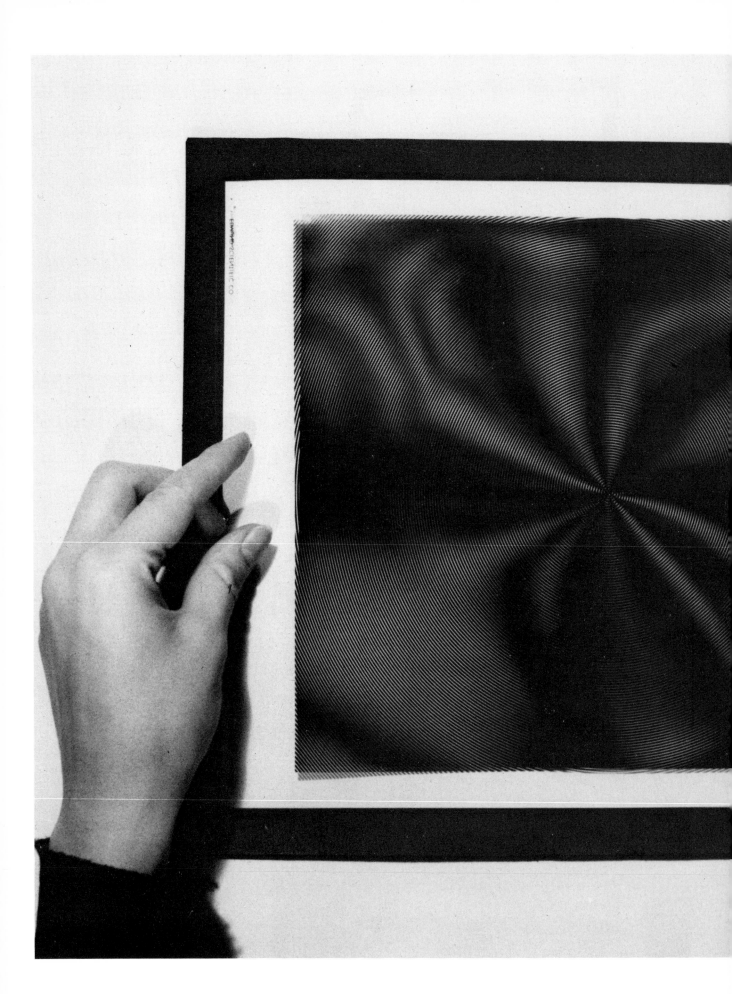

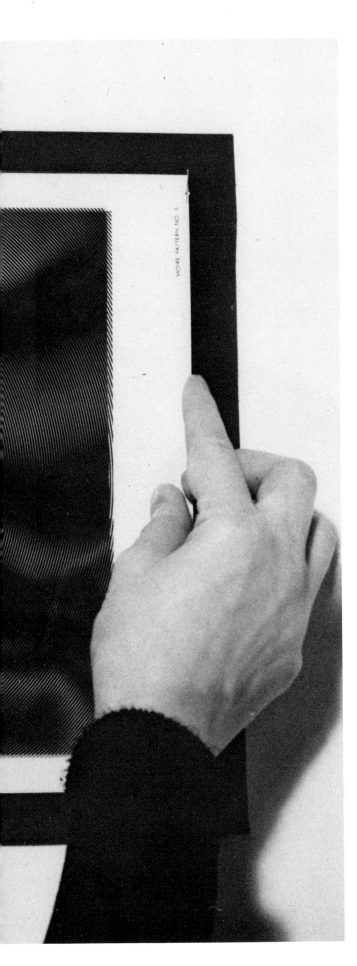

Patterns from a Single Grid

Although moiré patterns are usually made by overlaying *two* parallel line grids, the illusion may also be created with only one grid. In this case, a single parallel line design, printed on clear plastic, is placed just above a mirror, allowing the lines of the printed design to interact with the reflection. A kinetic dimension may also be introduced by motorizing the mirror. Materials and kits for moiré experimentation are available from the Edmunds Scientific Company and the American Science Center (see Suppliers List, p. 170). Materials include a variety of parallel line designs, concentric ring patterns, line patterns varying from fine to coarse gratings, radiating line patterns, fresnel plates, Gaussian gratings, converging circles, and logarithmic gratings. Aside from purchasing the patterns directly from the sources mentioned above, you can also make them yourself by using charting tape, art type, ruling pens, profilm cutters, or by using a "mask and spray" method.

Color in Moiré

Interesting intermediate effects are achieved by combining moiré designs of different colors. For example, if three moiré patterns are overlayed using yellow, magenta, and cyan as the component colors, the moiré phenomenon that emerges is in subtractive colors—blue, green, red, and black. When two different transparent colors are used, the moiré emerges in a third color. The accompanying photographs visually demonstrate the moiré illusion, showing how a variety of grid patterns can be overlayed to produce different effects.

Concentric Rings, equaspaced, are overlayed to produce a dramatic moiré illusion. This pattern has a frequency of 65 lines per inch from the center, and oscillates as the angle of view changes. Pattern #5, Edmunds Scientific Company.

Demonstration 1
A Moiré
Construction

When I first became aware of moiré effects, I was simultaneously struck by their obvious analogy to nature—especially to water waves, but also to other forces and energies that constitute the dynamic rhythms and movements of our environment. The grid patterns I prefer for producing these moiré effects are the *sine wave* designs. These produce strong oscillating waves when superimposed, resulting in illusions that are not only attractive, but reminiscent of the liquid movements of the ocean.

The construction shown in this demonstration I entitled *Cyma,* which is Greek for wave. It is made of 16 modular units of superimposed sine designs, each producing strong wave illusions. When these units are grouped together they heighten the moiré effect even further.

Materials

Plywood base, approx. 34″ × 34″ × ¾″

16 plywood squares, 7½″ × 7½″ × ¼″

16 pieces of acrylic sheet, 7½″ × 11½″

16 opaque copies of fine sines #12

16 transparent copies of fine sines #12

Thin white acrylic sheet to cover box

Plastic strip heater

Right-angle wooden jig

Drill

Fine screws

Heavy-duty stapler

Epoxy cement

Anti-static plastic cleaner

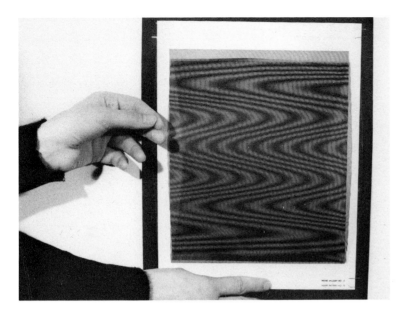

1. The basic components for Cyma are 2 super-imposed parallel line designs (fine sines # 12 from the Edmunds Scientific Company). The equidistant lines are spaced 65 lines per inch. The first design, printed on clear acetate, is held about 2" over the lower one, which was printed on glossy white paper. The resultant moiré illusion is dramatic, and it undulates with the viewer's slightest movement.

2. In preparing to construct the modules, I had 16 opaque and 16 transparent copies of the sine designs made by the Diazo process at a local graphic arts reproduction service. The opaque patterns are then attached to square plywood bases, each measuring 7½" × 7½", with contact cement. The transparent designs are superimposed 2" over the opaque ones, and they are stapled to the edges of the plywood.

3. (Below) A sheet of acrylic is then bent to a "U" shape on a plastic strip heater. The heater, set to a temperature of 250° Fahrenheit, softens the plastic very quickly. The plastic is subsequently transferred to a right-angle wooden jig where it is bent and cooled with a damp sponge.

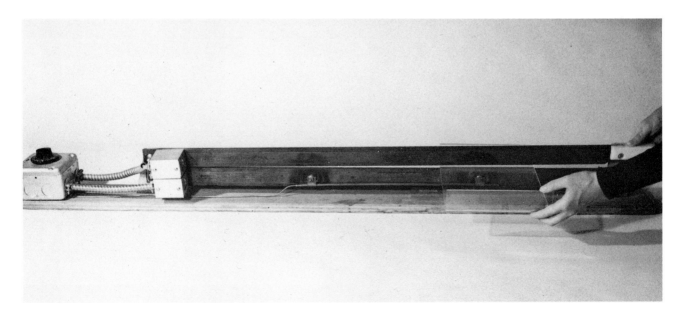

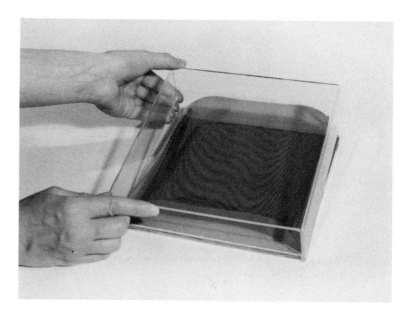

4. *The open box structure is placed over the moiré design and fastened to the plywood base with fine screws. The 16 modular units in this piece are all made in this way.*

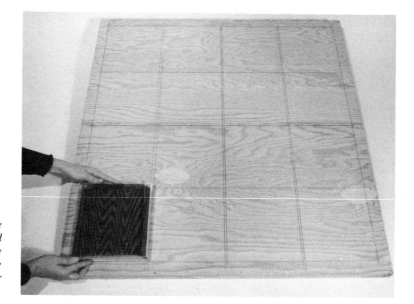

5. *A large plywood base is made to accommodate the component modules. The surface is first marked with pencil to position the units accurately. Before the units are attached to the base they should be carefully polished with an anti-static plaster cleaner and polisher.*

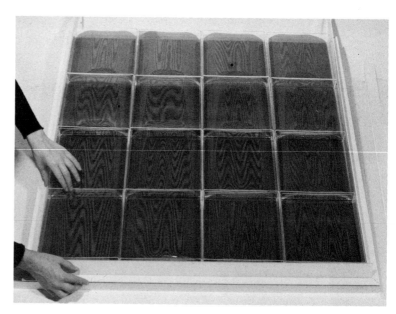

6. *Here all 16 moiré units have been attached to the base with contact cement. Strips of white acrylic are cut and cemented to the edges and base to finish the construction.*

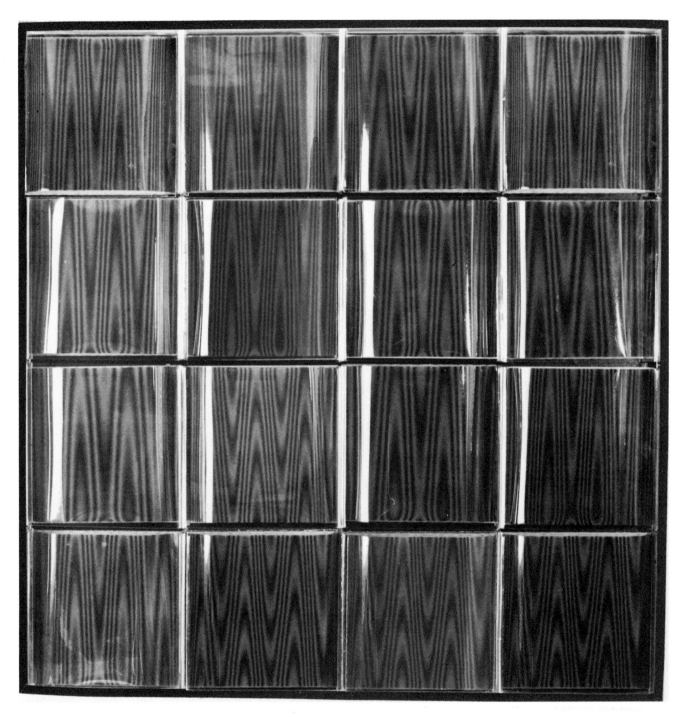

7. Cyma. *Acrylic, acetate, and wood, 34″ × 34″ × 4½″. As its Greek name suggests, the work oscillates with the slightest movement of the viewer.*

Demonstration 2
A Moiré Kinetic

In this demonstration I want to show how moiré effects can be easily combined with a motorized unit to make a kinetic art object.

Oroloi I has a clocklike appearance and presents a continuously moving panorama of optical textures. These optical effects are created by rotating two superimposed sheets of closely spaced dot patterns. The resulting illusions and pattern linkages are mesmerizing as they alternately swell and advance, then shrink and contract.

Materials

Plywood base, 12″ in diameter

3 clear acrylic discs, 10″ in diameter

Letraset dot pattern (100 ⅛″ dots per square inch) duplicated
 on two acrylic sheets by the Diazo process

White acrylic housing, 12″ in diameter

½ rpm. synchronous motor and wiring

Epoxy cement

Fine screws

White enamel spray paint

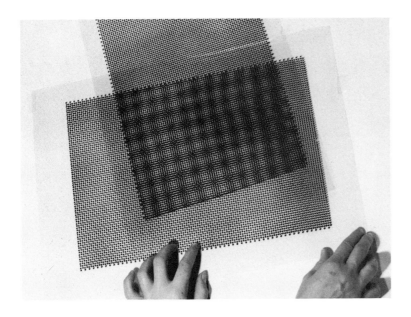

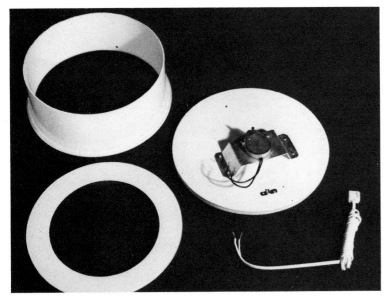

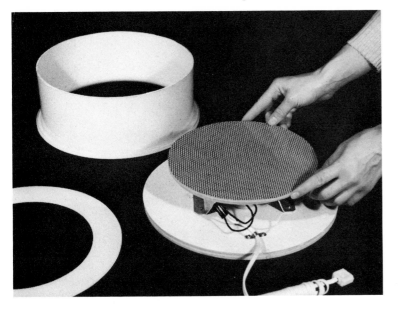

1. *This photo shows the emerging moiré illusion produced when 2 sheets of dot patterns are superimposed. The effects vary considerably as the top design is rotated. The transparent acetate patterns were duplicated by the Diazo process from Letraset contact sheets, each having about 100 ⅛" dots per square inch. (Letraset is available from most art supply stores.)*

2. *The structural components of* Oroloi 1 *shown here include the base, housing, and top. A small ½ rpm. synchronous motor is mounted to the plywood base.*

3. *A sheet of blue dot patterns is cut in a circle 10" in diameter, painted with white spray enamel from the back, and cemented to an acrylic disc. The electrical wiring is completed, and the unit is then mounted to the motor.*

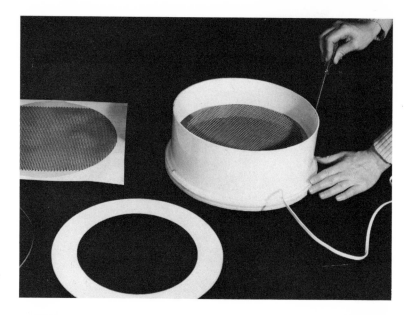

4. *The housing, made of white acrylic, is attached to the base with fine screws.*

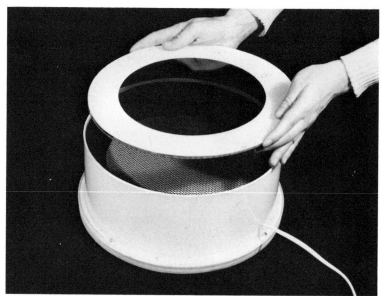

5. *The top component, made of 2 circular sheets of acrylic, sandwiches the second dot pattern. After careful cleaning, the unit is cemented to the top of the housing.*

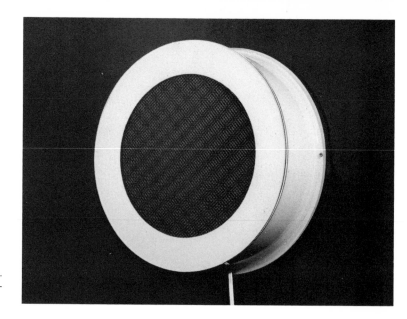

6. Oroloi I. *Acrylic, acetate, and wood, 12" × 5". The moiré kinetic produces illusory depth as dot patterns link to form a variety of optical textures.*

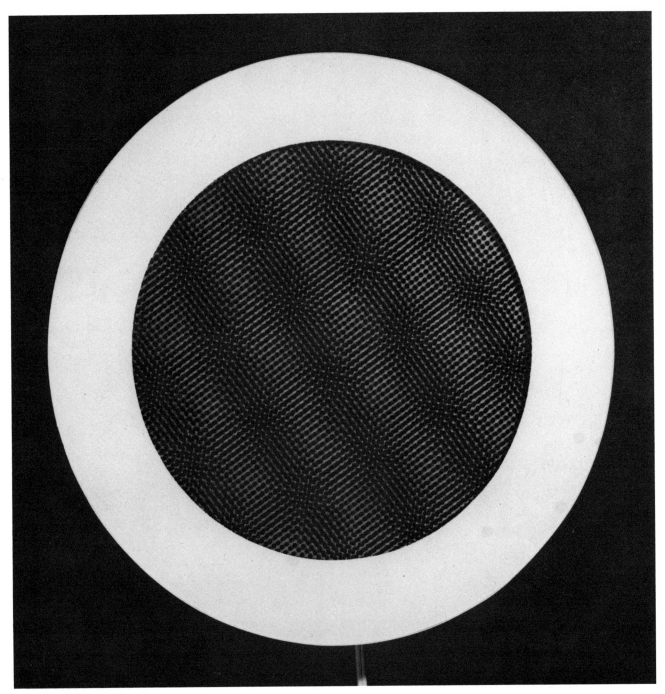

7. *Another view of* Oroloi I.

Flower of Freedom #1 by Jan Zach, 1968. Riveted stainless steel sheet, 3 × 3 feet. Brilliant surfaces and a high response to light, color, and surrounding form are the essential characteristics of this work.

REFLECTIVE SURFACES

"Art and literature, from the anonymous Chinese folktales to Jorge Luis Borges, have recognized the mirror as a window or door leading to 'other places,' worlds of reversal, counterpart, doppelganger, and symbolically (e.g., Jean Cocteau) as possibly entrance ways to totally separate and rarely known realms; from Narcissus to Dorian Gray to the surrealists, the roll call is endless."

Anselm Hollo, 1971. From a catalog
introducing the work of Hans Breder.

Mirrors perform a kind of magic. They possess the capacity to merge the real and the unreal, creating blends of equivocal space illusions.

Mirrors are instant portraiture, or caricature—they may manifest "virtual" volumes, or "dematerialize" solid mass. Their sorcery can add, multiply, reduce, divide, reverse, create illusions of infinity, and in the hands of an expressive artist conjure forth exciting art magic.

In the early 1900's, Brancusi polished his bronze sculptures to such brilliance that they became optical anachronisms—their mirror surfaces negated their monolithic volume.

Sculptural forms with mirrorlike surfaces tend to dematerialize; their reflective qualities open them to the environment. Reflected light becomes their patinae, and they are rightfully called "kinetic" as their surface color and character is derived from the changeable space around them.

Lucas Samaras and Domingo Alvaraz have created room environments with mirrors that produce ambiguous space and completely disrupt normal perception. Heinz Mack, from Germany, uses mirrors and fluted glass to make kinetic op boxes. Christian Megert employs mirrors to reflect the human figure, creating astonishing and often amusing anatomical relationships. Anthony Benjamin, an English artist living in Canada, combines chrome-plated metal with bright fluorescent plastic to make constructions with highly active reflecting surfaces. The Greek artist, Chryssa, creates neon sculptures whose forms are multiplied by the reflective interior of dark, transparent plastic boxes. They glow from their enclosures with enigmatic luminosity.

Piotr Kowalsky of Paris has programed the rays of the sun with a large architectural sculpture that he designed for San Diego State College in California. The sculpture includes three explosive-formed reflectors made of stainless steel and light-tracking electronic components.

What Is a Mirror?

Simply defined, a mirror is a surface that forms images by reflecting light rays. There are many types of mirrors, including plane, convex, and concave. A plane or flat mirror creates reversed images whose apparent position is on the other side of the mirror plane from the reflected object and equidistant from it. Curved planar mirrors produce exaggerated effects or distortions. You have probably been amused, as I have, by the humorous distorting mirrors at amusement centers. These glass mirrors transform the viewer into an instant cartoon character because of their concave/convex configuration.

Optical illusions generated from concave or hemispherical mirrors are unique insofar as they produce aerial projections.

Real images are quite different from virtual images reflected by plane mirrors. The virtual image from a typical plane mirror exists in virtual space *behind* the mirror and is right side up, whereas the image produced by the concave mirror is in *front* of the mirror and reversed.

These images seem to "hang" in three-dimensional space—the actual object and its reflected image both occupy the same physical space.

At Expo '70 at Osaka, the New York based group *E.A.T.* (Experiments in Art Technology) erected a huge 90′ hemispherical mirror room for the Pepsi Cola pavilion.

Suspended Aerial Reflections

An unusual application of concave mirrors is seen in the sculpture of Adolph Luther, from Krefeld, Germany. Luther combines concave mirrors, smoke, and light in a darkened interior to produce virtual volumes that "hang" in space. He uses the term "Vor-bild" to describe the suspended aerial reflections. The concave mirrors concentrate evenly absorbed light to a central focus, ahead of the mirror. Luther says that although light becomes visible upon contact with matter, it is equally present in space. This space, without physical matter, he calls the *transoptical* area. Illusive light sculptures are produced as the concave mirrors serve to collect light rays, "bundle them," and then return them back into space as light cones. The cones are made visible with the aid of smoke.

Aluminized Mylar

Some time ago, Andy Warhol launched lighter-than-air pillows made of mirrorized plastic. Since then, there has

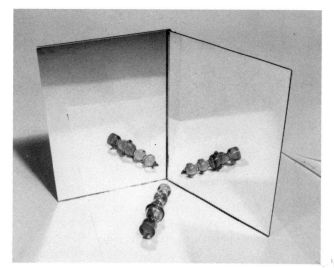

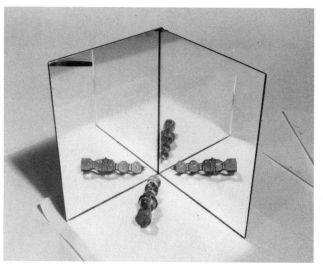

At an angle of 120°, adjoining mirrors produce 2 reflected images.

A mirror angle of 90° produces 3 images.

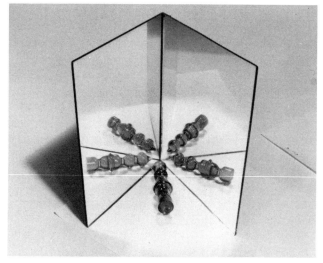

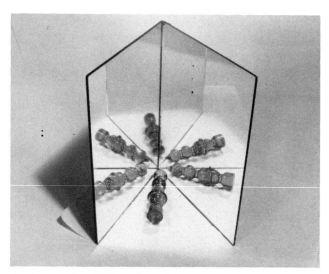

A mirror angle of 70° produces 4 images.

A mirror angle of 60° produces 5 images.

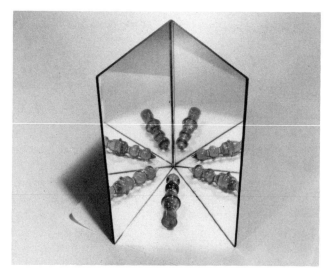

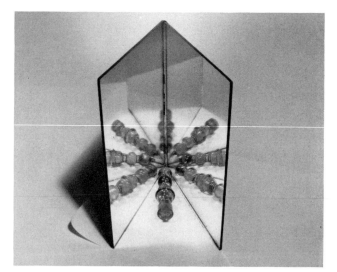

A mirror angle of 55° produces 6 images.

A mirror angle of 45° produces 7 images.

been an ever-growing variety of art forms made of this unusual flexible plastic.

Les Levine has used aluminized plastic to make large pulsing pillows in an environment called *Slipcover*. The large mirrorized plastic bags were filled with air and constantly inflated and deflated, producing the bizarre illusion of a huge liquid mirror. Light projected on the surface added to the unusual characteristics of this work.

Vibrating Varifocal Mirrors

A simple way to create a vibrating mirror is to tape a thin sheet of aluminized Mylar plastic tightly over a frame. Radio loudspeakers mounted under the Mylar modulate the mirror's curvature by the pressure of sound waves. Images reflected from the surface are perceived both visually and acoustically. This system was successfully used by Robert Whitman in designing *Pond,* which was exhibited at the Jewish Museum in New York in 1969. He constructed eight, 4 foot varifocal vibrating mirrors and used four 15″, 35 watt loudspeakers mounted under each mirror. The speakers were activated in unison with a 5-cycles-per-second sine wave. The effect was simultaneously heard, felt, and observed as the spectators' reflected images oscillated back and forth. Some of the varifocal mirrors were also combined with huge convex mirrors mounted over them in a "clamlike" juxtaposition, creating an upright aerial image of the spectator.

Available Materials

Any smooth, highly polished material will reflect light and mirror images to some extent. Front surface glass mirrors provide the sharpest reflection. However, mirrorized acrylic plastic sheet has an advantage—it can be drilled, sawed, or formed with ordinary carpentry tools. The flexible mirrorized Mylar plastic mentioned above can be cut with a pair of scissors; thicker sheets may be manipulated in a manner similar to handling paper sculpture. Polished aircraft aluminum can be rolled or shaped to create curvilinear reflective forms that are useful in producing distorted images or designs. Any chrome-plated forms produce highly reflective surfaces. Black acrylic plastic, glass, or black mirrors provide more subtle reflections.

Multiple Images

By varying the angle of adjoining mirrors, up to 10 reflective images may be created. The photographs presented give an approximate idea of the relationship between the number of reflective images and the appropriate mirror angle.

Concave Spherical Mirror. A is the pole; *B is the* focus; *distance* AB *represents focal length; C is the* center of curvature, *or the center of an extrapolated circle of which the mirror's curvature forms a part. When an object is outside of C, the reflective image is inverted and* smaller *than actual size. As the image approaches A, it becomes* larger. *At C the reflected image is the* same *size as the actual object. Between C and B, it becomes* larger. *Inside B the image "flips" to an erect state and is quite magnified.*

Demonstration 3
A Mirror and
Acrylic Construction

The concept of making objects involving a relationship of real and reflected forms (virtual images) is a fascinating one, and this demonstration will show just one of its many applications to fine art.

Telesm 13 is an equivocal sculpture that creates ambiguous space by the simple means of combining fluorescent plastic shapes and angled mirrors. The virtual forms are created by the juxtaposition of the shapes and mirrors. The reflective forms that drop into the depths of the mirrors complete a 360° pattern composed of both physical and virtual forms.

The light-piping characteristics of the acrylic components provide a neonlike glow that is multiplied by the mirrors, creating a labyrinth of brilliant hues. A variety of intermediate colors and forms evolve as the structure is viewed from different directions.

Materials

¼″ plywood sheet

Aircraft aluminum sheeting

2 each of 3/16″ acrylic sheeting in pink and green

Polyester resin and catalyst

Blue polyester dye

12 molds (aerosol caps and metal inserts)

Cardboard for patterns

Mirrors

Band saw and file

Paper cement and Epoxy cement

Mettal aluminum polish

1. Many preparatory sketches were made during the evolution of Telesm 13. *In addition to the sketches, I also conducted practical experiments involving angled mirrors and construction-paper shapes. These finally resulted in a three-dimensional concept that satisfactorily related chromatic shapes, reflective images, and structural form.*

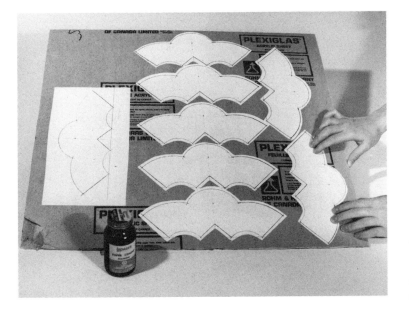

2. Three interlocking cardboard shapes serve as patterns for the main components of the sculpture. Pattern A is used for the basic structural form, which also includes four glass mirrors set at 90° angles. Pattern B is for the fluorescent acrylic shapes and pattern C for the cast polyester spacers.

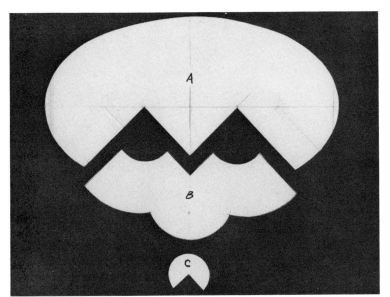

3. Here 13 Xeroxed duplicates of pattern B are cemented to 3/16" acrylic sheet (7 are lime green and 6 fluorescent pink). The shapes were subsequently cut out on a band saw and the edges filed and polished.

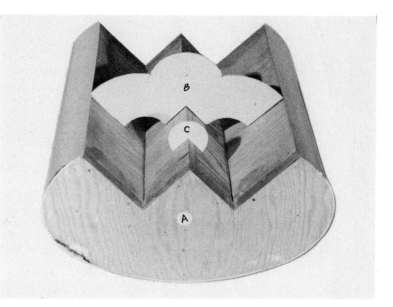

4. *A plywood structure is made using pattern A. The curved back is made of polished aircraft aluminum attached with contact cement. This photo also shows how the acrylic shapes and spacers will ultimately fit the basic structural form.*

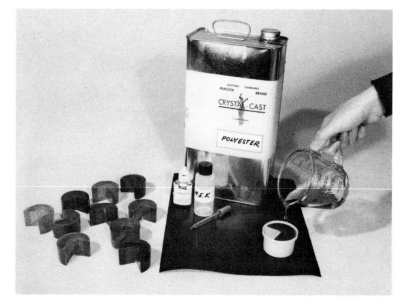

5. *A total of 12 transparent blue spacers are made by pouring catalyzed polyester resin into a makeshift mold (a polypropylene aerosol cap and a 90° angled metal insert).*

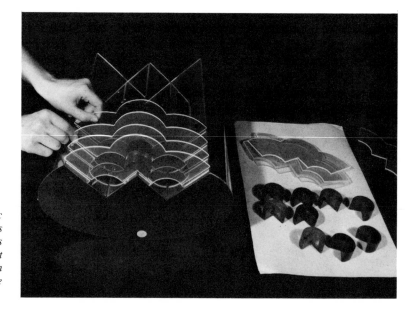

6. *Glass mirrors have been attached to the basic form with contact cement. The protective paper is stripped from the acrylic shapes, and each piece is polished with anti-static acrylic polish. Fluorescent pink and lime green shapes are alternately glued in position, separated with the transparent blue spacers. They are attached with clear epoxy cement.*

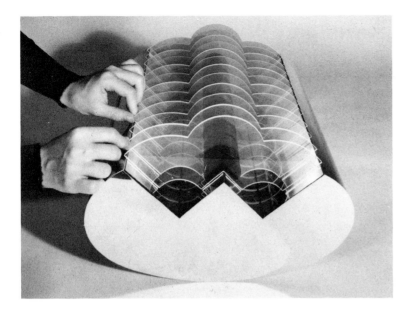

7. *Minor adjustments are made as all 13 acrylic shapes and spacers are glued in position.* Mettal *aluminum polish is then used to clean and brighten the aluminum surface. The light conducting properties of the fluorescent plastic produces a neon-like glow on the edges of the shapes. These multiply into a maze of illusive shapes because of the reflective mirrors.*

8. Telesm 13 *(Below) by Nicholas Roukes, 1972. Plastic and reflective surfaces, 16" × 14" × 10". A compatible combination of materials—reflective mirrors and fluorescent acrylic—evokes a "clean" look. Virtual shapes intermingle with real shapes, creating an ambiguous admixture.*

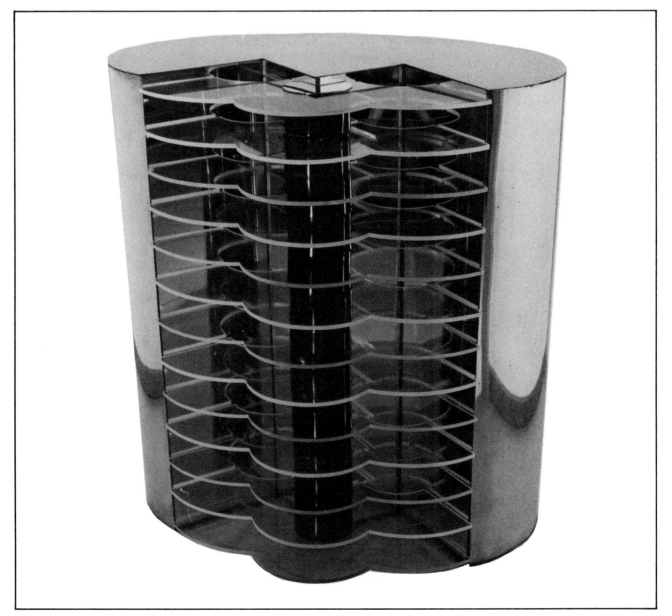

Demonstration 4
Curved Mirrors
and Reflective Shapes

Light Trap is composed of 16 basic units, each made of a concave polished aluminum reflector (the color receptor) and an acrylic construction sandwiching theater gels (the color activator). The colored reflective patterns from the gels project over the entire surface of the curved, polished aluminum.

Light Trap produces varying degrees of color luminosity depending on the amount of available light. It is quite dazzling when subjected to intense illumination. Even in low illumination, however, a bright, sparkling color pattern is projected over its entire field.

The work not only reflects and distorts the colored designs sandwiched within the clear acrylic, but allows light to pass through the transparent forms at various angles—producing brilliant patterns on the reflective surfaces.

Materials

Plywood base, $20'' \times 20'' \times \frac{3}{4}''$
16 concave aluminum reflectors
Thin black acrylic to cover base
32 pieces clear acrylic, $\frac{1}{2}'' \times 2'' \times 6''$
16 mirrors, each $1'' \times 6''$
Red, yellow, and blue theater gels
Silicone cement and Epoxy cement
Screws

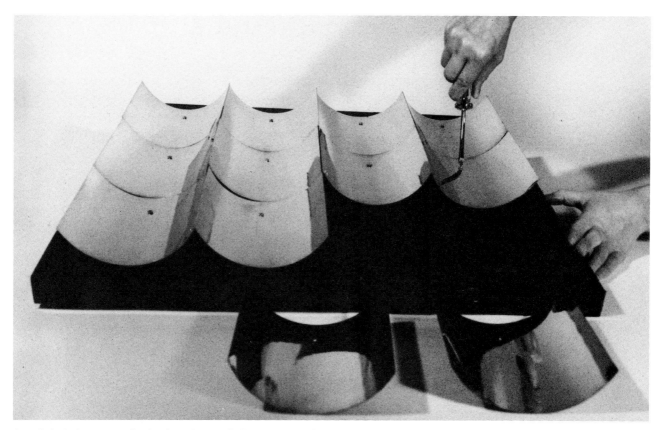

1. Polished aluminum reflectors have been rolled into concave forms at a local tin shop (the protective plastic was kept on the mirrored surface while rolling to prevent scratches). I achieved the proper curvature for the metal units by experimenting with one acrylic construction to test the resulting reflective pattern. The 16 metal units are then attached to a ¾" plywood base covered with black acrylic.

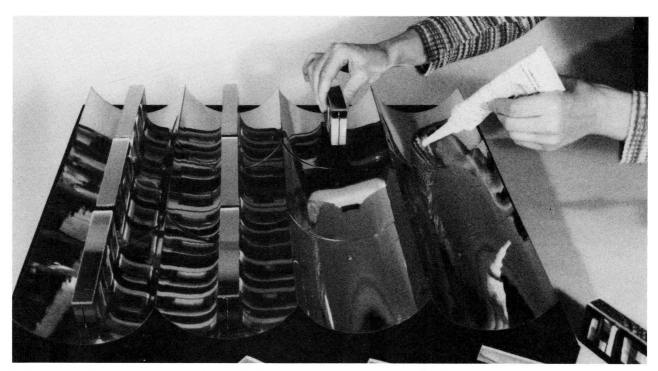

2. The constructions shown are "sandwiches" of ¼" clear acrylic, each measuring 2" × 6". They contain cut out transparent shapes of red, yellow, and blue theater gels within them, and they are bonded together with clear epoxy cement. Silicone cement is used to attach the acrylic "color activators" to the center of each of the metal reflectors. Rectangular glass mirrors, 1" × 6", are cemented to the leading edge of each acrylic component. The combination of reflected patterns and transmitted light produces a dazzling mosaic of light and color.

3. Light Trap. *Polished aluminum, acrylic, 20″ × 20″. As the available light changes, the work responds, producing sparkling color interactions even under minute light conditions.*

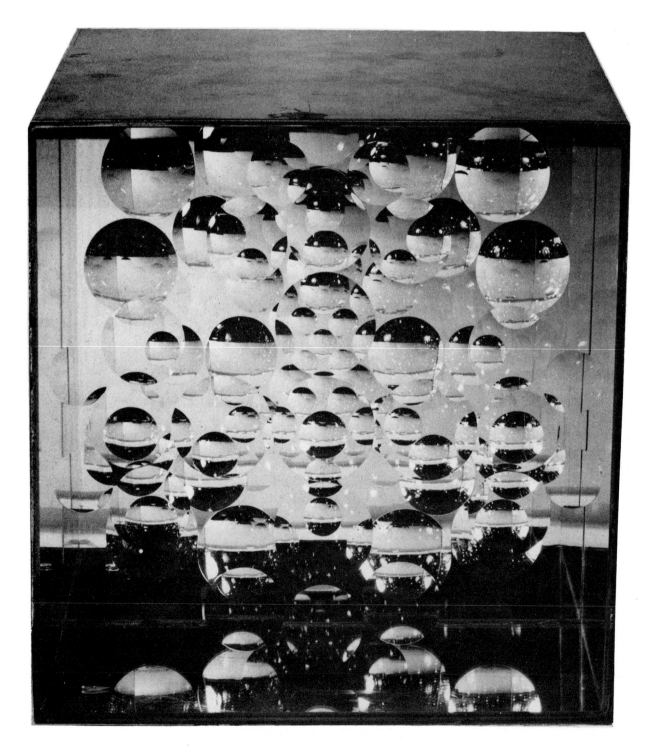

Janus Box Magiscope by Feliciano Bejar, 1968. Parabolic lenses are attached to several layers of clear plastic.

LENSES AND PRISMS

Lenses are used to form magnified or reduced images, or to spread or converge light rays. Both clear plastic and glass work well for this purpose. Plastic lenses can be made from clear polyester casting resin, solid acrylic blocks, or by pouring a liquid—such as water, mineral oil, or glycerin—into transparent containers.

Lenticular Sculpture

Synthetic materials, such as clear polyester and acrylic plastic, offer convenient means of creating lenticular sculpture (transparent sculpture that displays lens properties). Robert Bassler's work is a good example—his transparent sculptures are composed of two or more convex-concave components cast of clear polyester resin. The sculptures are brilliant light refractors and manipulate light by virtue of their lenslike structure.

Jacques Schnier is another artist who works with transparent volumes. He laminates sheets of clear acrylic into large transparent blocks which he then carves with traditional marble carving tools. His sculptures also feature concave forms that capture light, bounce it about inside the sculpture, and send it back broken into reflective patterns.

Like the diamond-cutter who brings out the maximum internal reflection of a gemstone by careful faceting, the artist working with transparent materials will similarly do well to consider the critical angle and refractive index of his materials, thus intensifying their light gathering properties. The term refraction means the bending of light waves as they pass through a transparent medium. The refractive index of acrylic plastic is about 1.5 and the transparency factor is 92%, which is higher than glass. The refractive index for clear polyester is 1.55, but its transparency is considerably less than acrylic.

The angle at which light rays in a transparent material are bent at the air medium boundary to become tangent to the boundary is called the critical angle. In the case of acrylic plastic, the critical angle is 42.2°. This means that light striking the acrylic at angles less than 42° will be reflected internally, producing mirror effects within the plastic and thus maximizing brilliance. The greatest internal radiance is produced only when the artist carefully plans the angles and shapes of his work to conform to these important physical characteristics.

Bruce Beasley, an artist from the San Francisco Bay area, achieves a high degree of success in casting lenticular sculpture. He has produced the largest transparent sculpture to date—the 13,000 lb. *Apolymon,* commissioned by the state of California in 1969. His sculptures are cast of liquid acrylic resin (methyl methacrylate monomer) and are polymerized in a large autoclave he designed himself. All his subsequent works are also cured in this 30,000 lb. tank which carefully controls interior heat, pressure, and humidity—insuring that the internal heat of the polymerizing plastic will not fracture the massive casts. An autoclave, of course, is not a typical item to be found in every sculptor's studio. Consequently, most transparent sculptures are cast of clear polyester resin as it does not require elaborate casting mechanics.

Lenses

Classical lens shapes are either spherical or cylindrical, and vary in structure within their concave or convex categories. Convex lenses are also referred to as converging lenses, bringing parallel light rays to a focal point in front of the lens. Concave lenses diverge parallel light rays outwardly.

The light compositions in the demonstrations that accompany this chapter will show how to use a variety of convex and concave lenses, as well as prisms. Lenses are available both from sources listed in the Suppliers List on p. 170 or from local optical supply houses. Discarded spectacle lenses are available from local optometrists and have many potential uses in creating lenticular art.

Multi-Lensed Thermoplastic Sheeting

Rowlux multi-lens plastic sheets are paper-thin sheets of polycarbonate, approximately .016″ to .018″ thick and available in 24″ × 54″ sheets. There are approximately 10,000 parabolic lenses in every square inch of this plastic sheeting. These lenticular plastic sheets may be used either singularly or superimposed, creating floating or sinking illusions, or shimmering moiré effects. They are available in a full range of colors, including some multicolored sheets. There are many applications for these interesting thermoplastic sheets, including vacuum forming and the creation of lens "collages" (see Suppliers List, p. 170).

Prisms

Prisms have two principal uses: redirecting light rays through internal reflection, or breaking white light into visible component colors. They may be triangular, square, pentagonal, etc., but their planar forms are so inclined as to

receive and transmit light. Light rays falling on a side of a prism are refracted or bent from their original course to an angle depending on the angle of incidence, the angle of the prism, and the material from which the prism was made. This angle of deviation increases as the wave length of the light rays diminishes. Consequently, if a very thin shaft of light falls on a prism, the component rays are separated or dispersed, resulting in the production of a chromatic spectrum. A lens, in essence, is a multiple prism system.

Hydro-Prisms

Angular shaped acrylic constructions, made of transparent sheets of acrylic plastic bonded together, can be filled with distilled water or mineral oil. In this way the artist may produce larger prisms, cutting costs appreciably.

An ambitious heroic-sized hydro-prism environment was created by Charles Ross for the *Magic Theatre* in 1968 (Rockhill Nelson Gallery, Kansas City). For this event he made 10 prism constructions, each 8 feet high, and weighing 250 lbs. empty. The prisms were made of sheet acrylic, cemented with PS-30 adhesive, and filled with distilled water. As the spectators moved in front of the prisms, the structures changed color in a remarkable fashion.

In the demonstration that follows, I have cast several right-angle and 60° prisms of clear polyester resin. An environment was made by placing the prisms in a cluster along with lenses and then subjecting the whole work to beams of collimated light.

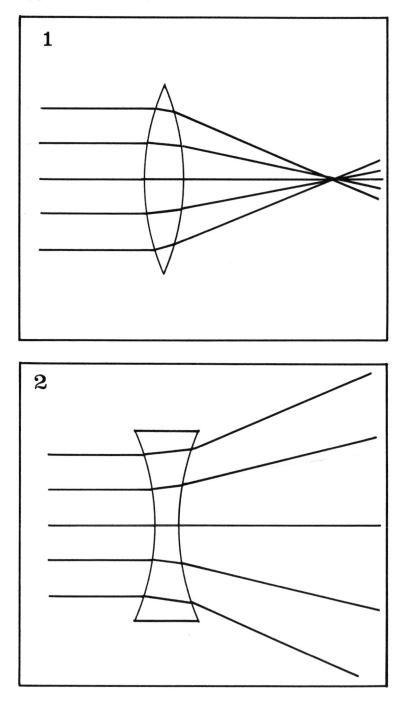

Refraction of Light by Lens Structure. Convex lenses (1) are thicker in the center and converge light rays. These lenses are normally used for magnification. Concave lenses (2) are thinner in the center, diverging the light rays, and serve as reducing lenses.

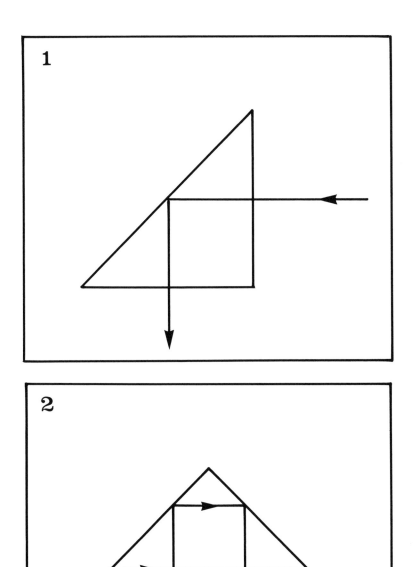

Prism. *This diagram illustrates how a right-angle prism changes the direction of parallel light rays by reflection. By positioning the prism in either Position 1 or 2, light rays may be reflected at either 90° or 180°.*

Demonstration 5
A Composition
with Lenses
and Prisms

Without getting involved in the complex subject of optics, this demonstration will deal with light in a practicable manner—describing a method of producing light compositions with the aid of inexpensive lenses and prisms.

In creating *Light Choreographer I,* I used several convex and concave lenses, 60° and 90° prisms, and mirrors. Collimated light rays enter the structure from the peripheral edges of the circular base, and a cardboard slit mask placed in front of the light source creates parallel lines of white light.

As the light rays enter the environmental field of lenses, prisms, and mirrors they are reflected, refracted, diverged, and converged into a tapestry of interwoven light patterns. A few of the prisms were mounted on inset turntables, adding the element of movement as well.

Materials

Plywood base, 24″ in diameter

White acrylic housing

Clear polyester resin and catalyst

Prism molds: 3″ × 40″ window glass and wood plugs

Convex and concave cylinder lenses

Glass and aluminum mirrors

5 ½ rpm. motors and wiring

5 small turntables

Silicone seal

Saw

Epoxy cement

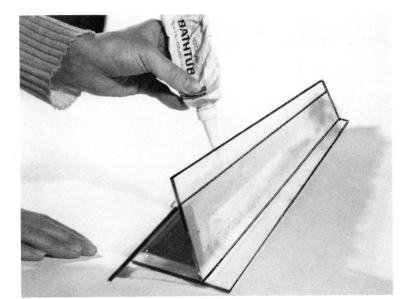

1. Molds for casting the prisms were made of window glass, cut to 3″ × 40″. Silicone seal adhesive is used to join the three glass slabs together. Several molds were made in this fashion, set either at 60° or 90° angles.

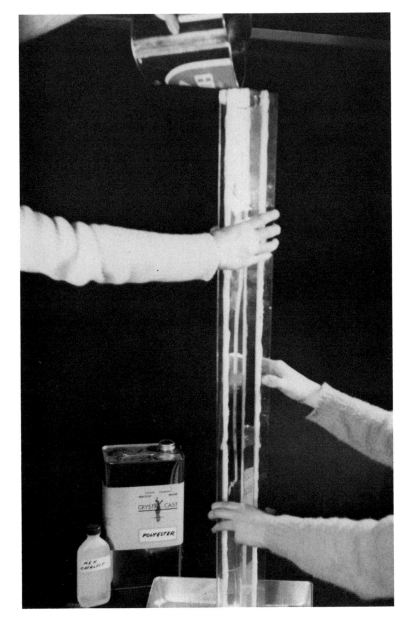

2. A triangular wooden plug is glued to the bottom of the glass molds with silicone seal. Clear polyester resin is catalyzed, stirred thoroughly, and then poured into the molds. Approximately two drops of MEK peroxide catalyst per ounce of resin were used for polymerization.

The glass molds are broken after 48 hours to release the prisms. Although not as clear as glass or acrylic, the prisms do not need polishing when released, and they work quite well for the purposes intended.

3. Five ½ rpm. motors are used to create even more visual excitement. Small turntables on top of the motors are inset in the circular base (made from white plastic) to rotate the prisms.

4. (Below) The main components are shown here prior to assembly. These include convex and concave cylinder lenses, 60° and 90° plastic prisms, and glass and aluminum mirrors. The lenses were made by shaping ½" thick clear acrylic on a sander and a polishing wheel. Many types of glass lenses are also available through sources listed on p. 170.

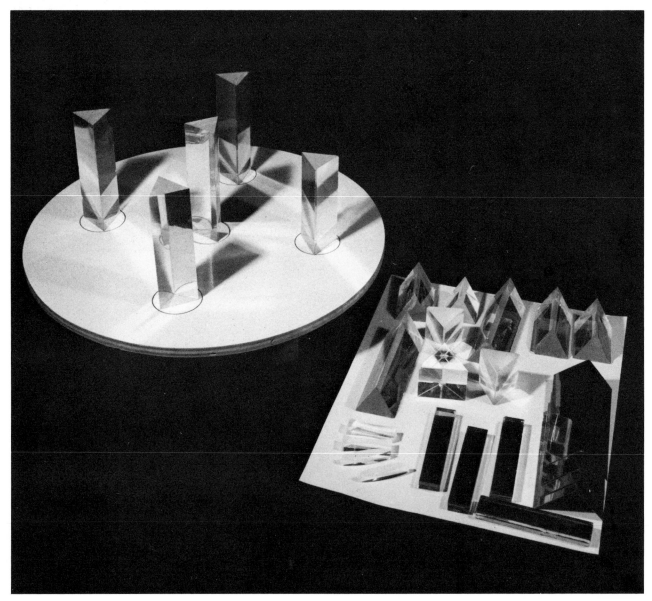

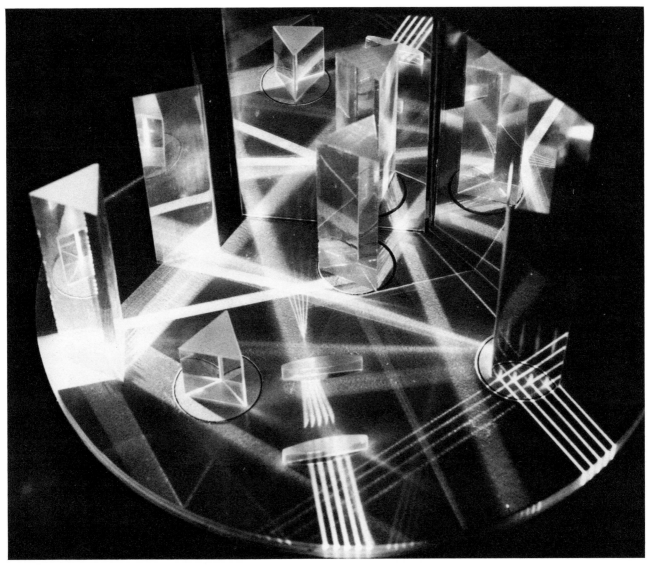

5. Light Choreographer I. *Glass, metal, plastic, 24″ × 10″. This work requires a darkened atmosphere for maximum impact. In this photo, high-intensity lamps have been placed at the outside edges of the work, producing a repetitive cycle of interwoven light patterns.*

Demonstration 6
A Lens and
Photomontage
Construction

This construction has two principal components: a "collage" of ruled lines and photographic prints glued inside the bottom of a shallow box; and clear acrylic rods, or lenses, arranged over them to produce the optical effects.

By viewing the construction from different angles a variety of colors, shapes, and apparitions "pop" from its depths. Lines and shapes seem to wrap themselves around the rods as they are magnified and distorted.

The underlying structure, or collage, may be varied by using typography, drawings, magazine illustrations, or fairly flat three-dimensional objects. Also, by experimenting with acrylic rods of varying thickness, and stacking them in either single, multiple, or uneven layers, a variety of optical effects are possible.

Further variations of this idea would be to make "hydro-lenses." In this case, glass or plastic tubes are filled with water, mineral oil, or colored liquid, capped with short solid acrylic "corks," and sealed with clear epoxy cement.

Materials

Shallow wooden box, 12″ × 12″ × 1½″
Acrylic rods of varying thickness
Collage (photos or prints)
Epoxy cement

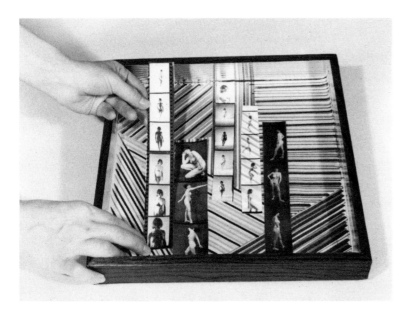

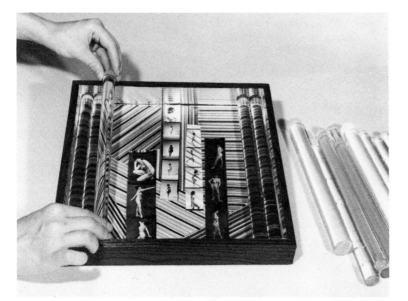

1. A collage of ruled parallel lines and photographic prints is pasted to the interior of a shallow box.

2. Acrylic rods, cut to fit the box, are placed over the collage to create optical effects. Images are magnified and distorted and have a tendency to "shift" as the spectator's angle of view changes.

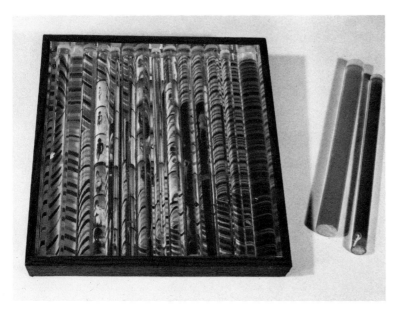

3. The acrylic rods vary in size and are pyramided to build several levels. Clear epoxy cement is used on the ends of the plastic rods to keep them in position.

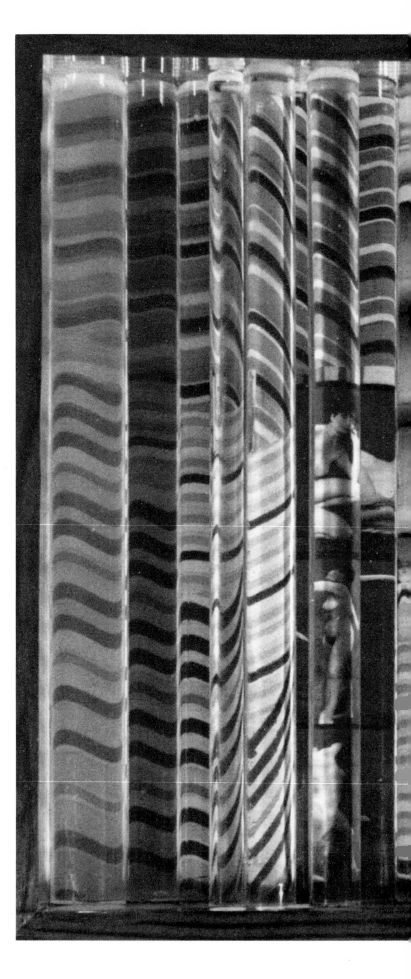

4. Lens and Photomontage Composition. *Acrylic rods and two-dimensional designs, 12" × 12" × 1½". Colors, shapes, and images ''pop'' with the spectator's slightest movement. The underlying designs are magnified and distorted to create a variety of interesting optical effects.*

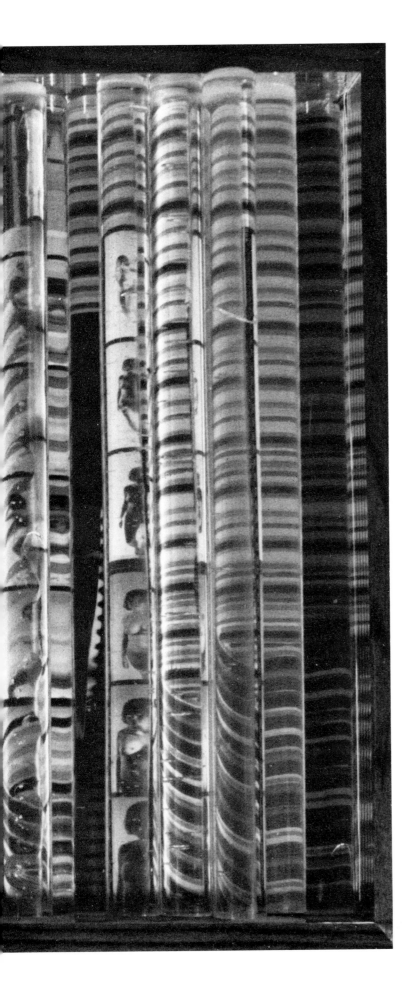

Demonstration 7
An Optical Box

The concept of visual transformation describes works that undergo some form of change in the presence of the viewer. A "game" element is present as well; the concept requires the viewer to actively participate, and to some measure control, the visual experience.

A common approach can be seen in the methods of Agam, Soto, and Cruz-Diez. These artists create bas-reliefs that are quite static. However, through careful arrangements of painted designs on repetitive fins, louvres, or grids that protrude from the work at specific angles, the various compositions emerge as the viewer passes before the work. The accompanying diagram shows two possible methods of construction.

This demonstration illustrates another method for visual transformation by constructing an op box that "flips" its colors, shapes, and forms as the spectator changes his angle of view. The unit has two basic components: an arrangement of colored plastic shapes within a shallow box, and a sheet of patterned glass placed over the top surface of the box. It is the glass, with its surface of honeycomb "lenses," that optically distorts the underlying shapes and initiates optical excitement.

Materials

Shallow box, mirror lined, 18″ × 18″ × 5″
Black acrylic to cover box
Colored acrylic sheet cut in small pieces
Honeycomb-patterned glass (½″ square parabolic lenses), 18″ × 18″
Small mirrors
Epoxy cement

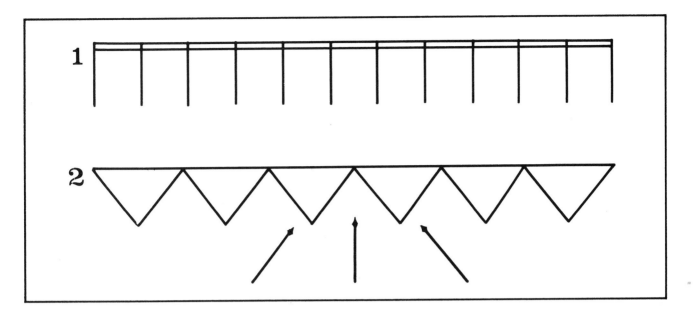

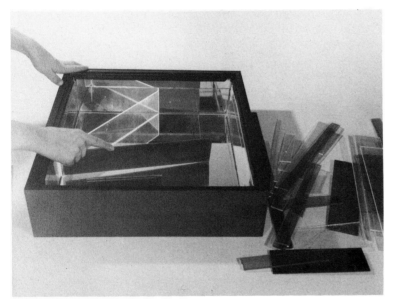

Transformation Diagrams. (Above). Here are typical designs for transformation structures. The first figure has been used by Soto, the second by Agam.

1. Brightly colored pieces of acrylic sheet are arranged within a shallow, mirror-lined box (5″ deep) to create an assemblage of shapes and colors. The acrylic shapes are cemented together with epoxy cement.

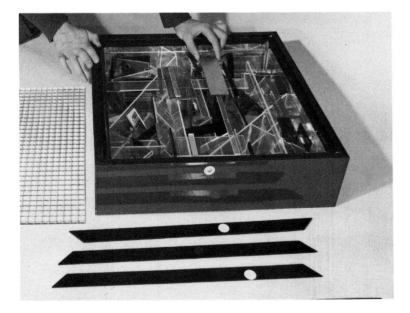

2. Many smaller rectangular shapes of transparent acrylic and small rectangular mirrors complete the interior structure.

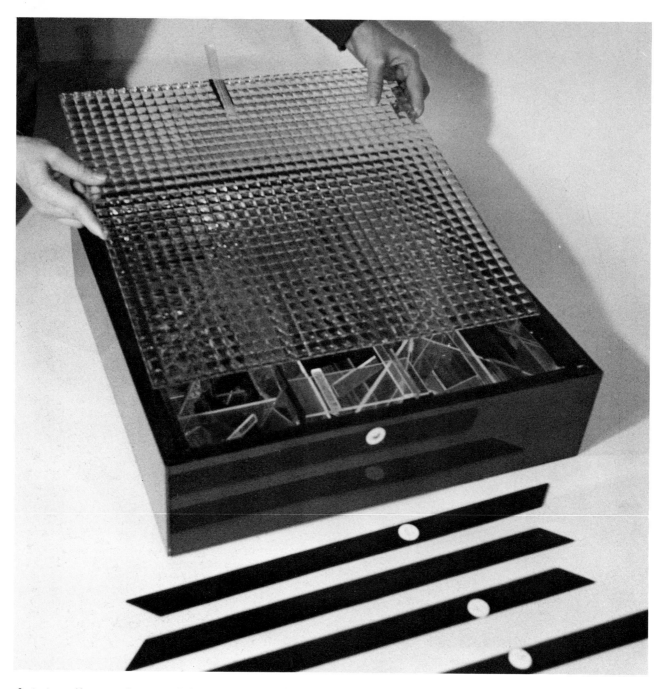

3. *A piece of honeycomb-patterned glass with a face of ½" square parabolic lenses is shaped to fit the top of the box. Many types of this patterned glass are available at local glass shops, and all produce interesting optical effects. The optical patterns have a "focus" determined by the distance the glass is placed above the underlying structure. By prior experimentation, a distance of 5" seemed most effective for this design.*

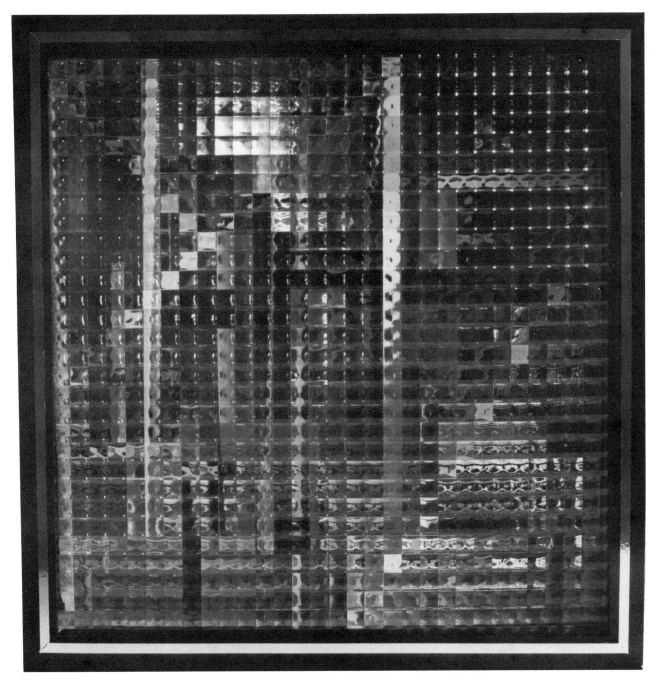

4. Transformation Op Box. *Glass, plastic, and mirrors, 18" × 18" × 5". As the viewer moves in front of the box, a mosaic of jewellike colors "pop" and shift on the ambiguous surface. Available light is captured and reflected by the underlying construction to generate a brilliant glow of color.*

Demonstration 8
A Lens Kinetic

The basic idea for this kinetic piece is somewhat similar to the op box described in the previous demonstration. It differs, however, because the movement is initiated by mechanical means rather than by spectator displacement. The basic components of *Lens Kinetic* are a "color rotor" attached to the face plate of a small motor, a deep mirror-lined box, and a piece of honeycomb glass. When the color rotor is in motion, the face of the construction, covered by the honeycomb glass, alters dramatically. Segments of color pulse brilliantly, moving rhythmically about the glass surface. To me, the work evokes the quality of running water passing quietly over submerged forms.

Materials

Deep box, mirror lined, 12″ × 12″ × 15″
Thin black acrylic to cover box
Aluminum sheeting
2 sheets honeycomb-patterned glass
½ rpm. synchronous motor and wiring
Colored theater gels
Black cloth tape
Epoxy cement

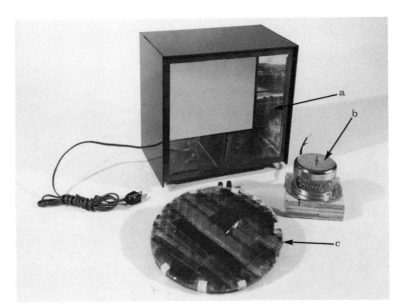

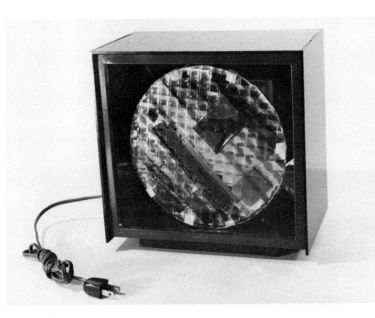

1. *Components for this kinetic include (A) a deep mirror-lined box, (B) a ½ rpm. synchronous motor, and (C) a color rotor made of a circular piece of aluminum covered by honeycomb-patterned glass with colored theater gels sandwiched between them.*

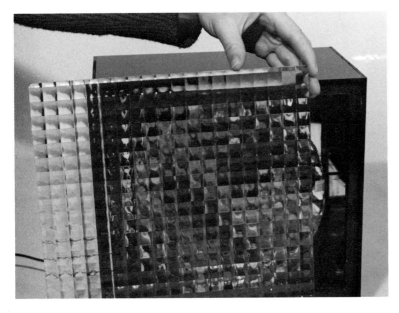

2. *The color rotor is attached to the face plate of the motor, and the unit is then secured within the box.*

3. *A rectangular piece of honeycomb glass is attached to the top surface of the box and secured with strips of black cloth tape. The outside of the box is dressed up with black acrylic attached by contact cement.*

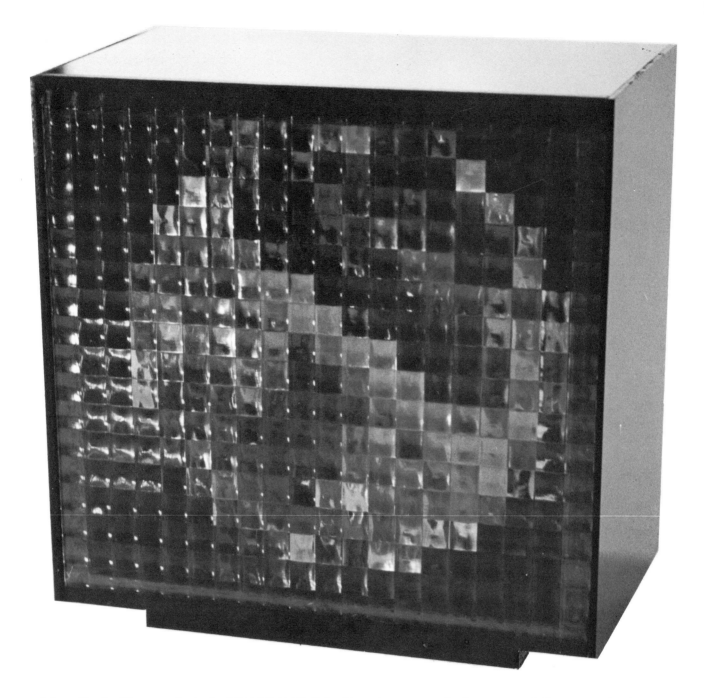

4. Lens Kinetic. *Glass, wood, plastic, 12″ × 12″ × 15″. Soft, shimmering patterns of color appear and disappear on the glass surface of this construction. Two sheets of patterned glass provide hundreds of parabolic lenses, which in turn create the color modulating effects.*

Visual Dynamics by Toni Costa, 1968. *The structural line design interacts with its own shadow to produce strong moiré effects.*

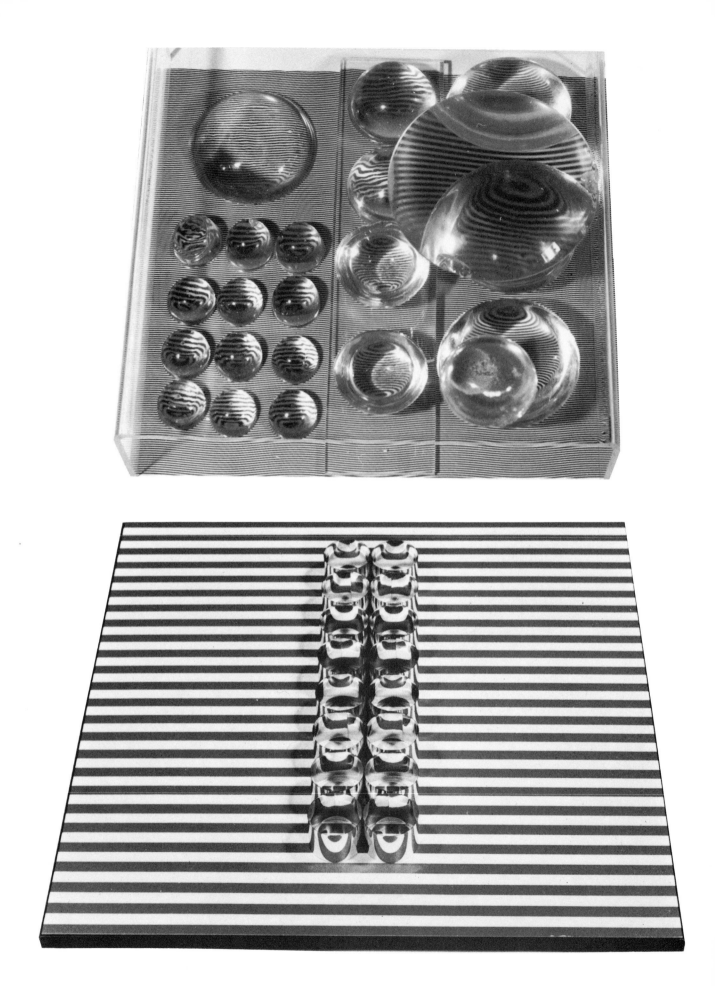

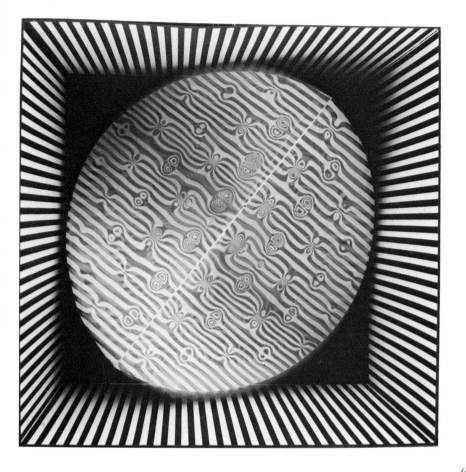

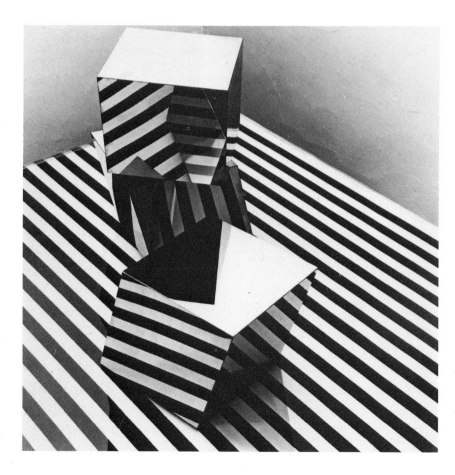

(Opposite Page Above) This photo shows optical magnification and distortion created when parabolic lenses are placed over a parallel line design. The lenses are on two planes.

R-12 (Opposite Page Below) by Le Parc, 1970, 16" × 16" × 2". Short cylinders of clear acrylic rod disrupt the parallel line field to create kinetic patterns. Denise René Gallery, Paris.

Tramé Alterne (Above) by Le Parc, 1968. Serigraph, metal, motor, 12" × 12" × 12". The central disc is made of polished aluminum, bent in the center to create a distorting spherical mirror. As the disc slowly turns, the stripes are reflected and transformed into intricate linear patterns. Denise René Gallery, Paris.

Untitled (Left) by Hans Breder, 1966. Highly polished cubes of aluminum "pick up" the patterns of the surface on which they are placed. They seem to dissolve into the two-dimensional surface, creating an anachronism of visual perception.

Espacio Segun Leyes Azar (Overleaf) by Jordi Pericot, 47¼" × 47¼". A maze of hollow cylinders is set at right angles over a painted surface, generating a labyrinthian maze of reflective color. The tubes, made of flexible aluminized plastic, are set into a shallow box construction covered with a protective sheet of clear acrylic.

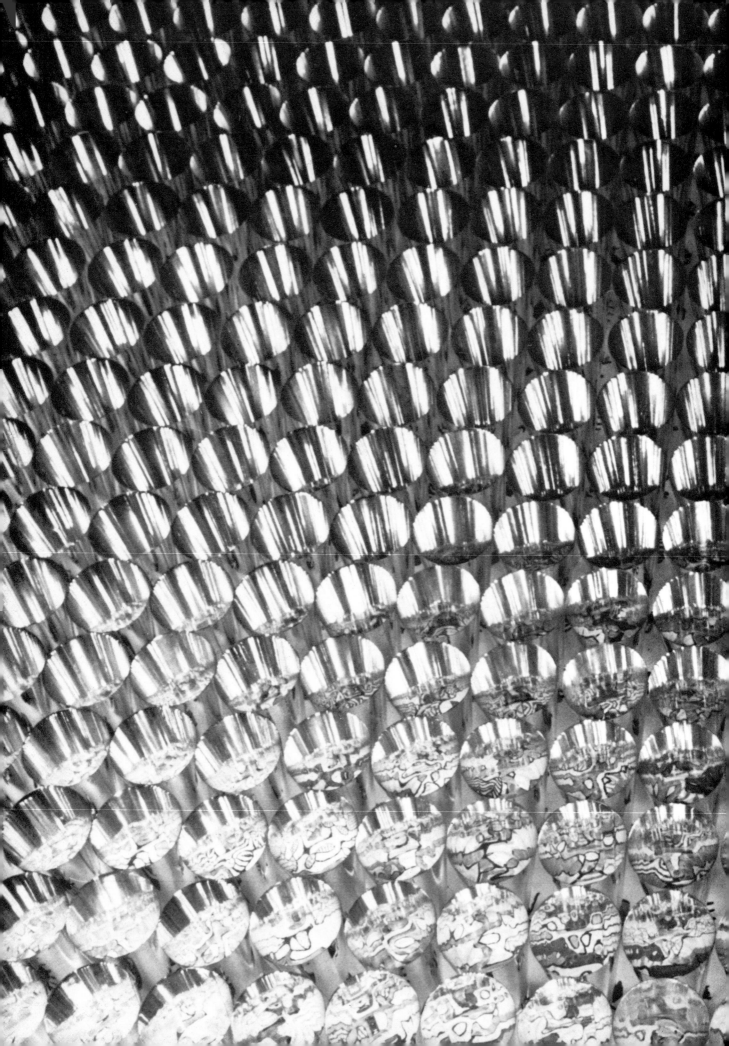

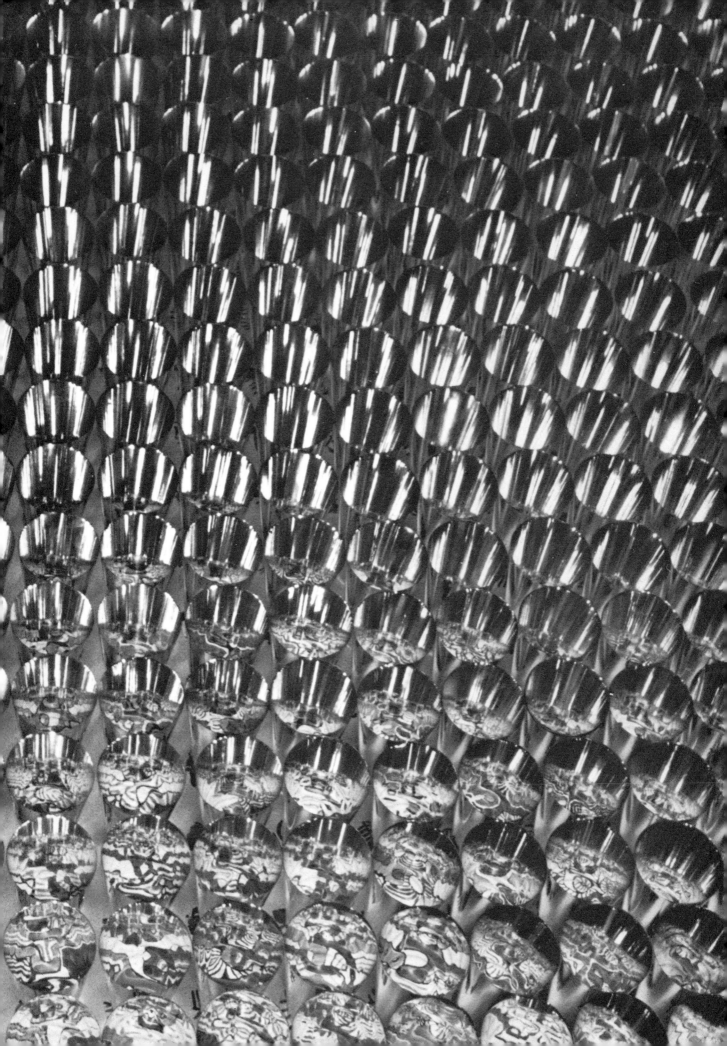

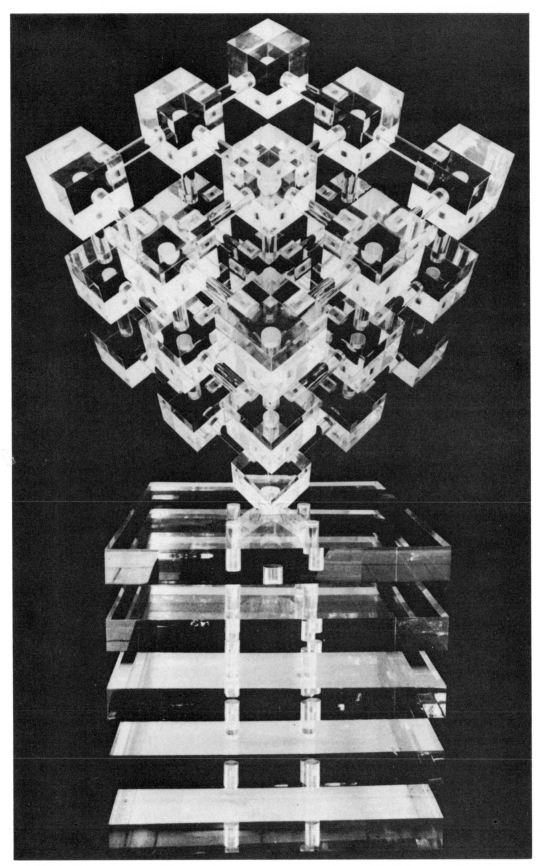

Multicube II by John Safer. This lenticular sculpture seems to "dematerialize" because of its ambiguous transparent volumes and reflective surfaces.

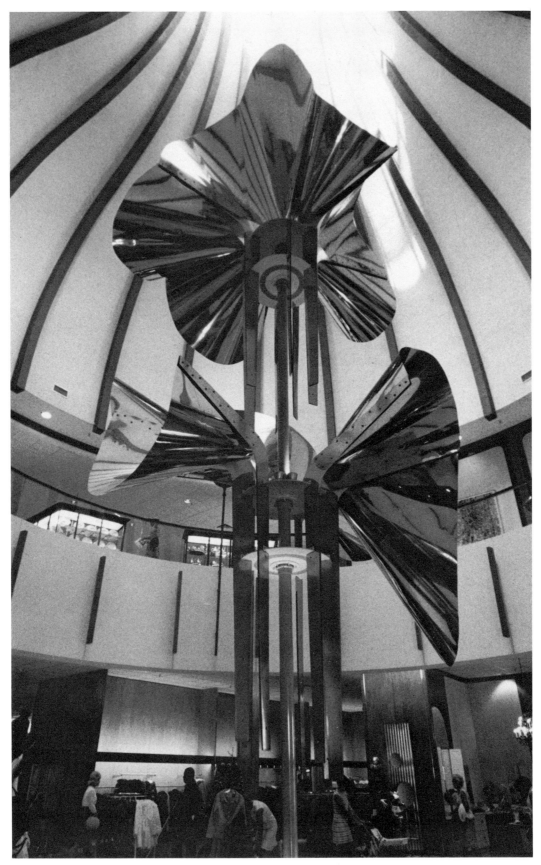

"Can-Can" by Jan Zach, 150 × 24 feet. This giant kinetic sculpture slowly moves to reflect the surrounding forms and colors in a large shopping center in Oregon. Stainless steel sheeting was cut with a metal nibbler and riveted. Rotunda of the Meier & Frank Co., Eugene, Oregon.

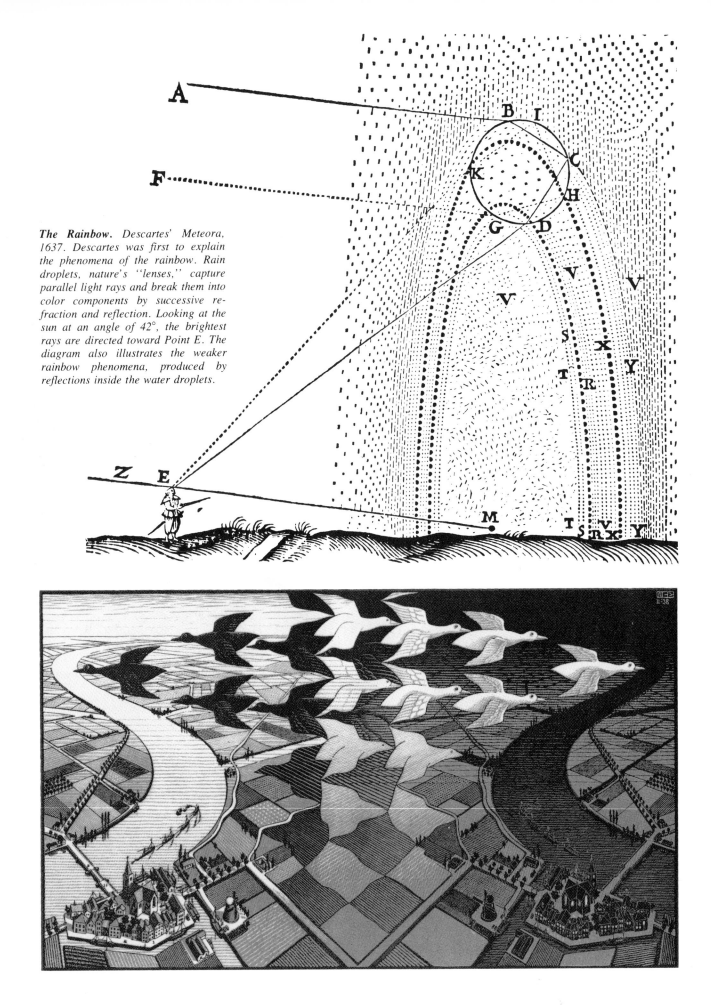

The Rainbow. *Descartes' Meteora, 1637. Descartes was first to explain the phenomena of the rainbow. Rain droplets, nature's "lenses," capture parallel light rays and break them into color components by successive refraction and reflection. Looking at the sun at an angle of 42°, the brightest rays are directed toward Point E. The diagram also illustrates the weaker rainbow phenomena, produced by reflections inside the water droplets.*

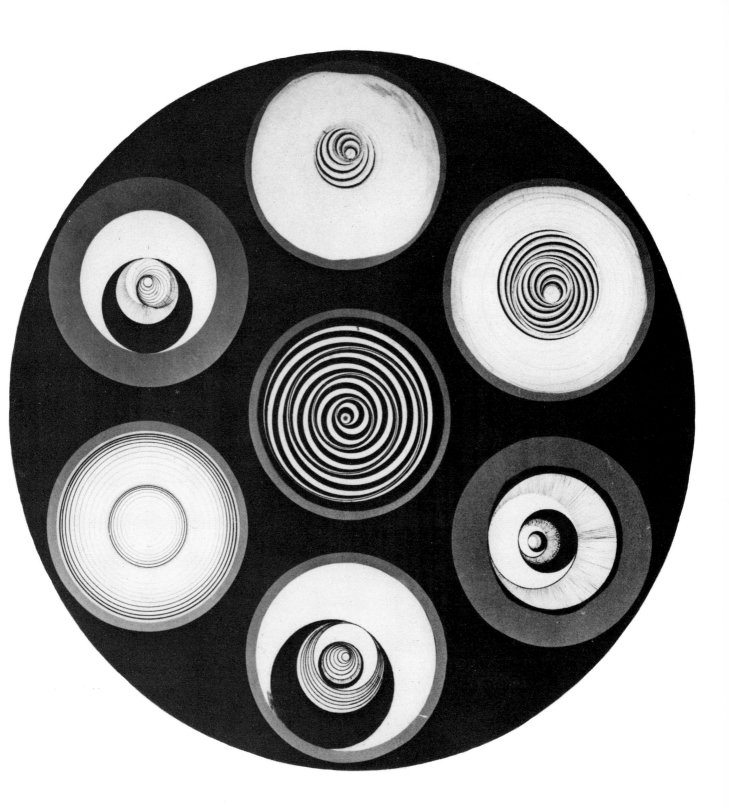

Day and Night (Left) by Maurits Escher, 28" × 13". The visual anachronism in this woodcut is described in the words of the artist: "Gray rectangular fields develop upwards into silhouettes of white and black birds; the black ones are flying towards the left and the white ones towards the right, in two opposing formations. To the left of the picture the white birds flow together and merge to form a daylight sky and landscape. To the right the black birds melt together into night. The day and night landscapes are mirror images of each other, united by means of the gray fields out of which once again the birds emerge." Courtesy of the Vorpal Gallery, San Francisco, California.

Rotoreliefs (Above) by Marcel Duchamp, 1923. Ink on paper, 8½" to 12¼". These drawings were made for use in the motion picture Anemic Cinema. When slowly rotated on a record turntable, the rotoreliefs swell and contract, producing a variety of three-dimensional illusions. The Seattle Art Museum, Washington.

Equivocal Construction by *Gordon Brown, 24″ ×
36″. A U-shaped acrylic construction is attached
to the surface of two mirrors set at right angles.
The U-shape continues into the virtual space behind
the mirror, completing an orbital form.*

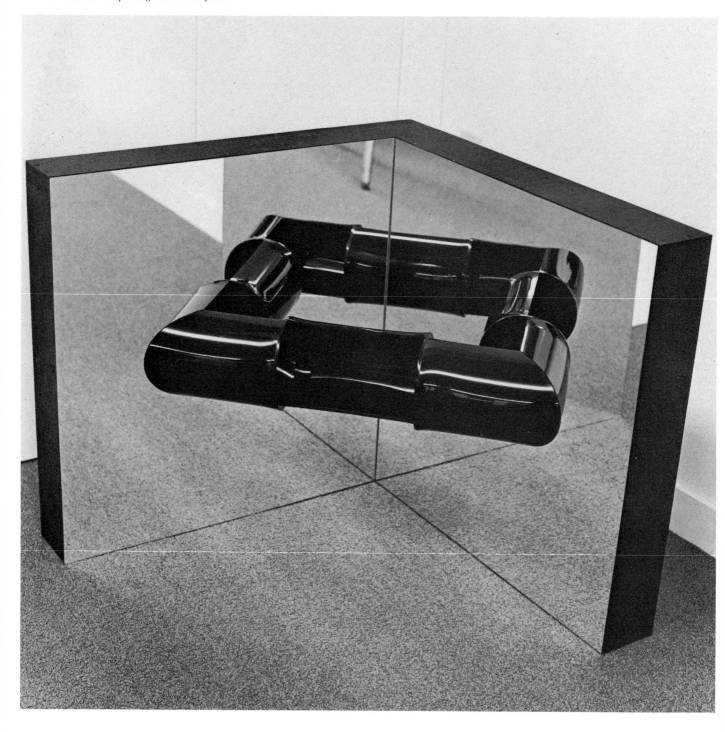

Body Work by Hans Breder, 1972. The artist uses photography to document experiments with mirrors and reflective images. The human body is the subject matter, and its anatomical forms recombine into compositions via the mirrors.

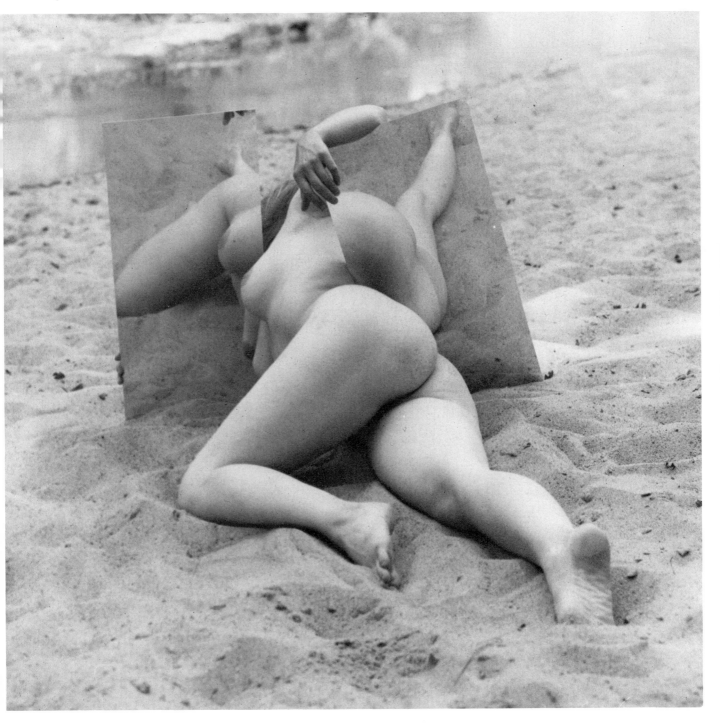

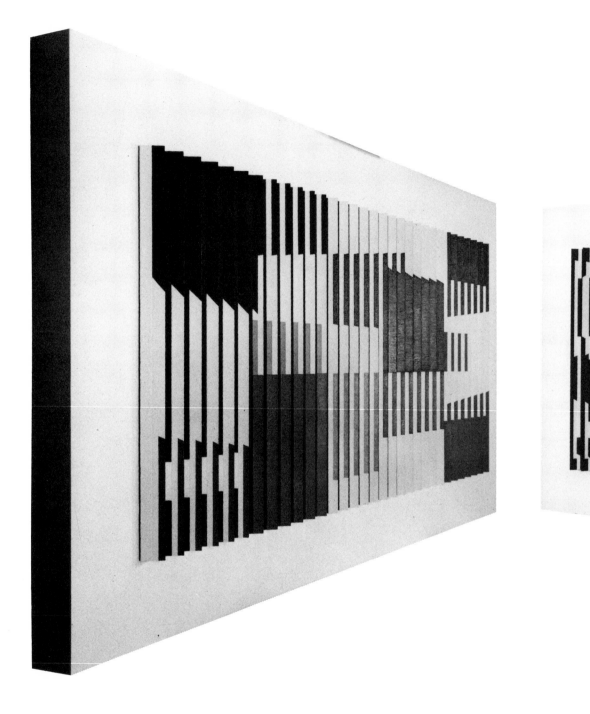

Hommage to J. S. Bach *by Yaacov Agam, 1965,
28½" × 60½". Painted on a corrugated base,
three separate compositions emerge as the spectator
walks by. The photos show the composition from
the left, head on, and from the right.*

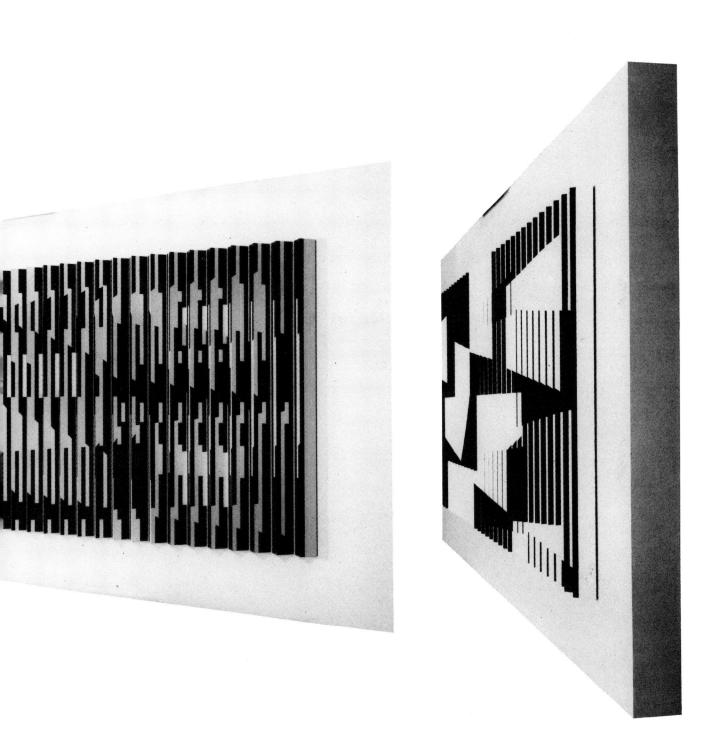

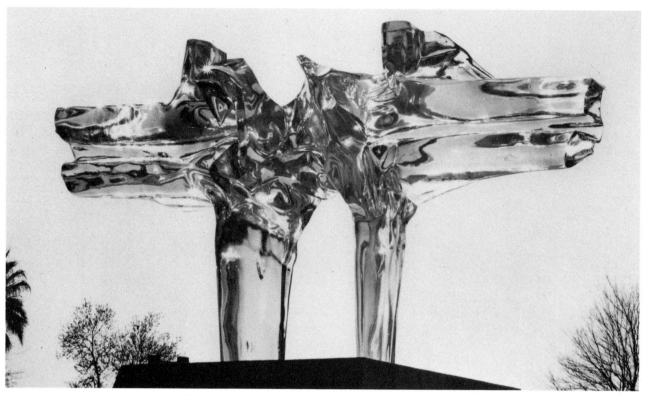

Apolymon by Bruce Beasley, 1967–1970. This work represents the largest massive pour of liquid acrylic to date. Weighing 13,000 lbs. and 15 feet high, polymerization of the transparent acrylic resin was controlled in a special autoclave designed by the artist. Many months of tedious labor were involved in the final polishing of the work to effect lenslike qualities. The organic structure is a complex lenticular system with carefully modeled planes and curvatures, calculated to maximize internal brilliance.

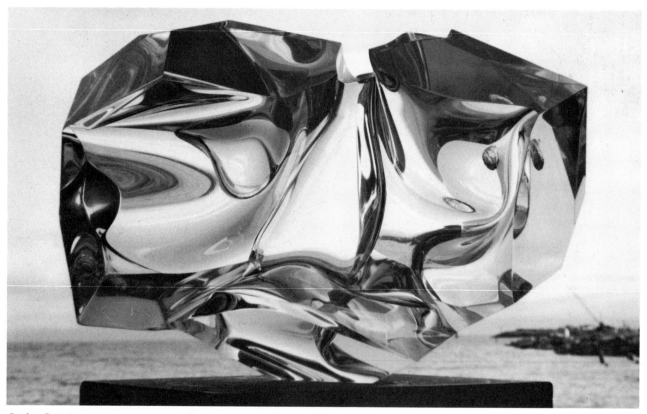

Scalar Gyration by Bruce Beasley, 1972. Cast lucite, 2 feet high. This transparent lenticular sculpture incorporates carefully controlled convex and concave volumes. A hybrid of organic and geometric form, it captures and reflects light even under the dimmest lighting conditions.

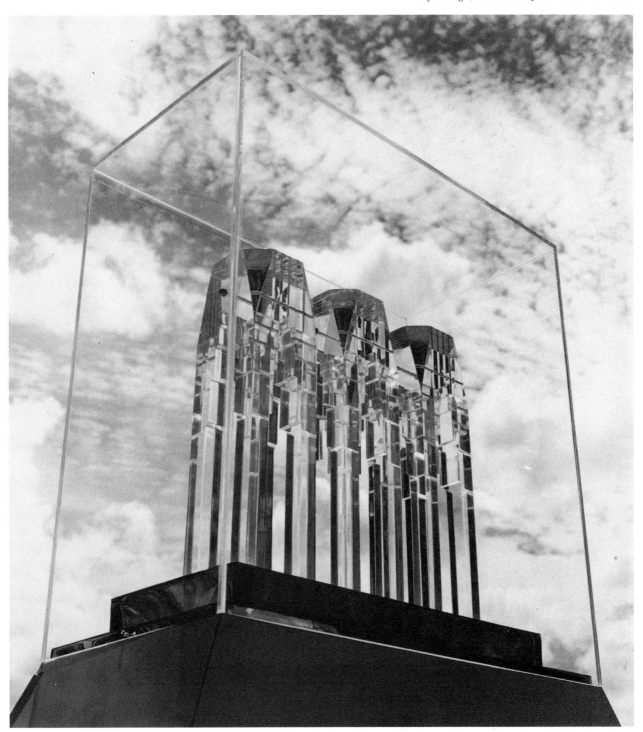

Toltec Temple by Jim Hill, 1973.
Copper, acrylic, and white formica,
3 feet high, illuminated from within the base.

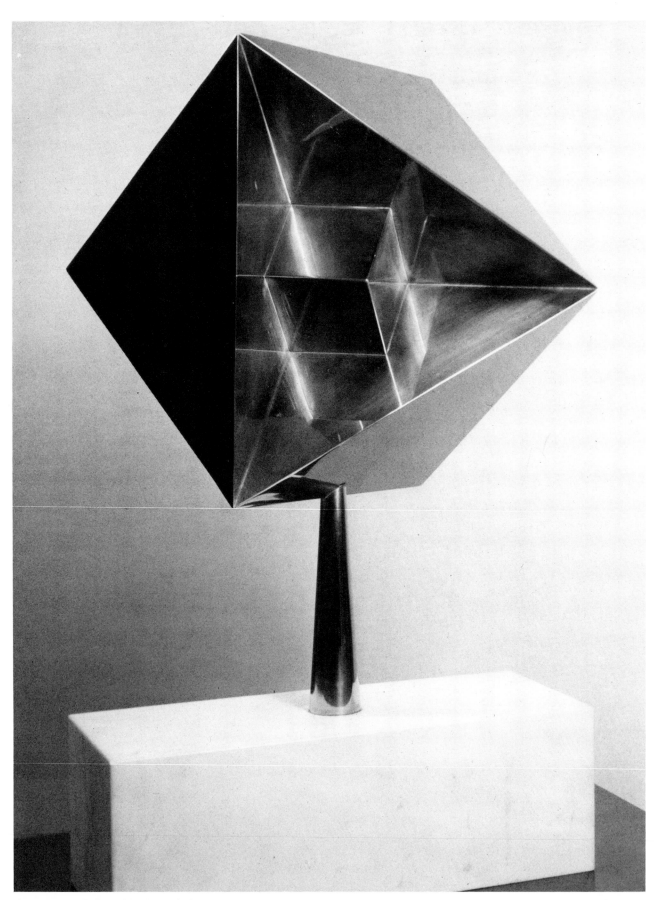

Construction With and Within a Cube by Max Bill. This sculpture interrelates actual and virtual volumes through a highly reflective metal surface. The Staempfli Gallery, New York.

Optogone *by Adolph Luther, 1968.*
Glass, mirors, and motor 42" x 42".
Denise René Gallery, New York.

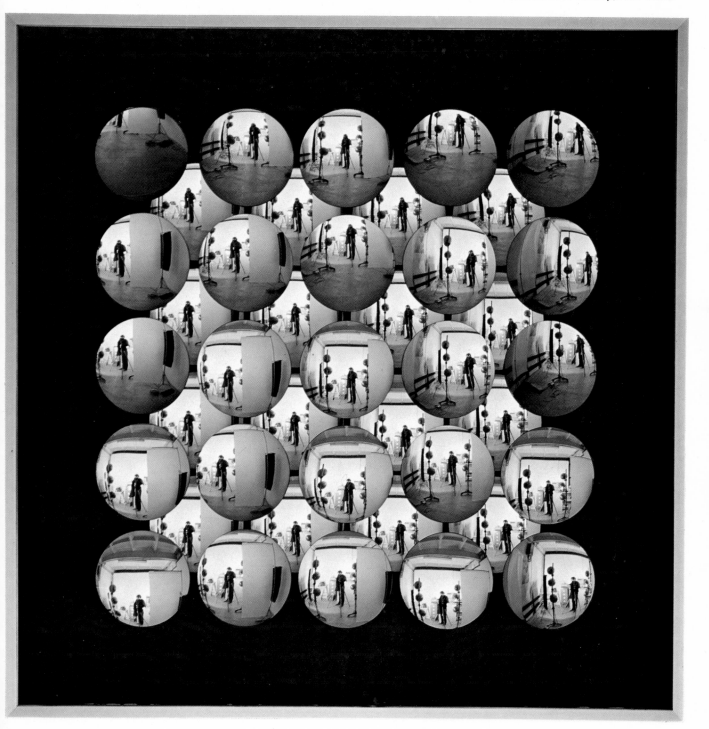

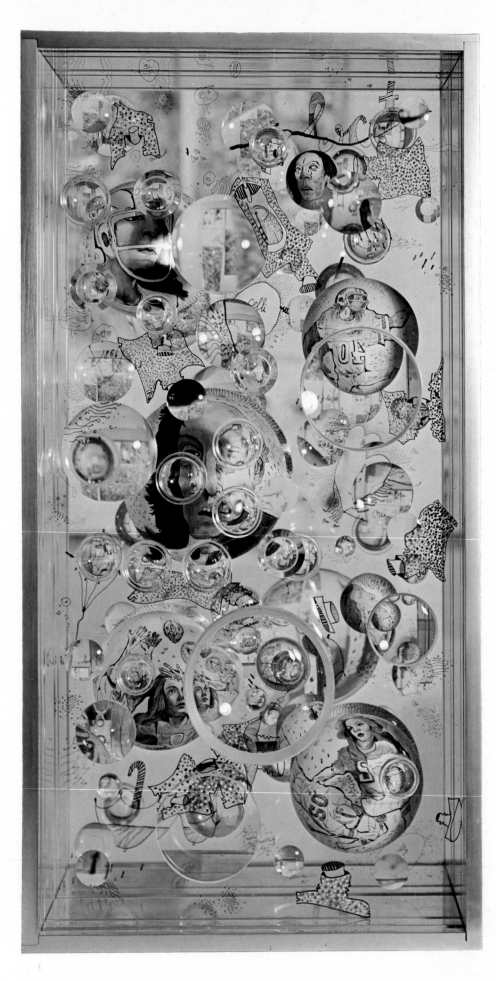

Beaute-alli
*by Mary Bauermeister, 1969.
Drawings, lenses,
and acrylic.*

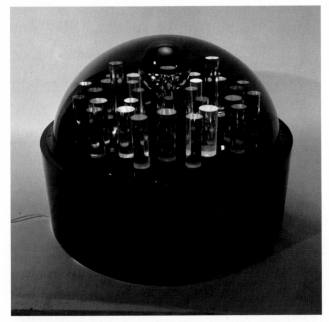

Color Gun by Nicholas Roukes, 24" x 19". Soft, pulsing colors are piped through acrylic rods in this sculpture from Demonstration 12.

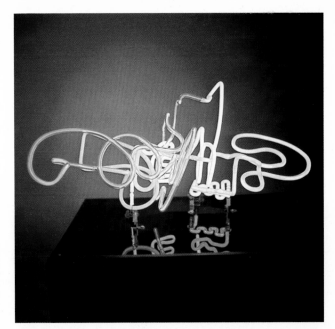

Neon Sculpture by Nicholas Roukes. Nineteen feet of glass tubing was used to create this sculpture in Demonstration 14.

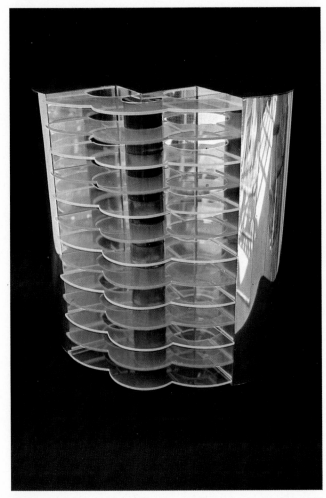

Telesm 12 by Nicholas Roukes, 16" x 14" x 10". "Virtual" shapes interact with actual forms in this sculpture from Demonstration 3.

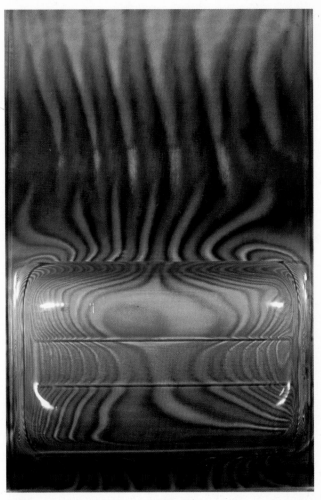

Eide by Leonard Hessing, 1969. Screen print on vacuum formed acrylic.

Lumia Light Sculpture *by Nicholas Roukes. This Lumino-kinetic produces an ongoing program of changing colors and shapes. Instructions are detailed in Demonstration 9.*

Transformation Op Box *by Nicholas Roukes, 18" x 18" x 5". This structure, from Demonstration 7, produces a mosaic of color shifts at the viewers slightest movement.*

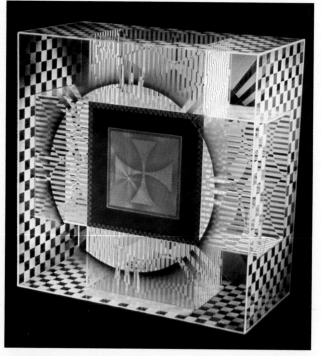

Acrylic Construction *by Robert Stevenson, 1969. 12" x 24" x 24".*

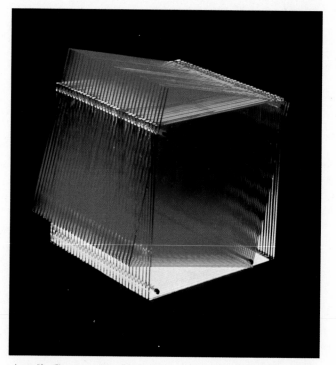

Acrylic Construction *by Takayasu Ito. Acrylic pieces in two contrasting colors are closely spaced to create an illusion of two interpenetrating cubes.*

Hat IV *by Victor Vasarely, 1972, 36½″ x 31½″.*
This visual kinetic presents
optical illusions as cubes seem to "flip."
Denise René Gallery, Paris.

Micro Temps 19 *by Nicholas Schoffer, 1965.*
Precision-made components of metal and plastic
are sequentially illuminated with chromatic light and
revolve at varying speeds, causing "virtual illusions."
Denise René Gallery, Paris.

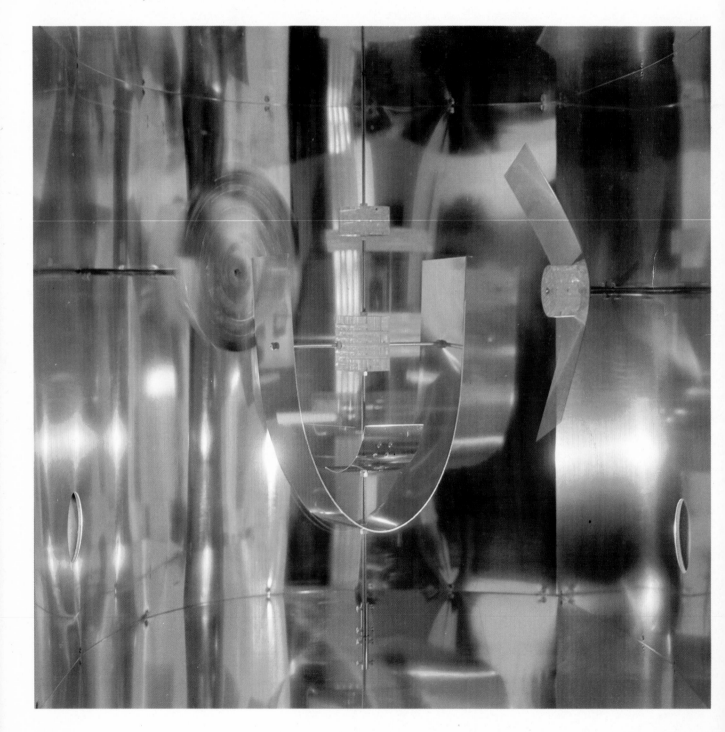

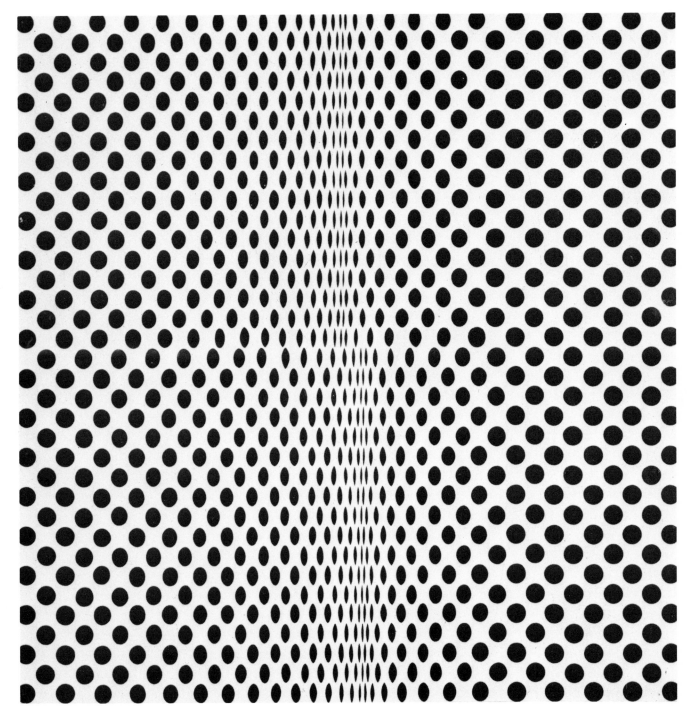

Fission by Bridget Riley, 1963. Tempera on composition board, 35" × 34". The optical field consists of repetitive dots, designed to "accelerate" energy toward the center of the painting. The Museum of Modern Art, New York.

Reflective Relief by Willy Weber, 1970. Convex and concave reliefs are formed from steel plates by carefully controlled dynamite charges. The reliefs are chrome-plated and mirror environmental form and color.

Multiple by Salvador Victoria, 1971.
Reeded plastic sheet covers
a silkscreened design.

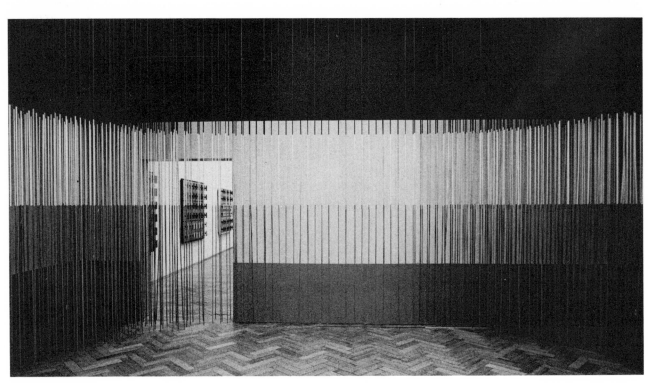

Environmental Kinetic *by Soto, 1969. This photograph shows only the end wall portion of the environment, which continues around the whole room. Stedelijk Museum, Amsterdam.*

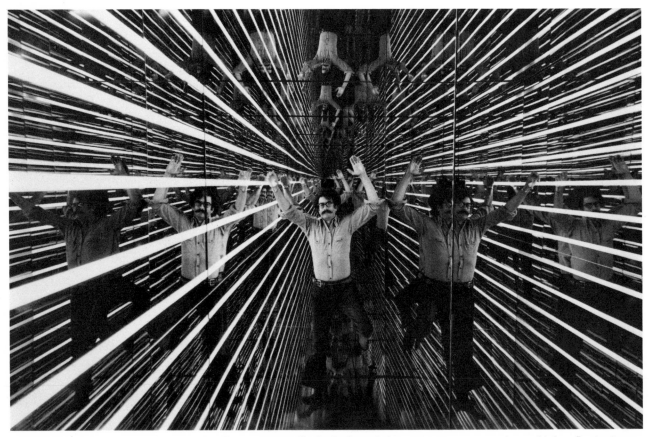

Infinite Images *by Domingo Alvarez, 1971. The spectator walks freely through this environment, generating multiple reflective images in a sort of "unreal theater."*

Epsilon *by Victor Vasarely, 1958–1962, 51″ × 38″. Equivocal visual linkage and after-image phenomena. The Denise René Gallery, New York.*

PART 2
MECHANICAL
KINETICS

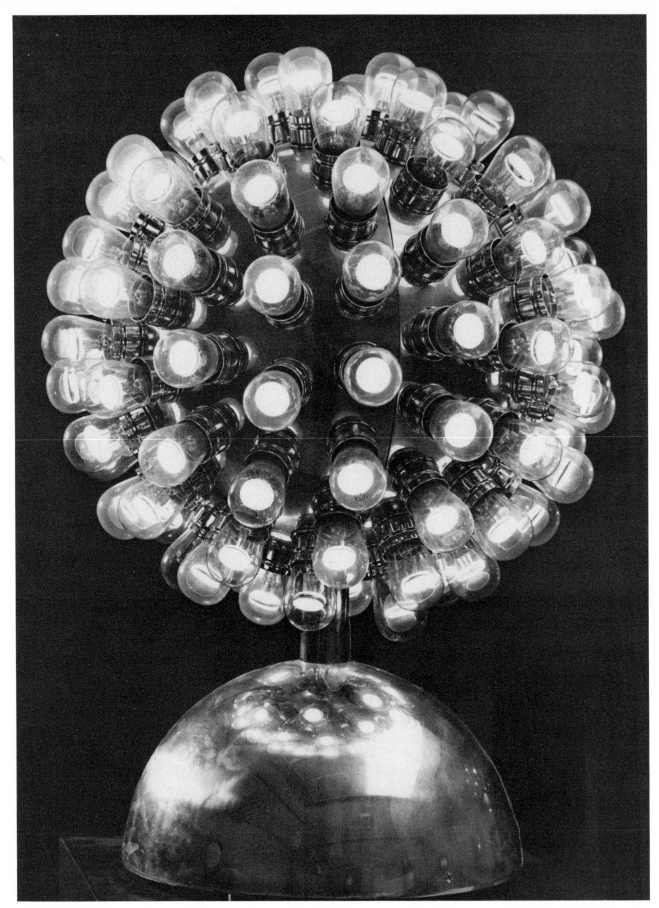

Electric Rosebush *by Otto Piene, 1965. A neon light construction, 26″ × 18″ × 18″. The Milwaukee Art Center, Wisconsin.*

INTRODUCTION

Kinetic *(ki-net-ik) a. (Gr. Kinetikos, kinetos,*
verbal adj., of kinein) move; causing motion.

Kinetic art is the art of "change." It is an art form that expresses itself through time-lapse—mobilizing force and creating interrelationships of its movements in points of time-space. "I can make my pieces fly, suspend in the air, or radiate odors," says Chicago sculptor, Mel Johnson.

Early Kinetic Devices and Automata

The development of automatic devices dates far back in history. Hydro clocks were developed during the Golden Age of Greek culture. In the Middle Ages, elaborate mechanisms were installed in town clocks to mobilize figures that went through all kinds of elaborate capers.

Squeek boxes, toys, music boxes, flicker books, kaleidoscopes, puppets, marionettes, pop-up books, shadow shows, kites, hoops, and magic lanterns were just a few of the devices designed to amuse or entertain through the medium of kinetics.

The "magic lantern" (the first projection device) was a 17th century invention. Images were painted on glass slides and placed in a box containing a concentrated light source, an oil-burning lantern with a primitive lens system.

Automata may be described as mechanical devices which are self-moving but not necessarily created for esthetic purposes. The automaton, *Psycho,* created in 1875, was a lifesize manikin containing a maze of mechanical devices allowing it to play whist. The mechanics were exposed to view as it played with three volunteers from an audience, oftentimes winning. *Psycho,* of course, would be no match for our Hal 5000.

Early automata also included Pierre Jacquet-Droz' *Writing Manikin,* made in 1770, and Jacques Vaucanson's *Duck,* 1773, which was made of gilded copper and ascribed to virtues of drinking, eating, quacking, splashing about in the water—and even "digesting" his food.

Beginnings of Kinetic Art

Kinetic art, as we know it, perhaps started in 1920 with Naum Gabo's wire construction. This was a simple device; an oscillating wire that exploited the phenomenon of persistence of vision, creating a "virtual volume" as it vibrated. Gabo designed the piece as a demonstration for his students in Moscow, simply to show that a line could transform itself into a volume through motion.

Other precursors were Marcel Duchamp's *Bicycle Wheel,* 1913; Tatlin's *Monument to the Third Internation-* *al,* 1920; Moholy Nagy's *Light Machine,* 1930; Thomas Wilfred's *Clavilux,* 1921; Alexander Calder's mobiles, 1932; and Duchamp's rotoreliefs, 1935.

Robert Rauschenberg's *Broadcast,* 1959, was significant as it was one of the first "combines"—a work integrating painting, collage, and sound. The sound emanated from radios behind the work.

The Realist Manifesto

Published in the early 1920's by Gabo and Pevsner, *The Realist Manifesto* states that: "We renounce the thousand year old delusion in art that held the static rhythms as the only elements of the plastic and pictorial arts. We affirm in these arts a new element, the kinetic rhythms, as the basic forms of our perception of real time. . . ."

The morphology of movement (morphodynamics) is well described in books such as: *Constructivism, Origins and Evolution,* by George Rickey; *Kinetic Art,* by Frank Popper; and *Beyond Modern Sculpture,* by Jack Burnham.

Technological Art: Materials and Devices

Some of the concepts and ingredients involved in making kinetic art include the following:

Pneumatics: air-supported systems, air-activated structures.

Floating, flying systems.

Motorized devices with varying speeds, cycles, rhythms.

Flexible surfaces and forms: "soft" art, light-reflective soft surfaces.

Materials under tension, pressure, or other forms of restraint.

Chemical art: heat-sensitive or pressure-sensitive liquid crystals, gases, combustibles; miscible or immiscible fluids, chemical light.

Sound: sound generators, oscillators, transducers, sonar, VTR, recorders, mixers, time-lag relays and accumulators, feedback, music synthesizers.

Light: projection techniques and devices, color organs; fluorescent, incandescent, neon, strobe, polarized, laser, coherent, ultra-violet light, aerial projections, virtual illusions, holograms, electro-luminescence, phosphorescence.

Lumia Lamp. *(Right). The components of this light projecting lamp are as follows: (A) a ½ rpm. motor; (B) high intensity lamps with reflectors; (C) pierced color wheel with irregular shapes; (D) patterned glass and lenses; (E) transparent globe; (F) cylinder lens made of transparent acrylic attached to a clear acrylic base with epoxy cement.*

This three-dimensional lumia construction produces varying patterns of colored light determined by the shape and character of the component elements.

Environmental Lumia Projection System. *(Below). Areas may be covered with lumia projections with the arrangement shown here: (A) a 10 rpm. motor; (B) a light deflector, made of cut out pieces of mirrorized Mylar stapled to a circular base; (C) Carousel projectors, trays loaded with slides made of gels; (D) wall, ceiling, or rear screen projection material; (E) color wheels, modified from Christmas displays, and wheels with opaque masks taped to surface.*

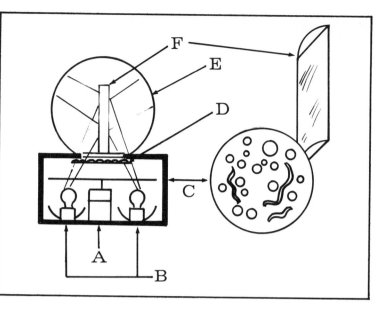

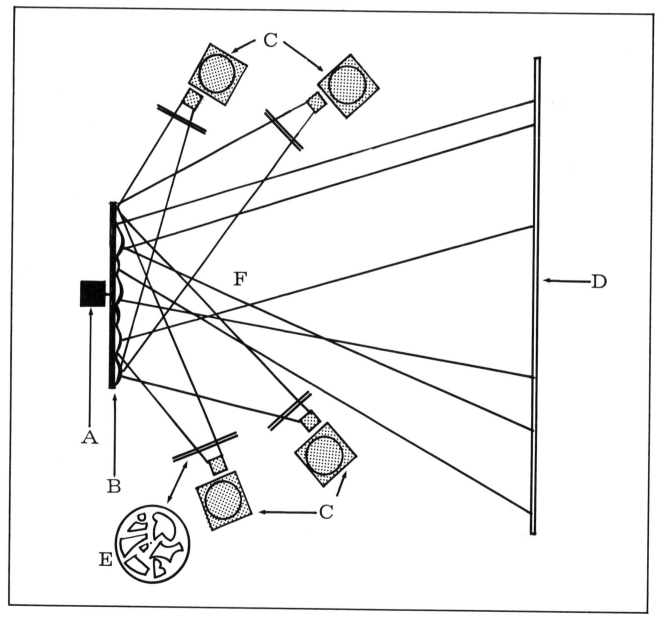

Interrupting devices and switches: mechanical, electronic, electro-magnetic relays; switches: mercury, pressure, heat, voice, light, proximity.

Technologically-aided design: computer-generated graphics, computer-aided design, computer matrix systems, serialization, mathematical notations of probability.

The list is far from complete, but will serve to give the reader a general idea of some contemporary "materials" and processes available for application to art. As technology produces new hardware and useful products, the artists will "try them for size" and develop the required "soft ware" for artistic use.

The Half-Way House

Kinetic art has often been described as the half-way house between the plastic arts and theater; a hybrid involving both physical and phenomenological form.

It is an art form that presents its "characters"—energies and forces—in a "play" involving sequential programing. The "script" may call for activity similar to the literal arts, such as introduction, development, conflict, resolution, etc. The audience, or viewer, may be witness (passive) or participant (actor).

Time Compositions: Articulated Energy

Kinetic devices may be repetitive (cyclic) or random—having either finite time-segment parameters or nonfinite characteristics. Applying finite control to kinetic art implies the development of time-compositions and the thoughtful incorporation of the appropriate hardware to control motion; initiating, disrupting, altering, transforming, and resolving movement—along with the incorporation of proper occurrences, variations, conflicts, resolutions, etc. Thomas Wilfred's light composition, *Opus Number 140, Visual Counterpoint,* for example, has a finite time-segment of 11 hours, 7 minutes, and 30 seconds.

To create time compositions, the kinetic artist will find himself browsing through technical catalogs or electronic supply houses, searching for the appropriate hardware to accomplish the task.

Timers

Both electro-mechanical and solid state timing switches can be used to program kinetic art. Mechanical timers are available with removable and adjustable camshafts, allowing for instant program changeover. The motors in these types of timers determine the length of the cycle and vary from ½ to 130 rpm. Roller-arm snap-action switches ride over adjustable cams, determining the time segments of electrical impulse. One or more of the timers may be used as a limit switch to start or stop other timers. Limit switches may be activated by typical on-off toggle switches or more elaborate impulse switches, clocks, relays, photoelectric eyes, proximity, heat, or pressure switches.

Sources for electro-mechanical devices are listed in the back of this book on p. 170.

SCR's

Silicone-controlled rectifiers (SCR's) are solid state components used to make electronic timers. Electronic timers are probably more efficient means of timing as they eliminate the problems of contact sticking, bounce, and wear usually associated with electro-mechanical contactors. Kinetic artists who are handy with tools wire their own timing circuits. A typical diagram is shown on p. 103.

A valuable publication for the artist interested in electronic circuits is the *SCR Manual,* published by General Electric Company, Department B, 3800 N. Milwaukee Avenue, Chicago, Illinois. The book describes SCR circuits in detail, and also provides information and diagrams for making other electronic devices, such as time-delay circuits, flasher circuits, and relays.

Steps in Construction

The typical sequential activities leading to the realization of a kinetic object are as follows:

Conceptualization, defining project.

Designing system, identifying hardware to be employed.

Acquiring parts, required materials.

Testing, experimenting with subsystems.

De-bugging, redesigning subsystems.

Assembly of complete structure.

De-bugging, final "tuning," installation.

In creating his works, the kinetic artist may often make relatively simple structures developed entirely on his own in his workshop, or perhaps plan and realize more complex structures requiring the collaboration of specialists or technicians.

Collaboration

The Greeks have a word for it—*Téchne.* The word means both art and technology; there is no distinction. Today, interdisciplinary "marriages" of artists and engineers are quite common. On every college campus there are frequent "brain-storming" sessions involving poets, artists, scientists, chemists, and engineers. The artist's self-image has transcended from the traditional specialist—"painter, sculptor, printmaker"—to a broader neo-Renaissance definition of a man who has many interests and is often the master of many disciplines.

The engineer, Billy Kluver, organized *E.A.T.* (Experiments in Art Technology) in the sixties for the purpose of exchanging technical information and making "matches" between artists and scientists. In 1971, there were approximately 6000 members in the organization, with 35 local chapters in the United States.

Nine Evenings, an event staged by Kluver in 1966, was a classic example of artists and engineers combining talents toward a common purpose. With the artist Robert Rauschenberg, Kluver recruited John Cage, Deborah Hay, Lucinda Childs, Robert Whitman, and others to present this happen-

ing. The spectacle presented media such as sonar to pick up body movements, walls of warm air, floating forms, translation of body functions to sound, on-the-spot recordings of events with VTR, feedback transformations, participation events, nonliteral dance, etc. Although the performances left much to be desired, the implication was clear: interdisciplinary teams *could* work together to present art spectaculars.

Another significant event involving art technology was the *Magic Theatre,* staged at the Rockhill Nelson Gallery, Kansas City, Missouri, in 1968. This show included eight monumental environments: a walk-on neon sculpture by Stephen Antonakos, a walk-in infinity chamber by Stanley Landsman, a strobe floor by Boyd Mefford, a sonic games room by Howard Jones, an electric garden by James Seawright, a prism environment by Charles Ross, and a time-lag voice accumulator by Terry Riley. All of the structures involved some form of audience participation. The popular exhibition proved a milestone in realizing the potential of "art-behavioral" systems.

In 1970, E.A.T. changed its modus operandi somewhat, shifting from its role of "matchmaker" to artist. The group selected a number of artists and engineers and accepted a commission from the Pepsi Cola company to create technological art for the Pepsi pavilion at Expo '70 at Osaka.

Among the successful realizations were a Fog Machine by Fujiko Nakaya and Thomas Mee which partially shrouded the pavilion in a fine mist. The device created fog by spraying water through minute holes in stainless steel nozzles. There was also a ninety foot hemispherical mirror room, made of Melinex, fiberglass kinetic sculptures (floats) by sculptor Robert Breer, and a four-color laser deflection system, incorporating a krypton laser which produced light patterns with signals from tape recorders (Carson Jeffries, Lowell Cross).

In 1973 E.A.T. was involved with using on-line communication equipment in Manhattan for children, and doing studies of constructional television programs in El Salvador, Guatemala, and India.

Concepts for Kinetic Events

Transformation: Evolution, transition, change, mutation, "events" in time. Transductive: change from one form to another.

Mimesis: of nature, ecosystems, biological symbiosis, anthropomorphic systems, sociological, technical systems (through analogy, metaphor, commentary).

Game: participation, interaction, entertainment, cooperation; response structures, systems, play.

Fantasy: irrationality, utopian, mystery, surreal, subconscious, bizarre, absurd.

Homeostasis: adjustment to excess to maintain equilibrium, self-seeking rectification of interference, self-organizing.

Experiential: event vs. autonomous form, process, behavioral, nonmaterial, participatory.

Teleological: "telic" seeking structures, "one-shot" spectacles, self-destructing, consumable.

Chance: random, nonrepetitive.

Auto-creative: self-structuring.

Game: Gianni Colombo

Gianni Colombo, a kinetic artist from Milan, says: "Psychology informs us that there is an innate tendency in man to interpret any new experience in such a manner as to conciliate it with previous experiences. However, psychology also tells us that man's brain is able to learn or devise new operations and means of combining the results of old experiences—hence, to invent new tests and categories. It is possible to construct a visual work of art as one would construct a test, retaining sufficient perceptive ambiguity in the components to prevent the observer from launching himself on a single known interpretation. We may construct visual situations which create zones of psychic involvement in which the observer will be helped to take his bearings from the interaction of the component parts, and consequently from the structural mechanism of the work. He passes from sensory to logical comprehender of the work; from passive viewer to active participant."

Event Structures

Event structures are sculptural forms or designs created especially for an art event or spectacular. These objects are either worn, manipulated, or otherwise used within the context of the event. Examples are lighter-than-air pillows to be launched into the atmosphere, devices to float on water, distorting mirrors, springy shoes, and squeeze-through clusters.

The water-walk event, an ongoing attraction from The Netherlands, employs huge inflated transparent plastic bags, within which the performer "walks on water" by rotating the bag around himself. At the *Documenta 5* exhibit in Kassel, Germany, 1972, John Dugger and David Medalla staged several happenings which utilized event structures and devices.

Art Systems

Some "art systems" are simple games or devices designed to demand the participation or interaction of the viewer. The viewer, or "player," undergoes some form of behavioral modification in the ensuing system-to-system encounter. Learning machines, used in schools or language labs, are examples of academically oriented system devices that are calculated to modify the participant's intellectual skills. Their game counterparts are pinball machines and other such electronic devices. Unfortunately, however, there are few esthetic counterparts.

The term "systems" in art also denotes a technologically created *setting,* or anti-object art form, in which technological devices are employed to produce esthetic encounter zones. The term "cyborg art" is associated with art that responds in this manner.

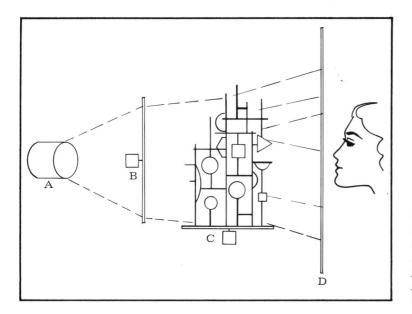

Chromatic Shadows. *Arranging structural elements to produce chromatic shadows involves (A) a spotlight; (B) a color wheel; (C) a light modulator, which may include opaque, transparent, translucent, reflective, or perforated elements; (D) the rear projection screen material. The modulator is set on a turntable moving at a slow rpm.*

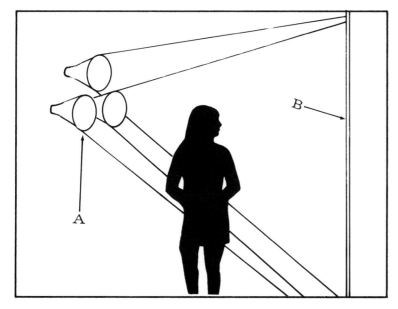

Kinetic Shadows. *Primary light colors—red, blue, and green—are projected from the spotlights (A) to a screen (B) producing white light. Objects interrupting this white light produce chromatic hues.*

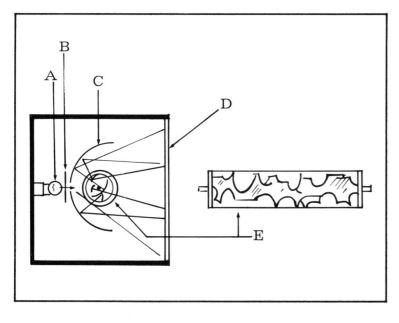

Lumia Construction. *Another lumia device is Land's* Chromara. *This structure involves (A) a high intensity lamp; (B) a heat filter; (C) fixer reflectors; (D) a projection rear screen; (E) a rotating reflector (clear acrylic tube filled with reflective mirror, metal, lenses, and prisms) powered by a ½ rpm. motor on one end. Land's* Chromara *also incorporates a metal shutter and a "color mosaic" between Points B and C.*

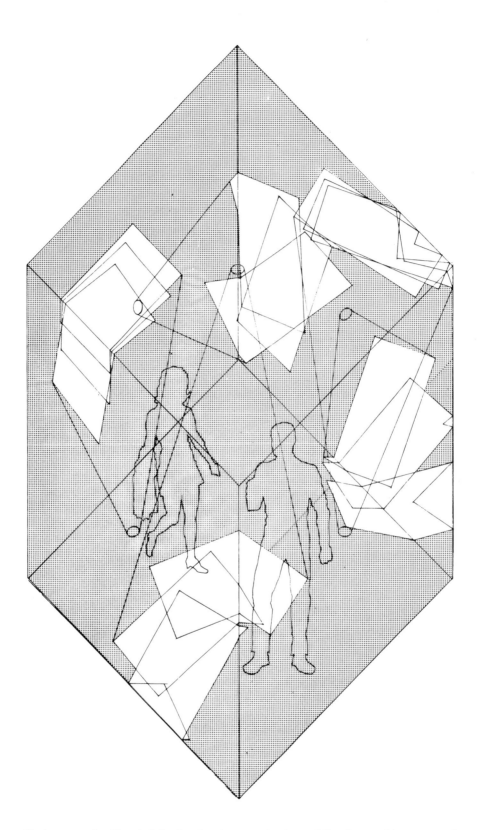

Environment by Gianni Colombo. Luminous projections of flat forms with programed switching change direction gradually and play on the inside walls of a cube of habitable dimensions. The programed lighting is superimposed on the inside of the cube, which influences its effect and which in turn is influenced by the shape of the cube itself.

The relationship of these two contrasting entities places the spectator in a dialectic condition; spacial depth and luminous chromatic fields extending horizontally and vertically give place to a program of successive structural constellations in three dimensions.

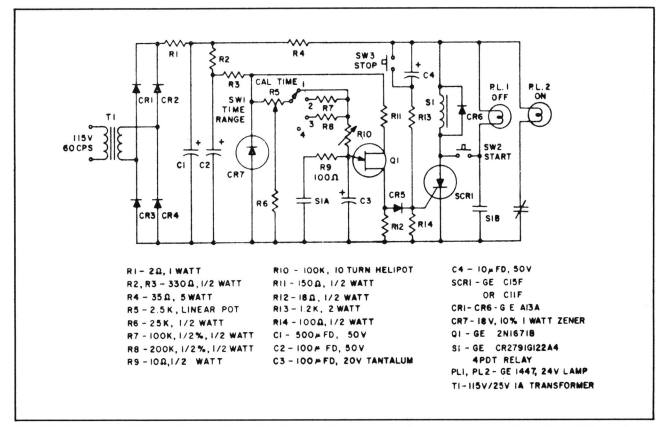

R1 – 2Ω, 1 WATT	R10 – 100K, 10 TURN HELIPOT	C4 – 10µFD, 50V
R2, R3 – 330Ω, 1/2 WATT	R11 – 150Ω, 1/2 WATT	SCR1 – GE C15F
R4 – 35Ω, 5 WATT	R12 – 18Ω, 1/2 WATT	OR C11F
R5 – 2.5K, LINEAR POT	R13 – 1.2K, 2 WATT	CR1–CR6 – G E A13A
R6 – 25K, 1/2 WATT	R14 – 100Ω, 1/2 WATT	CR7 – 18V, 10% 1 WATT ZENER
R7 – 100K, 1/2%, 1/2 WATT	C1 – 500µFD, 50V	Q1 – GE 2N1671B
R8 – 200K, 1/2%, 1/2 WATT	C2 – 100µ FD, 50V	S1 – GE CR2791G122A4
R9 – 10Ω, 1/2 WATT	C3 – 100µFD, 20V TANTALUM	4PDT RELAY
		PL1, PL2 – GE 1447, 24V LAMP
		T1 – 115V/25V 1A TRANSFORMER

Variable Time Control Circuit. The timing interval is determined by the setting of a precision ten-turn Helipot R_{10}, which may be set from 0.25 to 10.25 seconds in increments of 0.01 second. The initial setting of 0.25 seconds takes into account the added series resistance of the time calibration potentiometer R_5. Additional series resistance of 100K and 200K may be added by SW_1 to extend the time range by 10 seconds and 20 seconds. A fourth position of SW_1 open circuits the timing resistors and thus permits unrestricted on-off control of the circuit. Tests of the circuit have shown an absolute accuracy of 0.5% after initial calibration and a repeatability of 0.05% or better. Courtesy, General Electric Company.

Kinetic art systems may fall into one of several categories:

Closed systems (fixed dynamics): The spectator, or participant, seeks to discover the fixed parameters of the kinetic device or structure. Emphasis is usually on the morphological or phenomenological changes produced: it may be an object-oriented system.

Open systems (flexible dynamics): Devices or structures that may have fixed parameters, but respond differently, according to environmental input (i.e., sound, light, movement, proximity). These may be hybrids of object-art and systems-art.

Open systems (reciprocal control): Symbiosis of man/machine: states vary according to spectator input. Also, structures may not be important in their own right as "art objects," but serve as "communication links" between participants; emphasis is on information exchange directed towards perceptual encounter, inducement of creative behavior, and "game" strategy.

Homeostatic Systems

Homeostatic systems are structures that may be composed of complex components capable of movement, but that are placed in an inert state. When tripped by external intrusion, the system generates movement, but seeks to regain its equilibrium and return to its inert state. Examples of this in art range from the mobiles of Alexander Calder to the complex electronic environments by Steve Willats of London.

Ecosystems in Art

According to Marshall McLuhan, man transformed the earth into a theater by encircling it with a "proscenium arch" of satellites. Today, many artists are concerned with isolating actual systems of nature and placing them in an art context. Alan Sonfist, for example, works with natural, biological, chemical, and physical systems—exhibiting them as percepts of nature's energizing force. Ecosystems are not closed; they are interdependent, and part of a link of a larger chain. By presenting natural systems in action, artists are, in a sense, presenting analogies and percepts of our own cultural and behavioral systems.

Sonfist's biological works present invisible microorganisms in the air. These are nurtured in a medium that eventually fosters their accelerated growth into patterns that are visible to the viewer.

In his crystalline systems, Sonfist exhibits raw crystalline

Timing Switch. *The programing of kinetic structures is readily achieved by adjusting cams, and the camshaft unit is removable for quick program changeover. Micro-switches ride over notched cams, varying time segments for electrical impulse. Variable speed programing is possible by using one switch as a limit switch and several others as "work switches."*

Here the cams are being adjusted to vary time segments of electrical impulse.

Small Synchronous Motors *for kinetic structures. Speed varies from ½ to 300 rpm.*

material to reveal innate geometric characteristics. His exhibits allow the "art medium" a role in the creative process. His position as artist is simply to discover, isolate, and present the ecosystems to the viewer, thus making them perceptually viable. His exhibits contain natural mineral salt crystals sealed within an inverted chemistry flask. The application of external heat causes the crystals to vaporize into a purplish gas, rise to the top and sides of the glass container, then form heavy crystals within sections of the flask. These eventually become unsupportable and fall to the base of the container, repeating the cycle again.

In 1972, Sonfist displayed his *Army Ants* exhibit at the Architectural League of New York. This exhibition consisted of a complete, living colony of army ants, approximately one million in number, housed in a rectangular enclosure. Four food stations were placed within the rectangle and the ants were free to explore their environment and search for food. Observers were able to see the ants' mode of building and interacting. The exhibit displayed how the ant colony's natural order was stabilized following interference.

The artist presented the ant colony as a functioning order of a complete, living society, rendering it visible. He emphasized the creative operations of natural processes by imposing certain restraints on them. The resultant visual patterns were a product of natural instinctive and inductive behavior.

Toy Syndrome

Art, it has been said, is the "toy" of the adult. If you are fortunate enough to be doing what you like to do in life—enjoying leisure, inventing, exploring, or creating—you are probably also enjoying a large percentage of "play" time. The natural childlike wonder, curiosity, and need for play never leaves us, even as adults—the "play" objects simply change form.

If you teach art, challenge your students to create a new toy, game, or play object. Forget about making "art" for the moment. Creating ideas and structures for games challenges conceptual thinking, imaginative uses of media and materials, and demands the integration of the "participatory" ingredient.

There are many artist-toymakers at work today, creating "pop-up" art, flying and floating structures, sound structures, jig-saw puzzles, "feelies," nonsense machines, optical toys and objects, skill games, combatant games, environmental boxes, perception activating devices, springy shoes, bee's eyeglasses, word toys, concrete poetry, and more.

The growing popularity of art forms that de-emphasize "goods for sale," and place emphasis on participation—with natural lifestyle activities—simply points out that there is a latent need for things that simply entertain, make us smile, or allow us to "join in."

Form Through Vibration

In his book, *Intuition,* Buckminster Fuller says that there are no solids, continuous surfaces, or "things"—only waves and energy event complexes.

A man who explored the phenomena of waves and vibrations was Hans Jenny, from Switzerland. Jenny claimed everything in the world vibrates, whether organic or inorganic. The energizing process of nature is in constant action. Nature's sculptural forms continually evolve and transform through vibration. Through the use of crystal oscillators that vibrated materials placed on steel plates or thin diaphragms, Jenny recorded remarkable patterns and structures—evolutions of kinetic movement and transformation. He called his studies Cymatics, from the Greek, meaning waves, and documented his work in two remarkable books: *Cymatics* and *Cymatics, Band Two* (Basilius Presse, Basel).

Jenny's preoccupation with vibration was not simply to evolve unusual forms, but to study the energizing processes of nature. His exhibition, *Vibrating World,* toured the United States and Europe in 1968 prior to his death. The particular area of research still continues in his name at the Institute for Cymatics, Dornach, Switzerland.

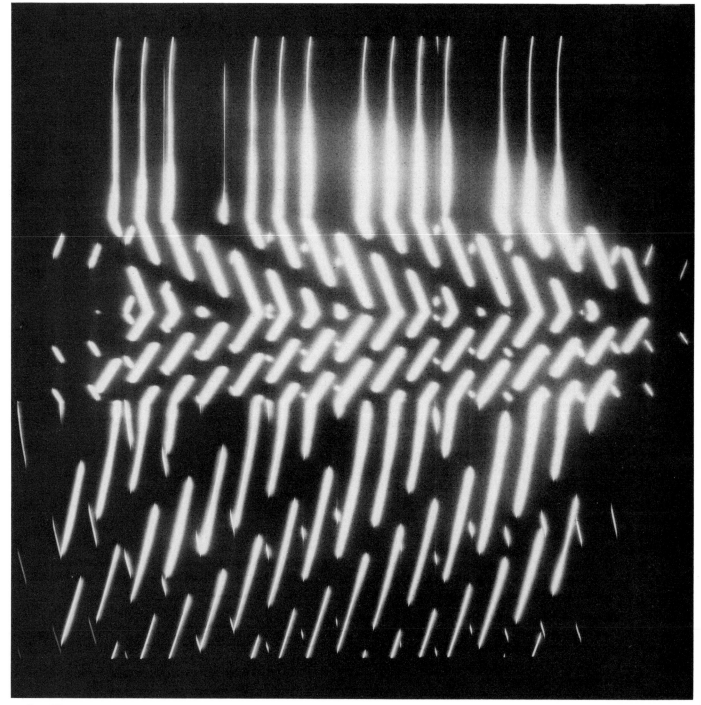

Bent Wave Pattern by John Goodyear, 1967. Wood, plastic, grid, and light, 24" × 24" × 12". The Milwaukee Art Center, Wisconsin.

LIGHT KINETICS

"Truly the light is sweet,
And a pleasant thing it is
For the eyes to behold the Sun."

Eccl. XI-7.

The sun, central body of our solar system, is 93 million miles away from us. Yet how utterly dependent we are on it for its energy and radiance to sustain life on this planet. That there will be light today and tomorrow goes without question.

We have seen rainbows—phenomena produced by the interaction of sunlight and moist atmosphere—the electro-luminescence of the aurora borealis, and the spectacular choreography of chain lightning during a stormy night.

Technology imitates nature, protracting the illuminating rays of the sun by artificial means. Man-made luminosity has extended the light environment to 24 hours, all but anni-hilating darkness in urban society. Our cities are now easily "light-identified"—we have an immediate mental impres-sion of San Francisco, New York, London, Paris, Tokyo, or Venice by night.

Aside from illuminating our environments and spaces, we are entertained by the spectacle of light through the medium of TV or cinema; we explore, heal, and communi-cate with coherent light and lasers; we entertain and cele-brate with candles and fireworks; or we just relax before a campfire or fireplace to enjoy the soothing rays of firelight.

Although contemporary man takes synthetic illumina-tion for granted, a few old-timers still remember the gas-light days. During a recent trip out west, I came across this nostalgic reminder in an old hotel in Sonora, California:

This room is equipped with Edison electric light. Do not attempt to blow out the light bulb. It has been proven that incandescent light is *not* injurious to health; and contrary to public opinion, does not bring about Sciatica, Rheuma-tism, Apoplexy, or Lumbago.

Precursors

A Jesuit philosopher, Father Louis Betrand Castel, is credited for inventing the first color organ in 1734. This device, called *Clevessin Oculaire,* consisted of transparent colored tapes connected to a five-octave harpsichord. Candle-light was used to illuminate this primitive color organ; when the keys of the harpsichord were depressed, the appropriate colored tape would be illuminated.

In the 1800's Frederic Kastner created *Pyrophone,* a color organ involving hydrogen-filled glass tubes. He was followed by Bainbridge Bishop, Alexander Wallace Rimington, A. B. Hector, and W. Baranov-Rossine of Russia, all of whom produced some form of color projection device before the turn of the century.

Up until the early part of this century, however, the use of light was principally relegated to functional illumination, theatre, slide projection, and later, cinematography.

Light Art

Within the framework of technologically oriented art, the emergence of light art or lumino kinetics, constituted one of the major international phenomena of the sixties. All art, of course, depends on light to be made visible, but to em-ploy light as a *medium* is the particular bailiwick of the light or lumia artist.

The control of time factors in lumino kinetics is akin to creating musical compositions or non-literal dance choreo-graphy. Light, however, has a particularly strong physiolog-ical impact on our senses—a mesmerizing, almost hypnotic effect. The artist working with light has a distinct advantage because his work is usually presented in dim illumination, thus assuring fewer distractions and demanding almost total attention from the viewer.

Thomas Wilfred and Moholy Nagy were the first to use light as an artistic medium. Wilfred made his first *Clavilux* in 1919, a light projection device controlled by a keyboard. In 1922, he performed his first lumia recital. Later, in 1926, he appeared as guest artist with Leopold Stokowski and the Philadelphia Orchestra at Carnegie Hall in New York.

Wilfred produced about 200 light works in his lifetime. The most ambitious projects were the 210 foot mobile mural at the Hotel Sherman in New York, created in 1929, and his *Lumia Suite, Opus 158,* commissioned by the Museum of Modern Art, New York, in 1964.

Study in Depth was a device created in 1959 for the Clairol Corporation of New York. This lumia composition was designed especially for an office interior and involved a large screen, 6 × 9 feet in size. Colors projected on the screen created the illusion of an abstract painting in motion. Colored shapes and patterns swirled through a predeter-mined program lasting 142 days, 2 hours, and 10 minutes, then repeating. In 1935, he created his first "home-viewing" lighting devices, which he dubbed *Lumias.*

Meanwhile, at the Bauhaus, Moholy Nagy also experi-mented with light and motion—he created *Light Display Machines* from 1922 to 1930. His first light machine was a cubelike construction that included perforated metal shapes and 140 bulbs. It was arranged to be switched on and off within a cycle of two minutes, during which time a variety

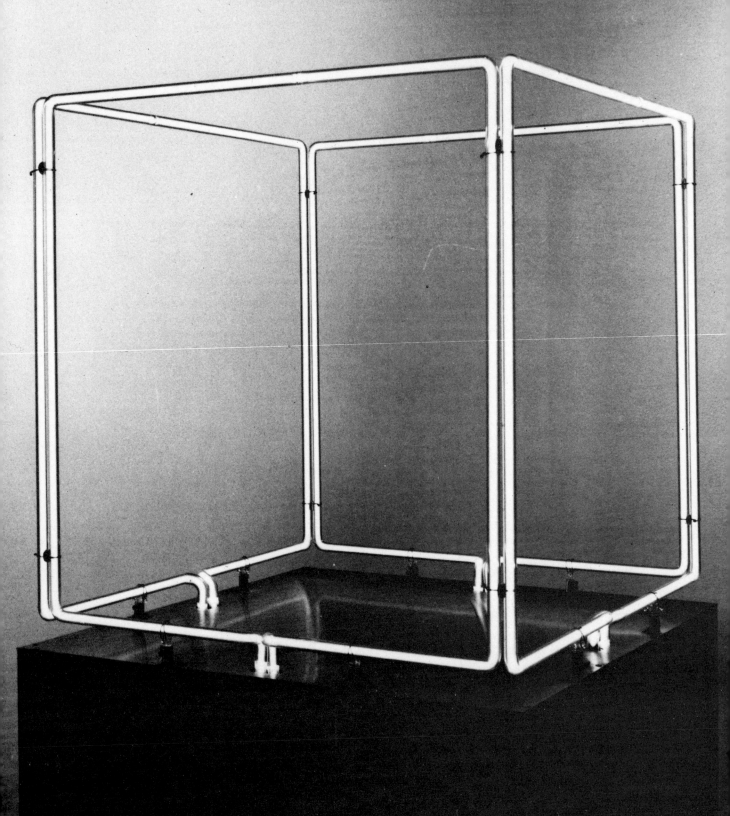

Blue Box by Stephen Antonakos, 1969.
An example of neon sculpture, 2 × 2 × 2 feet.

of both colored and clear spotlights produced a light display on the interior walls of the cube.

Pictorial Space. The lumia artist's pictorial space lies within the dark negative void of the black screen. From this space, luminous forms and colors emerge and interrelate. Thomas Wilfred considered four elements of prime importance in articulating the pictorial space within his light constructions:

Orbit: the form and *sweep* of a light composition.

Tempo: the *pace* of motion.

Cycle: the programed *occurrence* of forms (the repetitive cycles varied from minutes to years).

Field: the "path" of luminous form within the pictorial parameters of the screen.

By employing these elements Wilfred "programed" his *Lumias* to introduce, build, transform, and climax a variety of light compositions. Visual climax usually consisted of sudden volume expansion or sharpness of image, faster tempo, or sudden changes in color or intensity, followed immediately by subsequent rest.

Contemporary Artists. Within the realm of lumino-kinetics, these contemporary artists have achieved notable recognition: John Healey, Frank Malina, Abraham Palatnik, W. Christian Sidenius, Nicholas Schoffer, and Earl Reiback. Of course the list is far from complete, as there are countless artists involved in this particular area of art. Reiback employs a digital computer to determine the design parameters of his works.

Valerios Caloutsis, a Greek artist living in Paris, has developed a means of light projection that he calls the *Kinoptic System*. His sculptures consist of four components: a light source (clear bulb, 24w, 6v) housed in a metal container; a fixed polished reflector made of mirrorized aluminum; a rotating reflector made of polished aluminum; and a 1 rpm. motor to revolve the reflector. All the elements are housed in a box having light-limiting slits on the top surface. The design characteristics of the projected light patterns are determined by the configuration of the reflectors. The system is used for environmental projection, or for rear-screen projection within translucent acrylic boxes placed over the device. The accompanying diagrams illustrate the working components.

Electric Light Works

The use of continuous illuminescence is a practical way to combine light and art. In the forties, Guyla Kocise made reliefs of black acrylic and transparent acrylic rods that included light "piped" from the base. Dan Flavin creates light environments with standard fluorescent light bulbs. Antonakos, Chryssa, and Rayse utilize commercial neon tubing in their light works.

Howard Jones uses ordinary incandescent bulbs on his paintings. Some of his earlier works also made use of reflec-

tive mirrors which multiplied the luminous effects. In 1966, Stanley Landsman began making boxes using two-way mirrors containing lights. His structures appear as star galaxies in infinite space.

Flashing Incandescent Bulbs. Ordinary flashing Christmas lights contain a small bar that acts as an interruptive switch. Heat produced from the bulb expands the bar and breaks electrical contact. As the bulb cools, the bar again closes and current is restored. The lamp bulbs fire at different intervals from one another; they are probably the most inexpensive random light switching system available. When placed behind acrylic sheets or rods, the lights pipe color throughout the plastic—they offer many opportunities for art experimentation.

35 mm Slides and Film. Kinetic light shows are easily created with ordinary carousel projectors loaded with 35 mm slides. A simple means of making slides is to use two pieces of 1¾" square clear acetate. Designs are created on one piece of acetate with colored acetate inks, flo-pens, transparent cellophane, gelatins, rubber cement, clear adhesives, etc. The second piece of clear acetate is placed over the design, and the unit is then put into a commercial 35 mm cardboard mount. Several carousel projectors may be set up to simultaneously project slides on either one or more screens.

Using colored film in a 35 mm camera, the imaginative artist may also create a slide show by photographing unusual images or designs. The Electric Gallery in Toronto recently featured a theatrical event entitled *Reflexions*—a 35 mm slide environment involving 500 slides and 4 screens, synchronized to 13 minutes of music. The figurative slides were taken from models by indirect means—photographing their distorted reflections from curved, broken, or Mylar plastic mirrors. The slides were triggered by a pulse programmer and four dissolve units, accompanied by programed sound. Although not a show of major significance, it illustrates a successful means of coordinating light and sound.

In 1972, LaMonte Young and Marion Zazeela performed *Dreamhouse,* at Documenta 5, at Kassel, Germany. Within their presentation, they included *Ornamental Lightyears Tracery,* a series of simultaneously projected slides accompanied by the continuous drone of a sine wave oscillator. Several slide projectors were used, and the series contained numerous black and white designs. Each slide mount held a photograph and a combination of colored gels. The designs and color elements were combined into interlocking groups whose sequence, duration of appearance, and manipulation were determined by the artists during the actual performance.

Colored Light Projections. LaMonte Young and Marion Zazeela's performance at Documenta 5 also involved the suspension of flat white metal mobiles hung by filaments from the ceiling. Colored light projected on the mobiles from below created chromatic shadows on the ceiling and upper walls of the room.

The colors of the shadows cast by the mobiles varied.

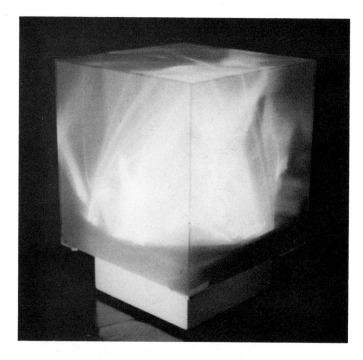

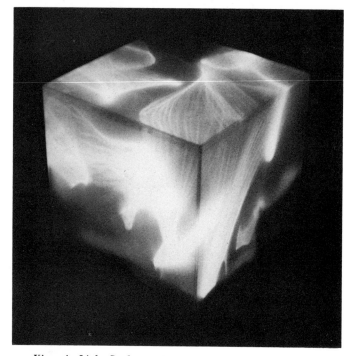

Kinoptic Light Sculpture by *Valerios Caloutsis, 1971. Acrylic, aluminum, wood, lumaline, motor, 19½" × 19½" × 19½". The two views above show how a translucent cube over a kinoptic system creates an on-going program of kinetic light images.*

Illuminated by a red and green light from two different angles, the shadows alternately appeared red, green, and yellow. Shadows from the red light appeared green, while shadows from green light appeared red; admixtures of both shadows created yellow. Secondary and tertiary shadows were also cast by the auroras of the light sources. The interruption of "white light" created by overlapping red, green, and blue light serves as one basis for making lumino-kinetic art objects or dance-kinetics.

Nicolas Schoffer

Nicolas Schoffer, from Paris, is probably Europe's best-known light artist. His *Lumino Dynamism* series are metal skeletal structures containing perforated discs. The units rotate slowly while illuminated by spotlights with moving colored gels. The resultant shadows are projected to a large translucent plastic screen and may be viewed from either one side or the other.

Schoffer's *Micro-time Structures* are kinetic devices containing fast moving perforated discs, polished metal rods, concave mirrors, and solid transparent acrylic blocks—all of which move at different speeds, some up to 3000 rpm. Light enters the moving components from both sides and is modulated by the spinning components much like water striking the propeller of a lawn sprinkler.

Schoffer's sculptures have a minimal structural quality, growing from the artist's personal conviction that kinetic art must have a "language" that transcends formal structure: the work becomes "immaterial" in essence—durations replace volume and temporal rhythms replace configurations of surfaces.

Schoffer's most ambitious projects along this vein are his *Cybernetic Towers*. His first architectural-size light sculpture, erected at Liège, was called *Light Tower*. The combination of 120 spotlights and moving mirrors spews colored light patterns into the night. The program varies and is controlled by electronic circuitry. He has planned a cybernetic tower for Paris—it involves 2000 lights and rotating mirrors, and it will be higher than the Eiffel Tower.

Poly-Projection

Poly-projection, or "mosaic projection," made a tremendous impact at Expo '67, in Montreal. At the Czechoslovakian pavilion, the designer Svoboda and his audio-visual team presented many extraordinary audio-visual techniques including Polyvision, Diapolyecran, Diavision, and Variable-cinema. The basic concepts involved in these methods are as follows:

Polyvision was an eight-minute show involving 8000 slides and over 21,000 feet of 35 mm film. These were projected on unique screens consisting of 36 stationary and moving cubes and rotating objects. The polyvision system was completely automated, with electronic memory circuits controlling the mechanics of projection, dimming, changing slides, and screen movement.

Diapolyecran was a huge gridded wall composed of 112

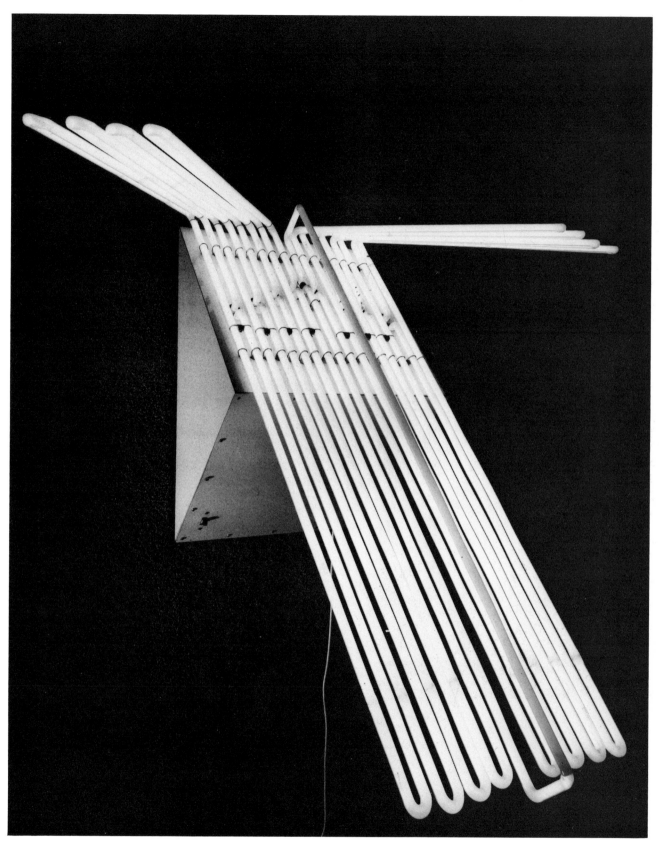

White Hanging Neon by Stephen Antonakos, 1966. Neon and aluminum, 35" × 50" × 30". The Milwaukee Art Center, Wisconsin.

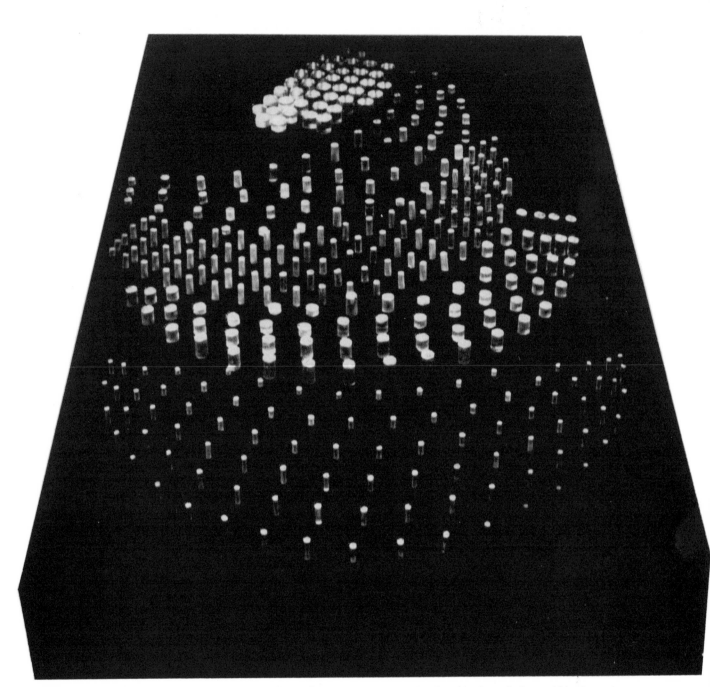

Light Wall *by Guyla Kosice, 1958, 40" × 21". Light is piped into the clear acrylic rods from within the structure.*

cubes, each 2 feet square and each containing two slide projectors loaded with magazines of slides. These projected rear screen images on the translucent faces of the cubes. The poly-projection system had the capacity to handle 17,000 slides for the 11 minute show. In some instances, all 112 units combined to form a large monolithic image utilizing the entire wall. At other times, the images divided themselves into 112 separate components, or varying combinations.

German-made Carousel S projectors were used within the cubes. Through previous experimentation, the Czech designers learned that the normal 1/5 second changing speed of the slide projectors was too slow and that the resultant "blink" was irritating to view. By adapting electro-magnetic shutters to the projectors, the slide changing interval was raised to 1/100 second. Also, by utilizing two projectors in each cube, fades and dissolves could be created to eliminate the "blink." Motion picture images were also projected at intervals on the faces of the cubes with Phillips FP-20 projectors specially adapted for this presentation. The projectors were equipped with special 800 watt discharge tubes producing an intensity of light equal to conventional arcs drawing 60 amps. The projectors employed self-winding film-loops with 1000 feet of film. In this way, both front screen and rear screen projection methods were involved in this complex multi-media concept.

The system was programed by 35 mm film. Each frame of the film was divided into a gridwork of 840 squares. Each square of each frame was then either blackened or not, depending on whether or not a trigger pulse was desired. A similar gridwork of photoresistors was mounted to provide a one-to-one relationship to the grid markings on the film. With xenon light projected through the film, the proper resistors were activated to provide higher current in electronic circuitry and consequently trigger a relay, which in turn activated the audio-visual display.

Diavision involved a semipermeable screen that appeared translucent with special lighting and revealed 78 projection screens. A multi-media show of 18 minutes was presented. The screen for Diavision had a special coating of photographic emulsion and appeared as a photographic print. However, with the special lighting, the print became transparent and the audience saw through it to the mosaic of 78 projection screens. Music was controlled by magnetic tape.

Variable-cinema utilized three projectors to show an abstract film on a screen made of three nets of multicord sewing threads, 3 mm to 5 mm in diameter. Two of the nets were static, but the third moved, as did the projectors, producing an unusual three-dimensional effect.

Dr. Miroslav Malik, audio-visual consultant for the project, described the timing of the performances as mathematically calculated—providing peak emotional response to adaptive time. Presently, Dr. Malik uses sophisticated hardware such as SG-eye movement monitors, Encephalograph feedback systems, and data cube telemetric systems to pre-check audio-visual concepts with test audiences.

It is interesting to note that out of 102 pavilions at Osaka '70 in Japan, 84 employed multi-screen or multi-image projection techniques.

Laser light sculpture and color laser television were introduced at the Hitachi Pavilion at Osaka. Three months later, the designer, J. Svoboda, made a practical application of laser projection (holography) by creating stage sets for Mozart's opera, *Die Zauberflöte,* in Munich.

Incandescent Light

Ordinary alternating current, as its name implies, is interruptive, having 100 to 120 extinctions per second. Because these extinctions are too short to be perceived optically, we perceive incandescent lighting as continuous. The filament bulb itself also helps maintain continuous illumination as it retains glow between extinctions.

A variety of incandescent bulbs are commercially available, some of which have unusual shapes and filament designs. Bronze or silver plated lamp bulbs have a one-way mirror effect, appearing as solid forms when not illuminated.

Strobe Lighting

The eye can "hold" about 16 impulses per second. A cycle faster than that produces blurred, incoherent perceptions. However, if a wheel spinning at 1000 rpm. is illuminated with a strobe light that also flashes at 1000 flashes per minute, the result is "stop action." The wheel, although spinning frantically, seems to have been "stopped dead in its tracks" by the stroboscopic illumination. If the flash rate is then changed—accelerated or slowed slightly—so that it becomes "out of phase" with the movement of the wheel, the results produce false cues of motion.

The "flicker" effect, similar to old-time movies, is achieved when people in movement are illuminated by a flashing strobe in a darkened space. By placing an ultra-violet filter over a strobe light, an ordinary strobe is converted to a black-light strobe, which is quite effective when used to illuminate fluorescent color wheels.

In photography, a camera set at "B" (open shutter) and used to photograph a moving form with stroboscopic lighting in a dark room produces multiple exposures on film.

Although somewhat agitating to view over prolonged periods, strobe lighting incorporated within art forms can produce fascinating illusions. Perhaps the most sophisticated applications of this technique can be seen in the work of Tsai Wen-Ying, whose work uses both vibrating rods and flashing strobe light to create unusual apparitions of virtual forms and images.

Peter Sedgley, from London, creates *Video Disques*— units of intricate colored patterns on circular plates. As the discs are set in motion by the spectator from a mechanized turntable, they are illuminated by ultra-violet light and/or strobe lighting. The spectator controls the rpm. of the motor and produces varying effects, from tolerable to dizzying. Multiple movements going in similar and opposite directions are also simultaneously achieved on the single spinning turntable.

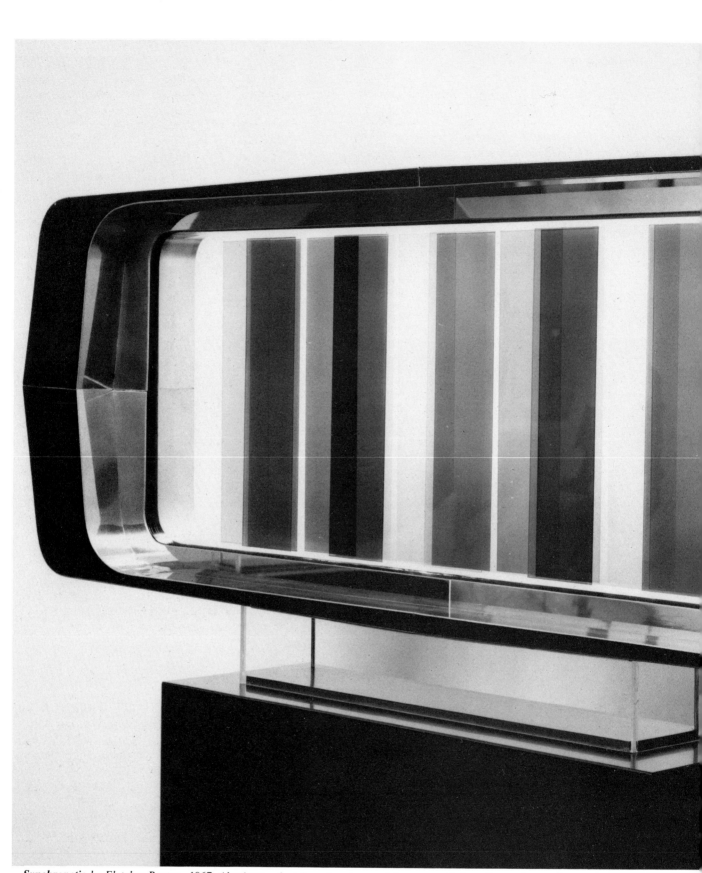

Synchronetic by Fletcher Benton, 1967. Aluminum, plexiglass, formica, and fluorescent light, 16″ × 49″ × 4¾″. Galeria Bonino, New York.

Neon

Neon is a cold light—the tubes are cold to the touch, and although the light is brilliant, it is also quite pleasant, giving off a soft, velvety glow. Neon has been described as controlled lightning. In nature, lightning emits an electrical discharge into the air. Air, of course, is a mixture of various gases. Similarly, in neon, an electrical discharge is created within a glass tube filled with rarified gas. The electrical current is supplied by a high voltage transformer (15 - 31,000 v.) to two electrodes sealed within the tubing.

Neon and argon are the most commonly used gases for making industrial signs. Argon gas in clear tubing produces blue light, while neon gas in clear tubing produces a red-orange light. Color variations are possible by coating the interior of a tube with fluorescent powders, or by using colored glass tubing. Besides argon and neon, other gases that are used, but less extensively, are helium, krypton, xenon, and mercury vapors.

Neon illumination may be programed by using a variety of timing clocks, cam switches, flashers, and solid state units which interrupt the low voltage side of the transformer. These may be used either singly or in combination.

Guyla Kocise made neon sculptures in 1947; Rayse, Watts, and Fontana in 1951. On the present scene, Billy Apple, Stephen Antonakos, and Chryssa are producing unusual works with this medium.

Fluorescent Substances. When fluorescent substances are applied to the interior walls of standard, clear sign tubes, a brighter light, and also a more efficient use of light is produced. The coatings used are particularly reactive to the ultra-violet radiation produced by typical sign tubes. These tubes use the same gases as used in standard tubes and additional colors are possible by the use of fluorescent particles. The rarified gases used in fluorescent tubing are argon, neon, and helium, with or without the use of mercury. The color produced by the tubing is determined by the combination of the particular fluorescent coating plus the appropriate rarified gas.

Polarized Light

When polarizing material is placed in front of a light source, it acts like the slots of a venetian blind, allowing light to vibrate in only one direction. If two polarizing filters are superimposed and turned to right angles, the result is that no light is allowed to pass. This is a simplified explanation of the principles behind variable density filters.

When a projected light source is interrupted with a polarizing screen and cellophane, Scotch tape, or other bi-refringent material, plus a second revolving polarizing filter placed in front of a projection lens, the result is a constantly changing array of prismatic color shapes.

Clear polarizing materials fixed within glass plates and viewed from varying angles produce varying color effects and constitute an exciting basis for experimentation.

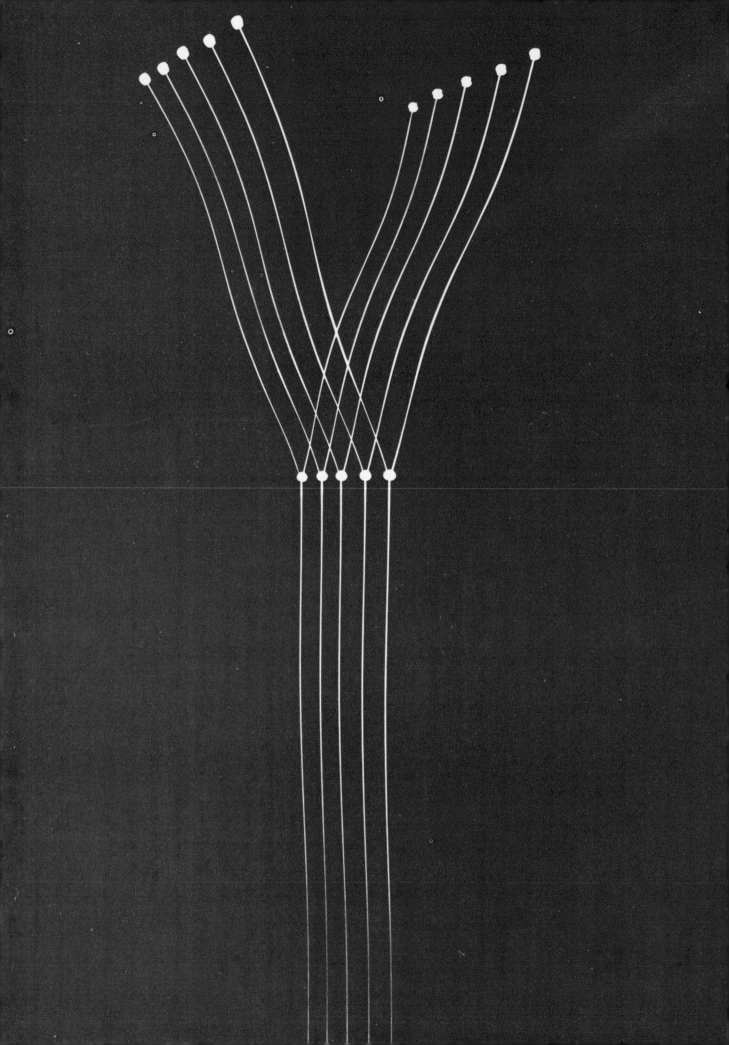

Fiber Optics

Dupont's Cro-Fon plastic light guides offer exciting possibilities for piping and controlling light. The flexible light guides are attached to a central light source and can easily bend around corners, carrying light to difficult areas, or can be used to multiply light from a single source.

Jacketed or unjacketed plastic fibers are available in 10, 20, 30, and 40 mm widths, along with caps for intensifying the light, illuminators, and color kits. They are available from the American Scientific Company or Edmunds Scientific (see p. 170).

Ultra-Violet Light

The combination of fluorescent paint, tapes, or other fluorescent materials with ultra-violet light, or "black light," has been used successfully by many artists to create various forms of black light kinetics.

Lucio Fontana was probably the first artist to use this combination, having created his *Spacial Ambiance* in 1949. This work was made of fluorescent paint on cardboard, suspended from the ceiling and illuminated by ultra-violet light.

Hugo Demarco of Paris makes structures of fluorescent painted spheres the size of ping-pong balls, which move in a darkened space. Illuminated with black light, the forms create apparitions of larger virtual forms through the illusion of persistence of vision.

Phosphorescent Materials

Phosphorescent particles imbedded in polyester, coupled with interruptive lighting, can produce strong "outer space-like" apparitions. Electroluminescent tape is also available and may be used on designs and constructions to achieve glowing characteristics in a dark environment.

Afterimage Kinetics

In 1962, Gianna Colombo created *Sismo-structure,* an afterimage light kinetic—a hidden bulb reflected its filament on a hanging polished disc which was supported from a spring. An eccentric cam moved the device intermittently, producing unusual after-image reflections on the surface of the moving disc.

Fire as Art

From Paris, Bernard Aubertin was perhaps the first artist to make fire his principal medium. In 1961, he produced *Red Cage of Smoke,* a teleo-seeking art mechanism which is described in his *Manifesto of Pyromaniacal Activity:* "First I turn on the two red lights. Then, I open the top and place the smoke powder on the top point of a nail in the inside of the box; I light the smoke powder and close the cover. Soon, the smoke leaves the box through the perforations and crosses the rays of red light accompanied by the sound of burning powder. A strong smell fills the space. The powder stops burning. Silence. Inside the box, visible through the holes, brilliant red and orange smoke smolders."

Demonstrations

The concepts of kinetic art may be expressed in a variety of forms—from the making of *tangible objects,* to the structuring of *events,* requiring only the dynamics of human interaction.

The principal focus of this book is the creation of art *objects,* along with the description of appropriate hardware and technical know-how. The following demonstrations show a few fundamental ways to create kinetic objects—these include light kinetics, lumias, lamps, neon, and magnetic constructions.

It is hoped that the reader will consider the information, demonstrations, and visual data contained in this book as motivational devices—not as objects or ideas to be slavishly copied. Some chapters may serve informational needs, while others may provide practical stimulus for exploring alternative artistic directions. The hardware and "software" presented here may help the reader articulate his own idea-consciousness, and in this way serve to produce independent ideas and original concepts.

4 Y by Tsai-Wen-Ying. Stainless steel rods, strobe light, vibrator, and audio feedback control, 20¾" × 24" × 17". An audio switch controls the flash rate of the strobe, producing unique illusions of "virtual form" and motion. Denise René Gallery, New York.

Demonstration 9
A Lumia Sculpture

"Lumia" is the term coined by Thomas Wilfred in the early twenties to describe the art of painting with light. Many artists have gone along with this descriptive term, while others have invented names of their own for light works.

This demonstration will show a Lumia light construction built from easily obtainable and fairly inexpensive materials—most bought at a local shopping center. The construction consists of three principal sections: a light-projection unit; a reflection rotor; and rear-screen projection material. The light is generated, intensified, colored, and projected from the light unit to the reflection rotor, which in turn reflects the light patterns to the dark lenscreen.

By adjusting the positions and angles of the three components, experimenting with different combinations of gels, varying the shapes of the plastic mirrors, and varying the speed of the motor, the program of the lumia was ultimately achieved. A toggle switch was placed in the wiring leading to the motor, allowing the viewer to stop the variations in motion at any given instant. There are many potential variations of this construction; several projection-reflection units may be housed within a larger structure to illuminate larger screens (incorporating motors of differing rpm.'s); lenses and prisms may be utilized to further interrupt the projected light; and timing switches may be employed to control motors and light cycles.

Light reflectors may be made of deformed glass, plastic prisms, or lenses. Store-bought crystal glass, clear plastic cement on clear acrylic, transparent containers filled with glass, lenses, metal, or glass mirrors may also be used. Experimentation with these materials may yield an interesting *revolving light modulator* which generates exciting light patterns. The patterns may be projected to the lenscreen with the aid of plane mirrors.

Materials

Wooden box, 15″ × 15″ × 7″

Thin black acrylic to cover box

20 gauge aluminum lining

Aluminum baking tin, 4″ × 10″

Aluminum cover plate

Concave reflector

Clear 40 watt candelabra light bulb

Night-light fixture and ½ rpm. motor

Electric socket, cord, plug, and toggle switch

Colored theater gels

Thin Aluminized Mylar

Pola-coat LS60 lenscreen

Drill and heavy-duty stapler

Black paint

Cellulose tape and double-faced industrial tape

Epoxy cement

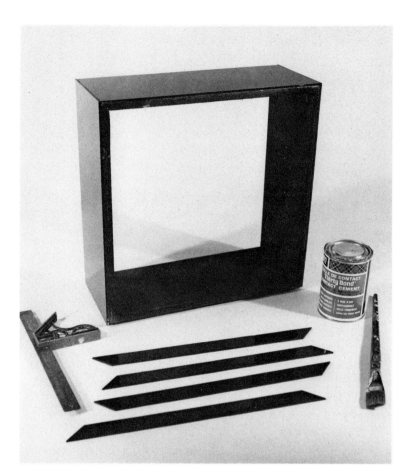

1. The housing for this lumia construction is a wooden box, 15" × 15" × 7", lined on the inside with 20 gauge aluminum cut to fit. Black acrylic covers the outside, attached with contact cement.

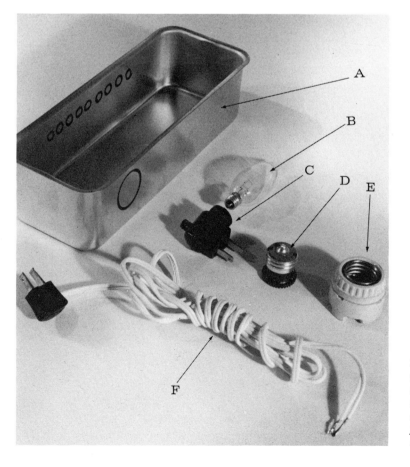

2. The light-projection unit. An aluminum baking tin, 4" × 10", was adapted to house the electrical components. Holes (to secure the fixture and position the gels) were marked for drilling. A clear 40 watt candelabra-base light bulb mounted in a night-light fixture, and an electric socket, cord, plug, and toggle switch make up the remaining components.

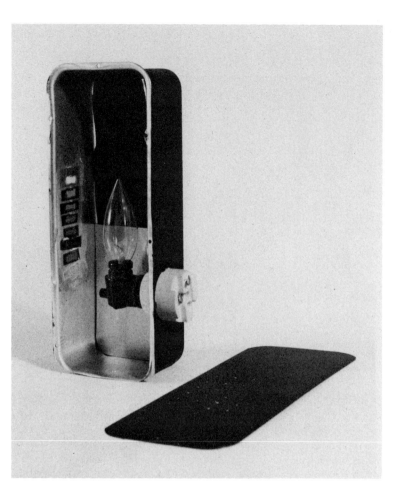

3. *The completed light unit, ready for electrical wiring. Colored gels were taped over the small holes, and an aluminum cover plate painted black was cut to fit the rectangular box. A concave reflector from a discarded projection bulb was attached behind the 40 watt bulb with epoxy cement to intensify the light.*

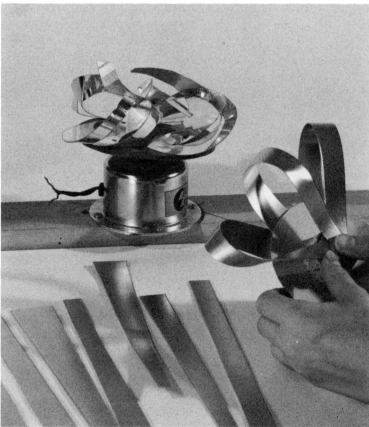

4. *The reflection rotor. Thin mirrorized Mylar plastic is cut in a variety of shapes with a pair of scissors, then stapled to the face plate of a ½ rpm. motor. The shapes, sizes, and dimensional configurations of the mylar determine the shapes of the reflected light patterns.*

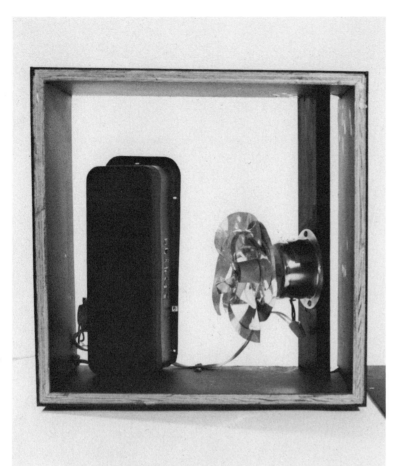

5. *The components are placed in position within the box and screwed into place. The interacting angles and distances of the units were worked out previously by trial and error.*

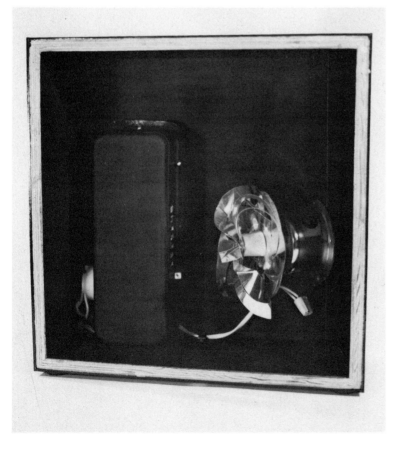

6. *The unit is wired and a toggle switch incorporated in the lead to the electric motor. A sheet of aluminum with holes for ventilation is cut for the back cover plate. The entire interior of the box is painted black to absorb stray light.*

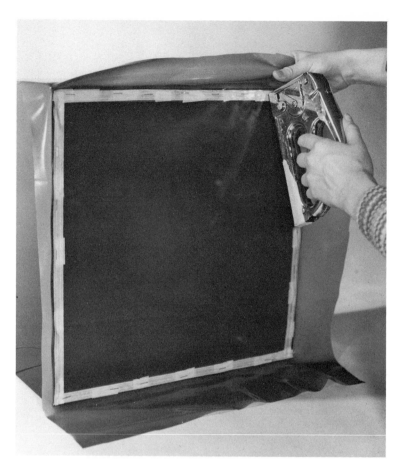

7. *Dark gray Pola-coat LS60 lenscreen is cut to fit and stapled to the front of the box. Cellulose tape is placed over the edges of the flexible plastic screen to prevent tears. Pola-coat is available in plastic, plexiglass, or glass and is excellent rear-screen projection material. Other screen materials, however, are translucent acrylic, shower curtain liner, drafting paper, and frosted acetate.*

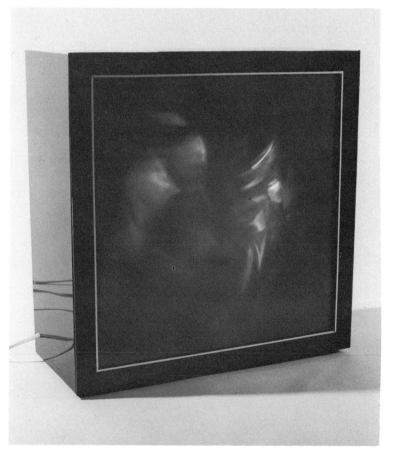

8. *To complete the light box, excess lenscreen is trimmed off, and an acrylic frame is attached with double-faced industrial tape.*

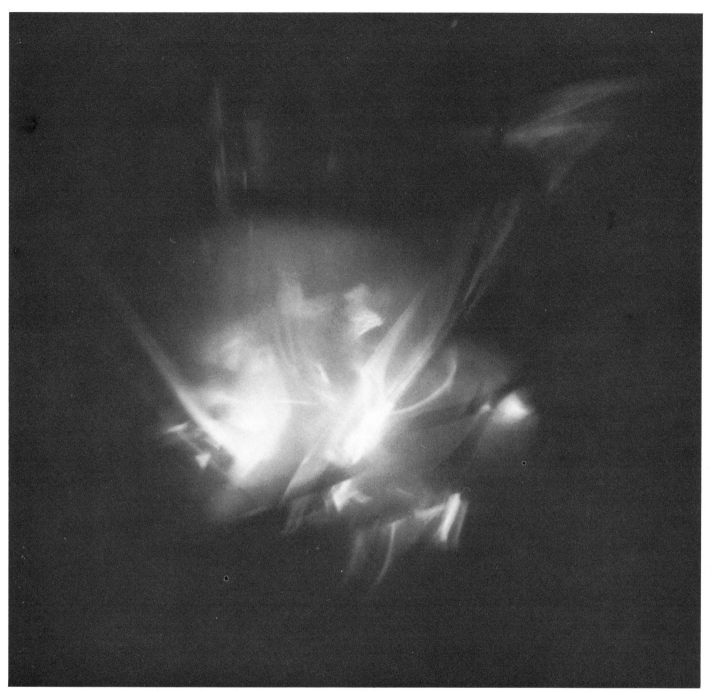

9. *The lumia light box in motion. This light show produces intriguing and constantly transforming shapes and patterns.*

Demonstration 10
A Kinetic Lamp

One of the simplest ways to make a kinetic lamp is to use wafer flashers —they are popped into electric light sockets prior to screwing in the light bulbs. These thermal flashers interrupt the electric current and make the lights blink. By using several bulbs, each with a flasher that has a different flash tempo, a random type of blinking action can be produced.

The kinetic lamp in this demonstration has three basic components: the metal base, which houses three colored light bulbs; masks and gels sandwiched on the top opening of the base; and a translucent white glass dome 12″ in diameter.

Flashers and winkers are obtainable from most electrical supply houses, translucent domes from lamp supply shops or second-hand or antique stores.

Materials

Wooden base, 11″ × 15″

Aluminum lining and outer covering

12″ translucent sphere

3 electric sockets

Wiring and toggle switch

3 wafer flashers

Red, green, and blue incandescent light bulbs

Aluminum foil mask and tabs

Colored theater gels

Nail-on furniture glides

1. A wafer flasher is the method used to interrupt electric current in this kinetic lamp. Wafers are placed in electric sockets and incandescent light bulbs screwed over them.

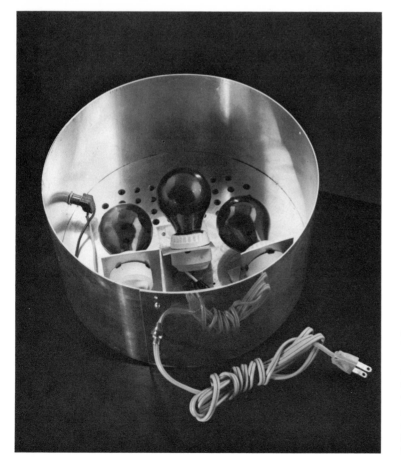

2. The lamp base, 11" × 15", is constructed of a wooden base lined with aluminum and drilled with holes for ventilation, and a strip of polished aluminum for the sides. Transparent red, green, and blue bulbs are screwed into the light sockets (containing wafer flashers) that have been attached to the base. Wiring to the bulbs also incorporates a toggle switch. Nail-on furniture glides are attached to the bottom of the base to elevate it and provide ventilation.

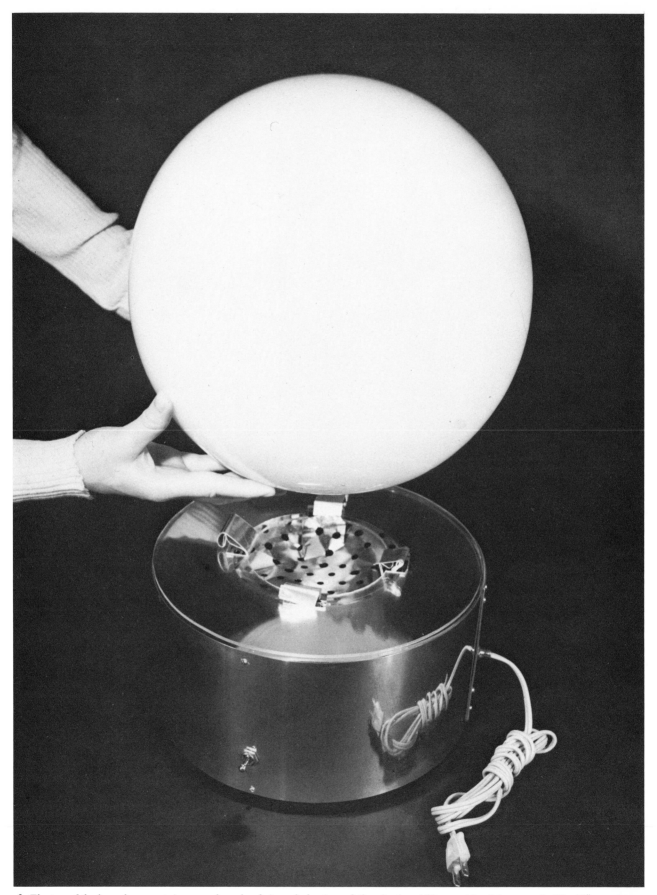

3. The top of the lamp base contains a mask made of pierced aluminum foil and colored filters made of theater gels. The 12" translucent sphere is a common lighting fixture and is held in place by four aluminum tabs.

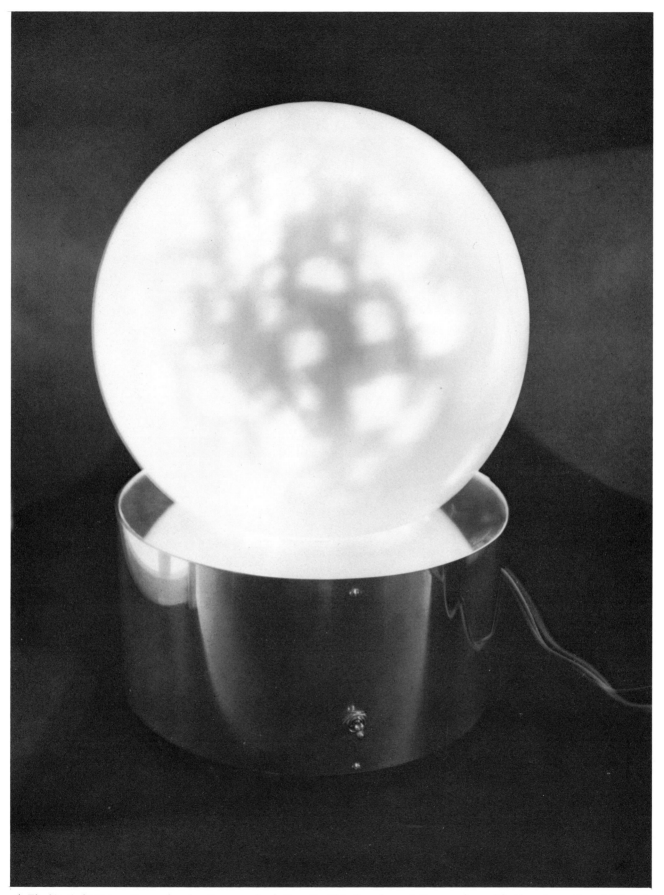

4. *The kinetic lamp in action: colored patterns randomly "pop" within the sphere. Action may be modified by using wafers of different flash tempos or by combining flashers and winkers. The completed lamp measures 17½".*

Demonstration 11
Piping Light

In this demonstration, Canadian artist Ronald Kostyniuk explains his methods for creating contemporary lamps with acrylics.

Kostyniuk is a constructivistic artist—he brings the typical, clean architectural quality to his lamp designs that also characterize his relief constructions. He views his lamps as illuminated sculptures rather than commercial lighting fixtures, and, as an artist, attempts to merge utilitarian function with fine art.

Materials

4 pieces acrylic sheet, 37″ × 9″ × 9″
2 pieces acrylic sheet, 9″ × 9″
Methylene dichloride and syringe
48 clear acrylic blocks, ½″ × 9″
Electric light sockets and wiring
40 watt elongated light bulbs
#320 wet-dry sandpaper
½″ Scotch tape
Flat black enamel paint and sprayer
Drill

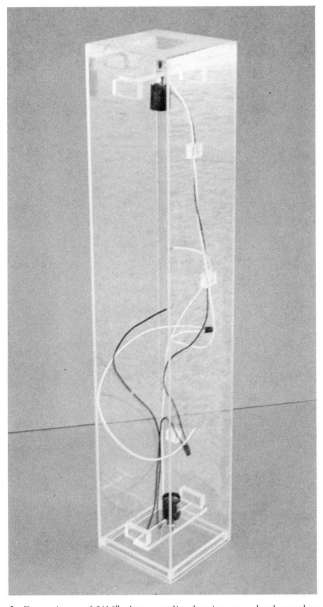

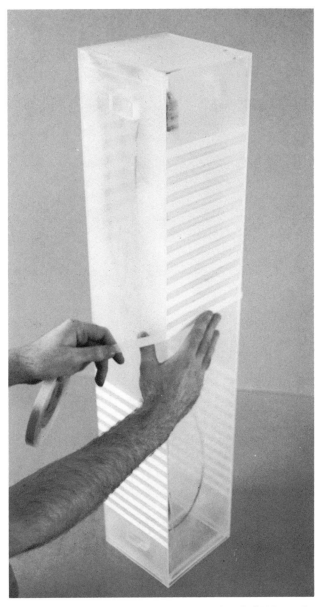

1. Four pieces of 3/16″ clear acrylic sheeting are glued together with methylene dichloride, applied with a syringe. Electric light sockets are attached to the top and bottom of the box and wiring completed. The end pieces, also made of acrylic, are removable for subsequent access to the lamps (40 watt elongated bulbs). Ventilation holes are drilled on the top and bottom components.

2. The surface of the acrylic is lightly sanded with #320 wet-dry paper to provide a tooth for spray painting. Desired areas are masked off with clear ½″ Scotch tape.

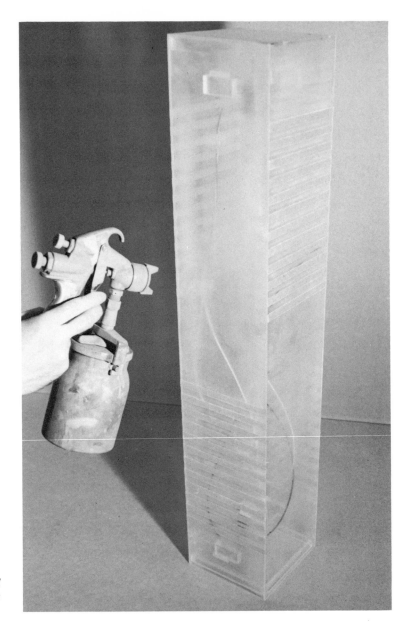

3. Flat black enamel, thinned slightly, is sprayed over the surface of the lamp base. Several coats are applied to achieve a uniform and opaque quality.

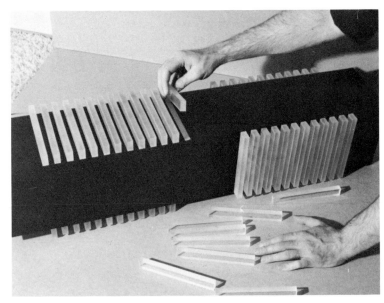

4. After removing the Scotch-tape masks, Kostyniuk attaches clear acrylic blocks over the exposed portions of the lamp base with epoxy cement.

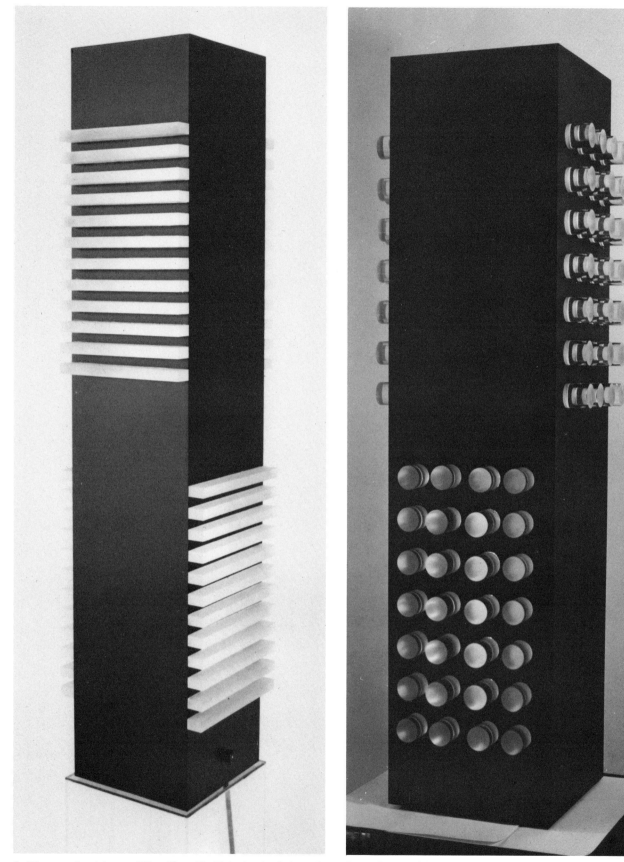

5. *The completed lamp, 37″ × 9″ × 9″. Light is piped through the clear acrylic blocks, producing a soft illumination. The lamp has a clean architectural look, characteristic of constructivistic art forms.*

Lamp *by Ronald Kostyniuk. In this piece, 112 acrylic rods, ¾″ × 1″, were attached to the acrylic with epoxy cement. Circular gummed labels were used to mask the clear plastic prior to spray painting with flat black enamel.*

Demonstration 12
Kinetic
Color Gun

Color Gun is a lumino-kinetic sculpture that I made in 1971. By virtue of its simple mechanical structure, it has never developed the technical problems typical of kinetic devices. On the contrary, it has never been back to the studio for repairs since its creation, although it has been exhibited frequently.

The light sculpture is both object and phenomenon oriented. To some, it appears as a diabolic instrument of physical encounter, "machine-gunning" colors in a soft pulsing manner to the "captured viewer." To others it appears as a utopian environment of the future—an illusionistic city of light and fantasy.

Personally, I created *Color Gun* simply as a visual toy or contemplation piece. It was originally designed for inclusion in an exhibition of artist's toys and games.

Materials

Masonite, 22″ in diameter

Black acrylic housing

Aluminum sheet, 22″ in diameter

Smoky gray acrylic dome, 22″ in diameter

Mirrorized glass dome, 5″ in diameter

36 clear acrylic rods, 1½″ in diameter, 4″ and 7″ high

4 high-intensity lamps

4 rpm. motor, wiring, and toggle switch

Cooling fan

Colored theater gels

Aluminum foil

Cellulose tape

Methylene dichloride and syringe

Saber saw and drill

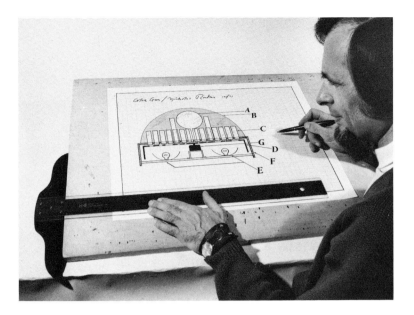

1. *Before constructing* Color Gun *I made a detailed drawing showing the configuration and components of the structure: (A) a mirrorized glass sphere, 5" diameter; (B) a plastic dome, made of smoky gray acrylic; (C) 36 clear acrylic rods 1½" diameter, 4" and 7" high; (D) a color wheel; (E) a high-intensity lamp unit (includes cooling fan); (F) a black acrylic housing; and (G) a 4 rpm. motor.*

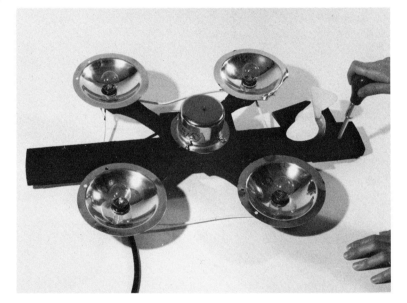

2. *The light unit incorporates four high-intensity lamps, a small, silent cooling fan (shown at the right), and a 4 rpm. motor that is mounted in the center and used to revolve the color wheel.*

3. *The color wheel is made of Masonite, 22" in diameter. A strip of aluminum is attached to the edge to contain stray light. A saber saw and power drill are used to cut out the designs drawn on the top surface of the Masonite.*

4. *Theater gels of varying transparent colors are attached over the cut out shapes and secured with cellulose tape. The face plate for the 4 rpm. motor is mounted in the center, underneath the color wheel. Aluminum foil is applied to the underside of the Masonite.*

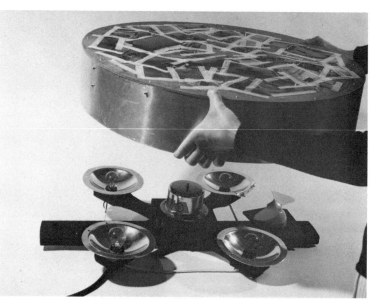

5. *The color wheel is mounted over the light unit. The small fan dissipates heat efficiently.*

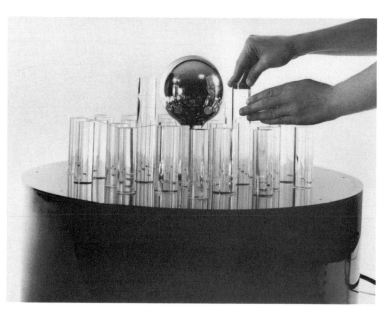

6. *The housing is made of acrylic, and 1½" holes have been drilled on the top surface in a pattern of concentric circles. Thirty-six 1½" clear acrylic rods are then carefully fitted within the holes. The mirrorized glass sphere is then attached to the center with epoxy cement.*

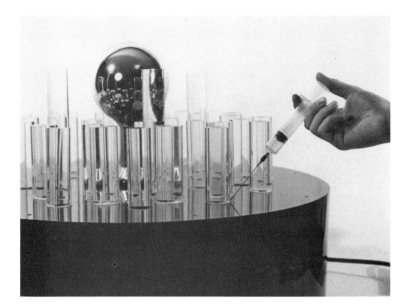

7. *Methylene dichloride is carefully applied with a hypodermic needle to the bases of the clear rods, "fusing" them to the top of the acrylic housing.*

8. *An on-off switch is incorporated into the electrical wiring. The lights, motor, and fan are simultaneously activated when the button is depressed, turned off when released.*

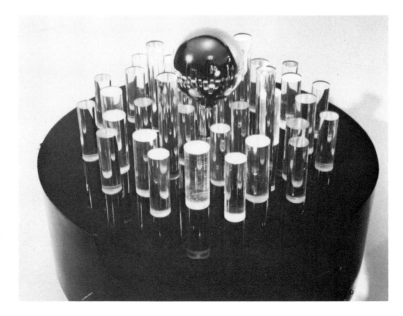

9. *Here the unit has been turned on to check light-programing characteristics and mechanical functioning. Minor adjustments were made on the color wheel, changing some gels and patterns, prior to completing the sculpture.*

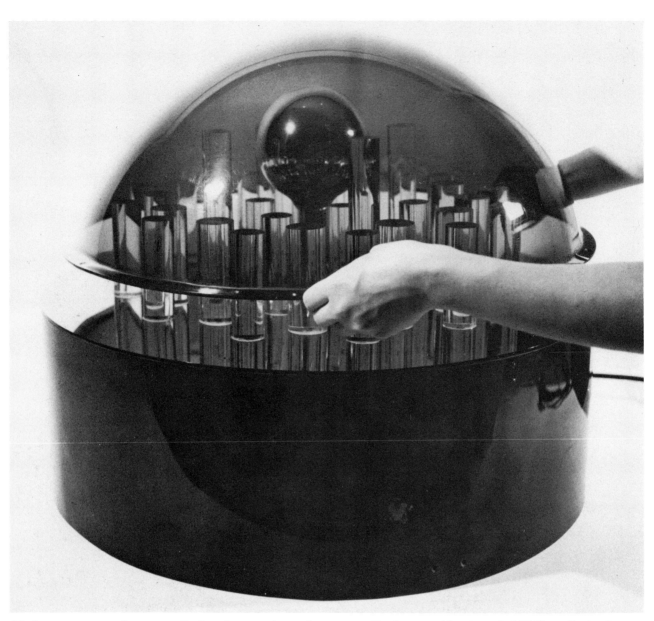

10. *A transparent, smoky gray acrylic dome is mounted over the structure. The dome was blow formed of 3/16″ acrylic sheeting at a local commercial sign shop.*

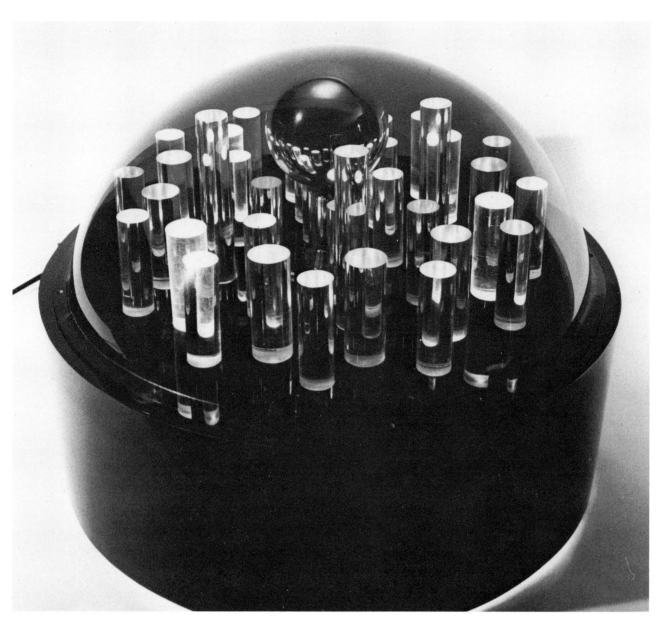

11. Color Gun *measures 24" × 19" and appears as an illusionistic landscape of clear and reflective structures, pulsing with chromatic light.*

Demonstration 13
A Light Polarizer

The production of color through light interference is a natural phenomenon, observable in the plumage of certain birds. The feathers of the peacock, for example, are colorless—they have no intrinsic color within them. Yet, through their intricate construction and density, they produce brilliant iridescent hues that change with the angle of view. Within each millimeter of tail feather are 6,000 rods of melanin separated by keratin—together, they produce this astonishing phenomenon.

A contemporary Swedish artist, Eric H. Olson, has, in a sense, imitated the qualities of the peacock's feathers. For more than 10 years, Olson has pioneered "light wave art," an art form whereby colored light patterns are produced through the use of polarizing materials sandwiched between glass plates. Olson calls his work *Optochromy,* and he makes full use of both light polarization and double refraction interference phenomena.

Unpolarized light vibrates in all directions and planes. Furthermore, the pattern of unpolarized light may change continually, going from one pattern, direction, and plane to another. However, when polarizing material is placed in front of a light source, an astonishing thing happens—the light vibrates in one direction only. Thus, polarizing material may be said to act much like the louvres of a venetian blind in controlling light.

In 1938, Dr. E. H. Land invented "H-Sheet," a highly efficient polarizing plastic that is still produced today. When two sheets of this polarizing material are superimposed and crossed at 90° angles, they produce an almost perfect extinction of light. The plastic is made by a chemical process involving long-chain polymeric molecules containing iodine atoms aligned parallel to one another.

In the demonstration that follows, the kinetic light produces a continually changing phenomenon of transitional colors created by the action of the polarizing sheets and the bi-refringment material between them. The first sheet of polarizing material is placed directly in front of a light source. It gives the diffuse light from the lamp planar phasing and is called the *polarizer.* The second sheet has bi-refringent material (Scotch tape) applied to its underside. This sheet, placed above the first one, then acts as an *analyzer,* allowing certain densities of light and color to be made visible.

Materials

Wooden box, foil lined, 15" × 15"

White vinyl to cover box

Translucent acrylic disc, 13" in diameter

2 clear acrylic sheets, 15" × 15"

2 sheets of polarizing plastic

4 rpm. motor, wiring, and toggle switch

60 watt frosted bulb

Clear acrylic rod

White paint and sprayer

Scotch tape

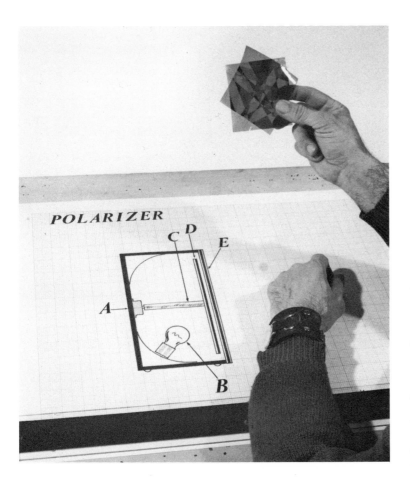

1. In this photo you can see the effects of superimposing 2 sheets of polarizing plastic. Sandwiched between the sheets is a bi-refringent material (Scotch tape), which produces a variety of visible color patterns. As the two sheets of polarizing plastic are revolved, the patterns and densities change. The sketch shows the principal components of the construction: (A) a 4 rpm. motor; (B) a 60 watt frosted bulb; (C) a clear acrylic rod (serves to connect motor and polarizing wheel); (D) a translucent disc, 13" in diameter, with polarizing plastic attached to top surface (polarizer unit); and (E) the face plate—2 sheets of clear acrylic with polarizing plastic sandwiched between.

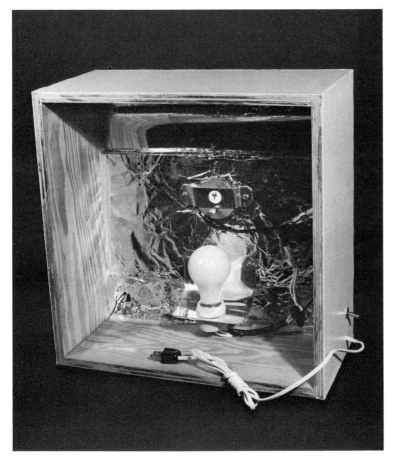

2. A wooden box, covered with vinyl plastic on the outside and lined with metal foil inside, serves as the housing for the light polarizer. Electrical parts include a 4 rpm. motor, a 60 watt frosted electric light bulb, and a toggle switch. Ventilation holes are drilled through the back to allow heat to escape.

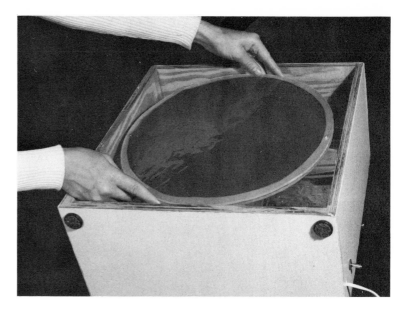

3. Polarizing film is cut into a 13" circle and mounted on a similar-size disc made of 3/16" translucent acrylic. A ½" clear acrylic rod serves as a connecting shaft to the motor.

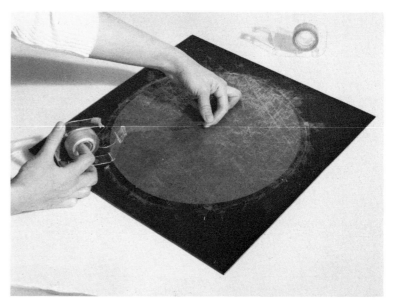

4. Crisscross patterns of Scotch tape (or any other bi-refringent material) are applied over the second sheet of polarizing material. The polarizing material is mounted to a clear acrylic sheet measuring 15" by 15". The acrylic was previously masked and sprayed to provide a circular window 11½" in diameter. A second clear acrylic sheet completes the "sandwich."

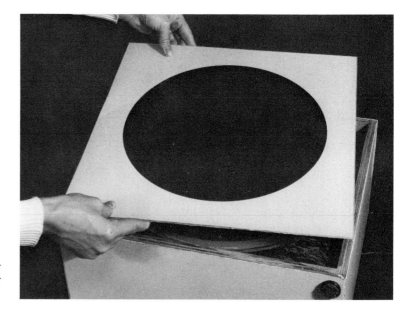

5. The polarizing unit is now attached to the top of the housing. Strips of acrylic will cover the edges of the unit as a finishing touch.

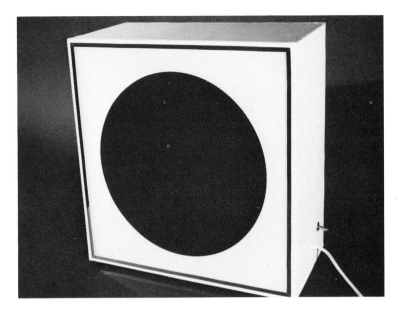

6. *The completed light polarizer in the "off" position. The central portion of the construction appears black.*

7. *The kinetic light polarizer in motion (below). The work provides a repetitive program of evolving prismatic shapes and colors, which alternately brighten, dim, disappear, and reappear. The completed work measures 15" by 15" by 7½".*

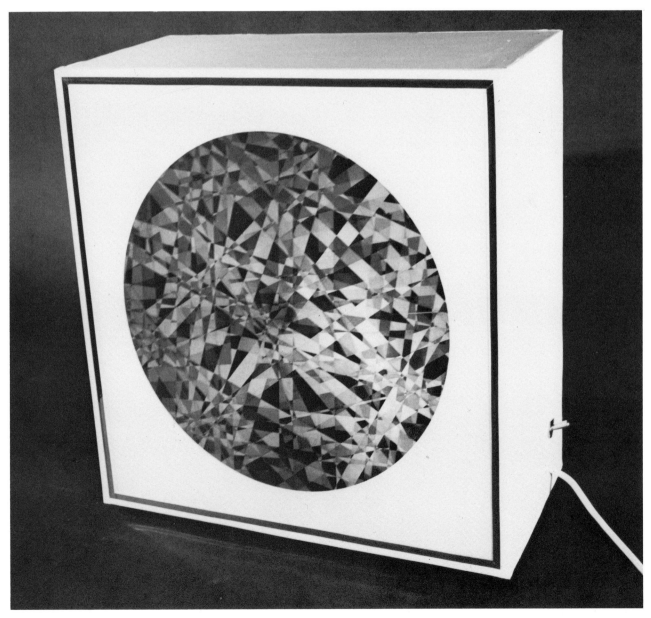

Demonstration 14
A Neon Sculpture

"Neon light is alive to the eye and to the mind."

Stephen Antonakos

The procedures generally used in making neon sculptures or displays are as follows:

1. Planning the concept and design structure.

2. Bending the glass tubing.

3. Inserting electrodes.

4. Bombardment: pumping out air, heating glass.

5. Pumping in gas.

6. Installation: connecting glass tubing to a base unit containing Pyrex electrode insulators, neon tube supports, and, if necessary, switching mechanisms. The switching mechanisms may involve time clocks, cam switches, or flashers. Some switches contain adjustable cams, allowing for greater flexibility in creating time-lapse programing.

The neon sculpture I created for this demonstration has two basic components: 19 feet of 10 millimeter glass tubing, bent to a spaghetti-like configuration, and containing two electrodes and neon gas, and the base, which serves as a housing for a 9,000 volt transformer.

In planning the electric sculpture, I first drew many "doodles" and sketches, searching for an interesting yet natural form for the glass tubing to assume. The pencil designs were followed by three-dimensional doodles using heavy-duty electrical wire. When I was satisfied with the results, I took my final sketches to a local neon display firm, having made prior arrangement with a technician to work there on a Saturday morning.

Obviously, because of the high voltages involved, care should be exercised in wiring this kind of unit. It is advisable to get a qualified electrician to wire the base of a neon sculpture if the artist is not knowledgeable in electrical circuitry.

Materials

19 feet of 10 millimeter glass tubing

Ribbon burner

Blow-hose

Pump table

Hand torch

2 electrodes and Pyrex insulators

Metal box

High-voltage transformer

Acrylic sheet to cover box

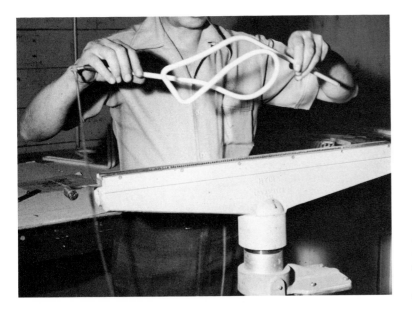

1. *Here you can see 10 millimeter glass tubing being shaped into curvilinear forms over a ribbon burner. Air is maintained within the tubing with a blow-hose to keep it from collapsing during the forming process.*

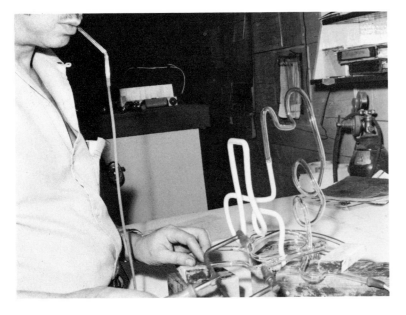

2. *Several sections of both clear and fluorescent-coated glass tubing are joined together with a hand torch.*

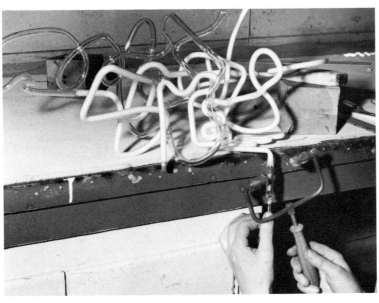

3. *Two electrodes are attached to the ends of the glass tubing.*

4. The glass structure is attached to the pump table. Here, it is heated to drive off impurities within the tubing, air is evacuated, a vacuum produced, and then neon gas is pumped into the tubing.

5. A closeup of the pump table. Vacuum and diffusion pumps are behind the grill, neon gas flasks in front left. Stop-cocks allow the technician to control evacuating air, creating a vacuum, and pumping gas into the glass tubing.

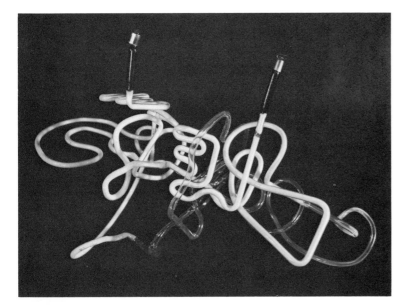

6. *The completed glass structure. The tubing is now filled with neon and caps are placed over the electrodes.*

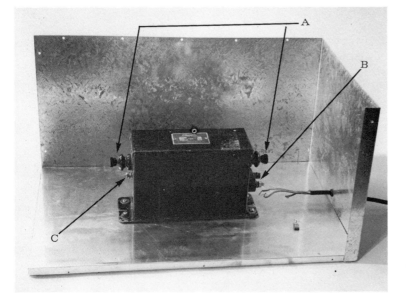

7. *A high-voltage transformer is installed within a metal box. The transformer delivers 9,000 volts at ¾ amps. The transformer is grounded and insulated from the base with asbestos washers and 6" of air space has been provided around it. (A) High-voltage terminals. (B) Low-voltage terminals. (C) Ground.*

8. *Acrylic plastic sheet, 3/16" wide, contains the 2 Pyrex glass insulators. Leads are connected to the high-voltage terminals of the transformer.*

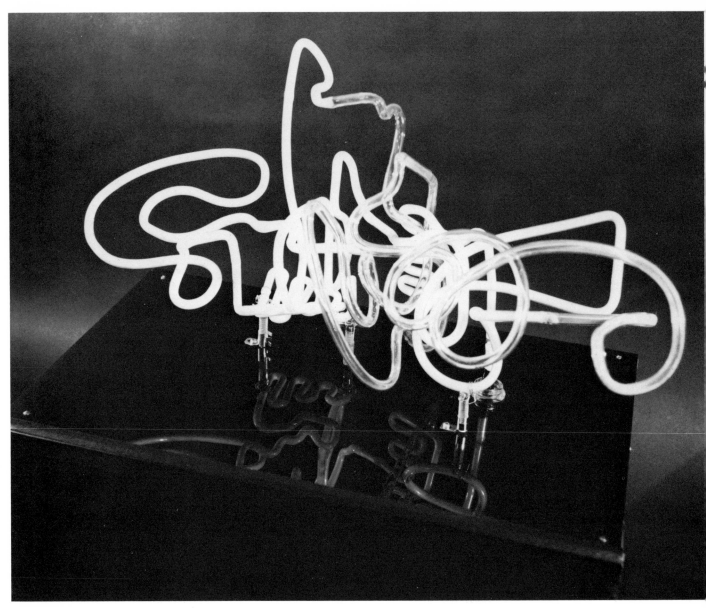

9. *Glass hooks and wire are used to secure the glass tubing to the base. The electrode ends of the glass tubing fit snugly into the tops of the insulators.*

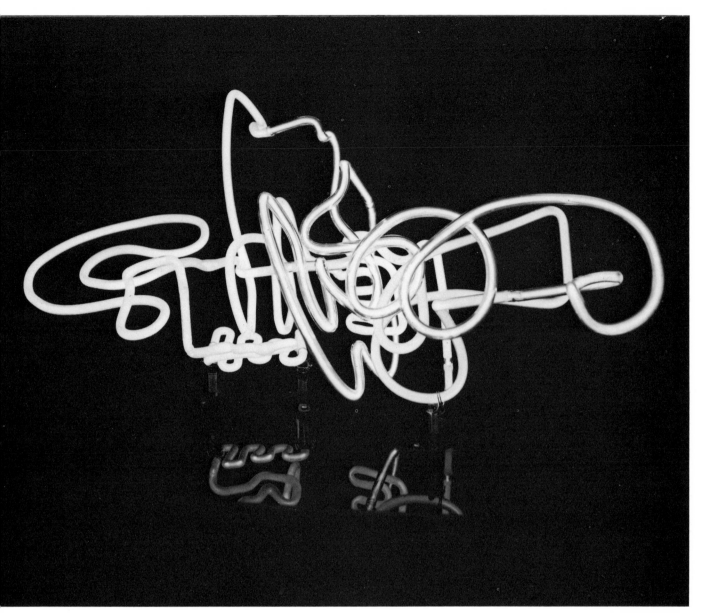

10. *The completed neon sculpture contains 19 feet of 10 millimeter glass tubing. Several lengths of both clear and coated tubing were joined together, producing red-orange and pink illumination.*

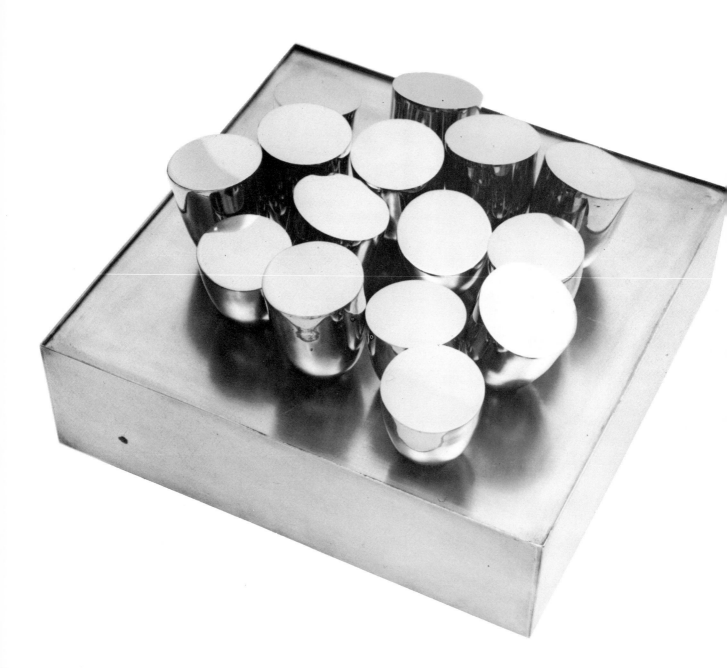

Ogives *by Pol Bury, 1969, 13½″ × 13½″ × 8½″. Hidden magnets revolve slowly within the base, creating fluctuating magnetic fields that move the sculptural ogives on the surface. Galerie Maeght, Paris.*

MAGNETICS

Webster describes "magnetism" as a peculiar property occasionally possessed by certain bodies (most frequently iron and steel), whereby under certain circumstances, they naturally attract or repel one another according to determinate laws.

This phenomenon of molecular polarity and coercive force has intrigued many contemporary artists, notably Takis, Bury, Boriani, and Collie. Allen Ginsberg says of Takis: "The only vision I ever had of magnetism was during a conversation with Takis in Paris in his studio, looking at his little metal cones hummingly waveringly pulled by like wires straight at their little magnet fathers; and he, Takis, explained to me that the stars were all pulled together with myriad thin invisible wires of magnetism radiating from every star to every other star—so we imagined, if you pulled out any one star the whole thrumming mechanism would slip a cosmic inch like a quavering mobile and all twang together into place at once on lines of unseen magnetic tracks, thunk."

Takis began making magnetic structures, which he called *Signals,* in 1955. The work utilized magnets, but relied on chance air currents to be activated. Pol Bury also uses magnetic fields to produce motion. Bury's sculptures, however, move very slowly. A critic once remarked that Bury's work moved so slowly, you would almost rank it with static art; although this does not sound exciting to read about, the confrontation with a Bury kinetic is as terrifying as a tale by Edgar Allan Poe. The mechanics behind some of his slow-moving, eerie kinetics are simple magnets carefully placed on revolving wheels within the sculptural base of the work. Metallic sculptural forms placed on the surface are moved by the magnetic energy in a strange kind of slowly-moving choreography.

David Boriani, from Milan, makes "Magnetic Surfaces," constructions with compartments containing iron filings. Behind them, magnets move with the aid of an electric motor, attracting and depositing the metal filings in varying compositional arrangements.

Collie's *Spatial Absolute #1* is anti-gravitational. It floats completely free from its base via magnetic thrust and is tethered to its base with thin nylon strings.

Tele-Sculpture by Takis Vassilakis, 1960. A large electro-magnet 10⅝" × 12⅝", combines with two suspended forms containing magnets. The swinging shapes are kept in motion by both gravity and magnetic forces. The black and white forms occasionally collide. The Museum of Modern Art, New York.

A diagram of Takis' electro-magnetic sculpture.

Demonstration 15
A Magnetic
Construction

The magnetic construction in this demonstration follows the principle employed by Pol Bury. A slow rpm. motor revolves a turntable made of 3/16″ acrylic that has four magnets attached to its top surface. The unit is set within a plastic box measuring 14″ by 14″ by 3″, which acts as the base.

A circular opening is cut in the top of the base, measuring 12½″ in diameter. The motor is installed in the inside center, with the turntable aligned so that the magnets revolve within 1/8″ from the top surface. Electrical wiring to the motor also incorporates an on-off toggle switch.

Next, a circular tray, made of acrylic plastic, and measuring 13″ by 3″, is placed over the opening. Steel ball bearings were then placed inside the tray. (The chrome-plated bearings were obtained from a local automotive transmission supply house.) The completed structure measures 14″ by 5″.

When the kinetic structure is turned on, the spheres begin to move slowly in a strange, erratic manner—alternately attracting, repelling, grouping, clustering, releasing, and regrouping in unpredictable combinations.

Materials

Wooden box, plastic lined, 14″ × 14″ × 3″
Acrylic tray, 13″ in diameter, 3″ high
Acrylic disc, 12″ in diameter
½ rpm. motor and wiring
4 magnets
Steel ball bearings

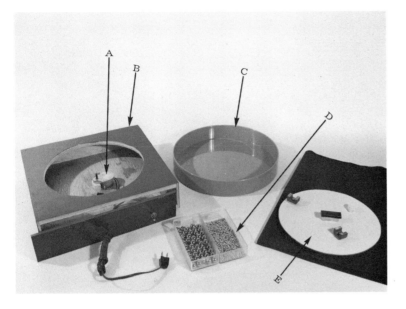

1. *This photo shows the component parts involved in making the magnetic structure: (A) a 1 rpm. motor; (B) a plastic-lined box measuring 14" by 14" by 3" with a 12½" diameter opening on the top; (C) an acrylic tray, 13" in diameter by 3" high; (D) steel ball bearings; and (E) a "magnetic wheel," made of a 12" diameter acrylic plastic disc containing 4 magnets attached to top surface.*

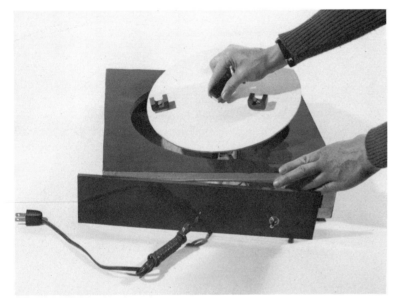

2. *The magnetic wheel is connected to the motor.*

3. *The acrylic tray is attached to the top of the base. The magnets are within ⅛" of the tray's bottom surface.*

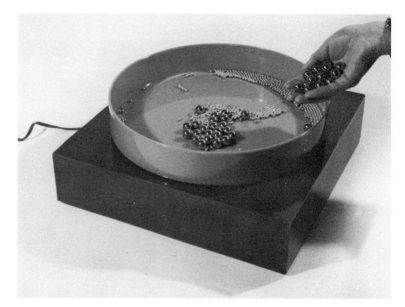

4. Steel ball bearings are placed within the tray.

5. (Below) The completed magnetic kinetic. Movement is slow, erratic, and unpredictable. Smaller spheres often cluster like barnacles over the larger ones as they randomly attract and repel one another within the magnetic field.

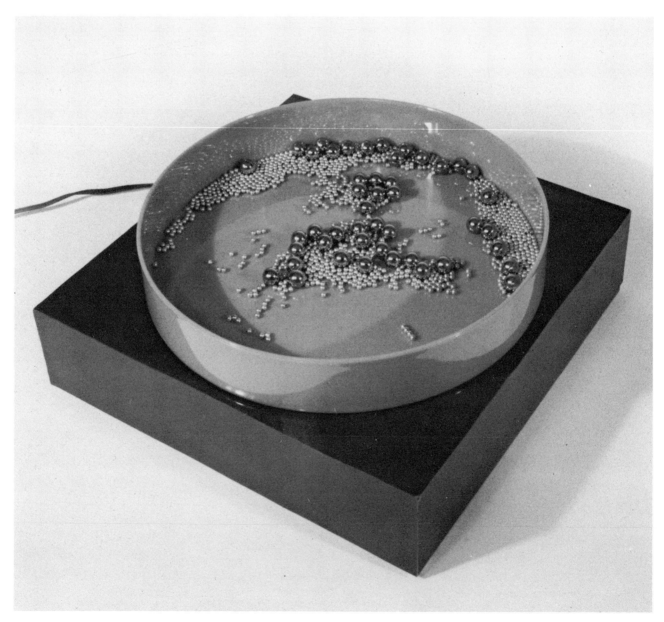

The Friendly Gray Computer, Star Gauge Model *by Edward Kienholz, 1965.*
Motorized construction, 40" × 39" × 24½". The Museum of Modern Art, New York.

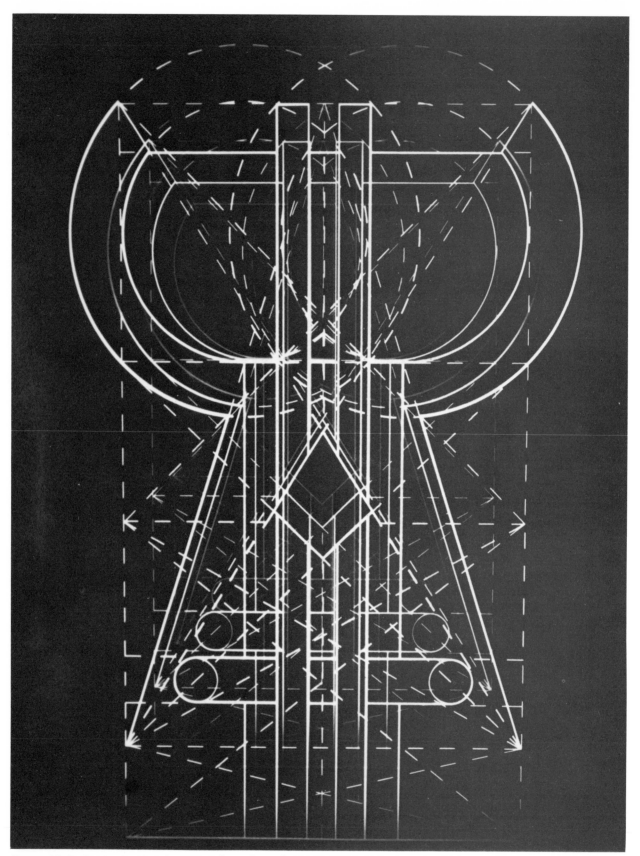

Barmecide *by Stanley Landsman, 1968, 74″ × 24″ ×18″. Illuminated fixed images and reflective surfaces create illusions of infinite space. The Leo Castelli Gallery, New York.*

Lumia Metamorphosis #2 by Earl Reiback, 1967. Wood, plastic, and motors, 24″ × 32″ × 12″. *The Milwaukee Art Center, Wisconsin.*

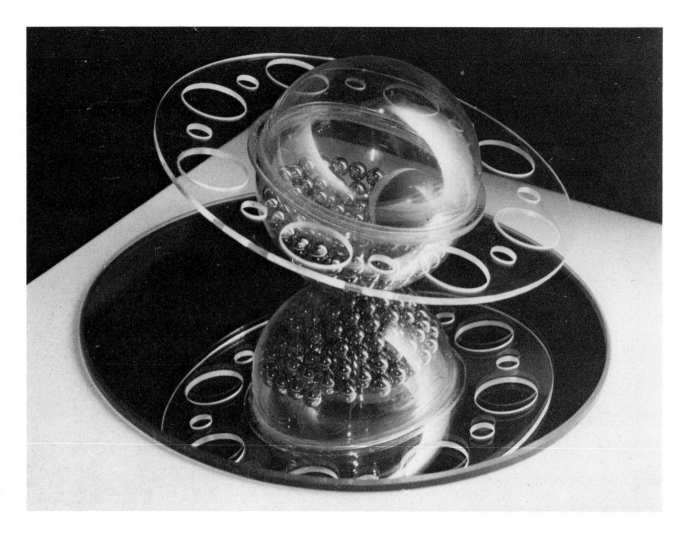

En (Above) by Norio Imai. As this art-toy is spun, chrome-plated steel bearings and clear acrylic reflect kinetic patterns on the mirrored base.

Hydro-activated (Right) by Guyla Kocise. Water, light, and acrylics. Condensation patterns continuously change within the sphere depending on environmental conditions.

Red Circle, Inside Corner (Opposite Page) by Stephen Antonakos, 1971, 8″ × 28″. A ruby-red "X" combines with a clear red circle in this neon sculpture.

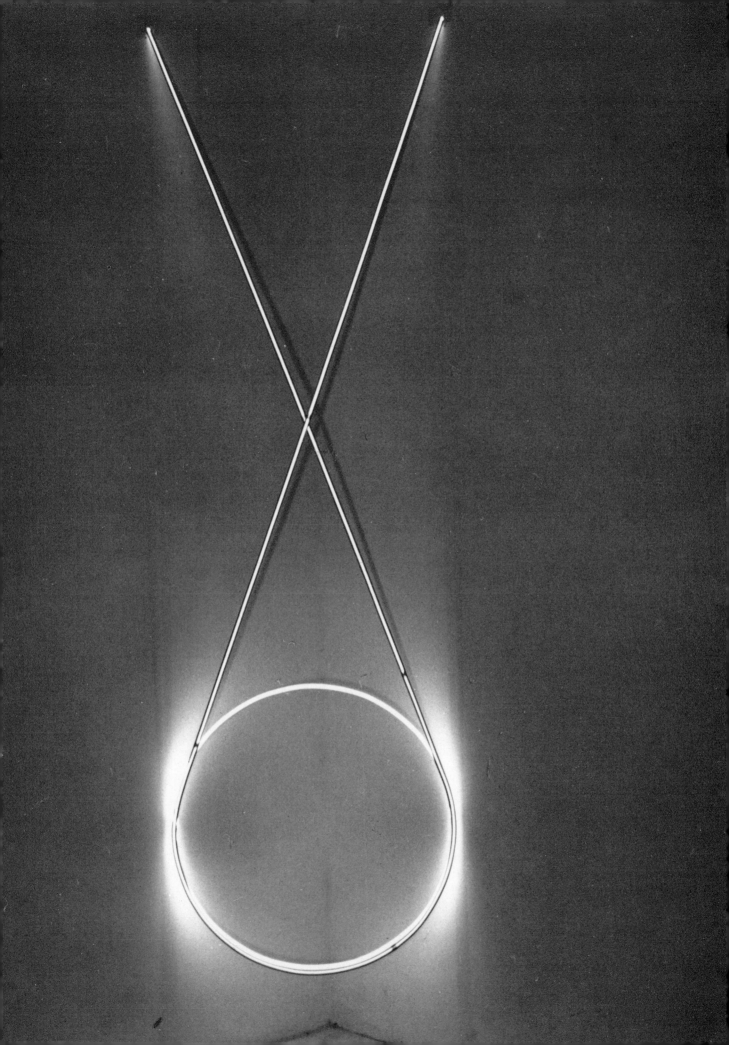

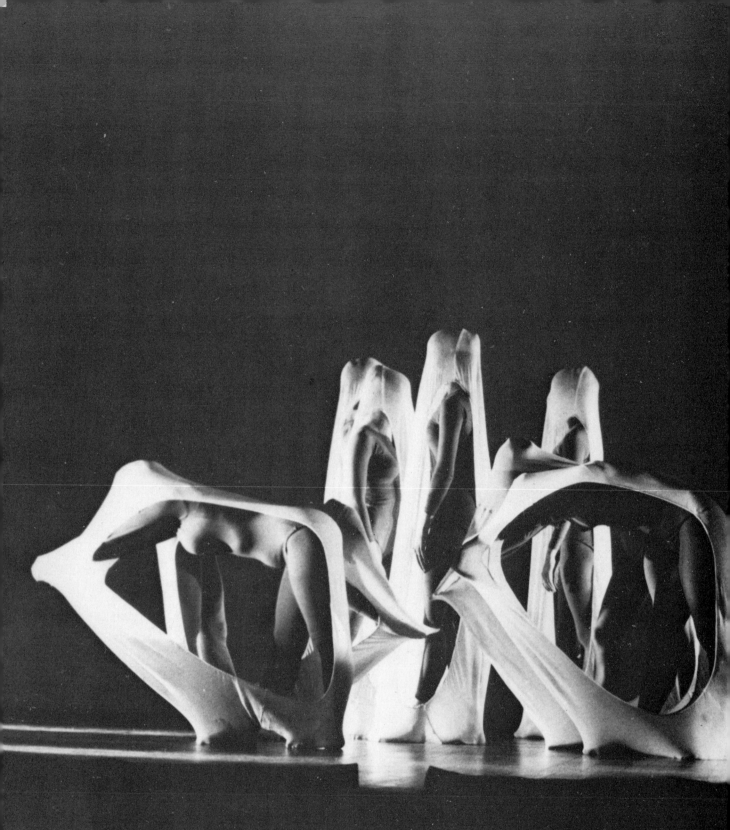

Kinetic Dance Choreography by the Nikolais Dance Theater, New York, 1972.

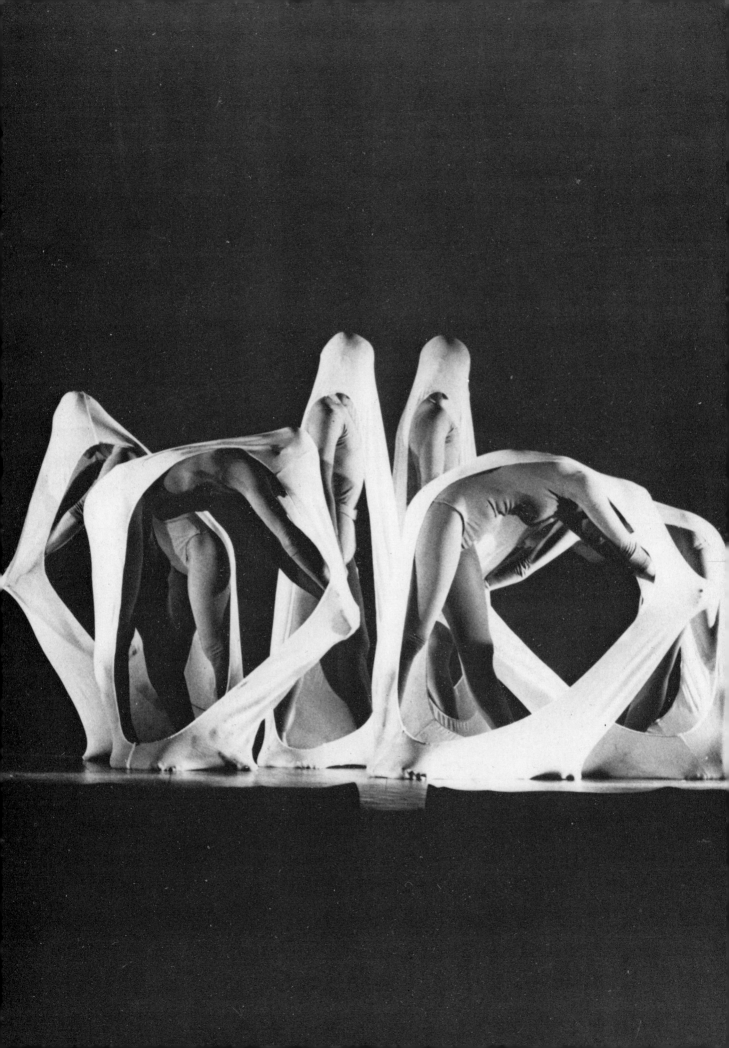

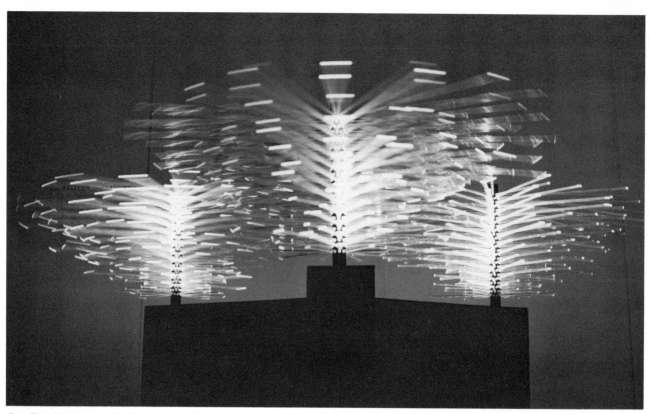

Star Tree I *by Preston McClanahan, 1967. Acrylic rods and fluorescent lights, 62" × 96". The Howard Wise Gallery, New York.*

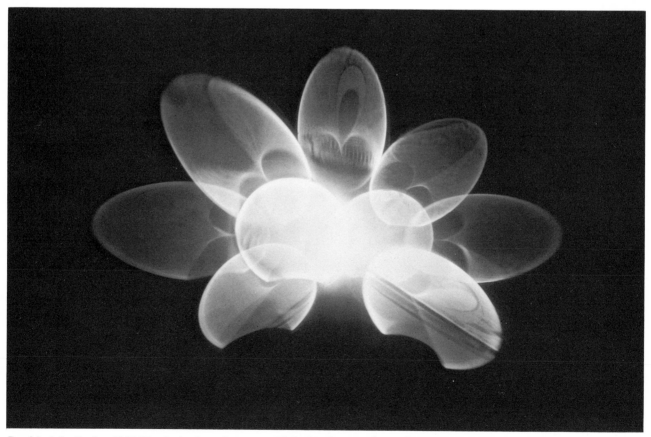

Box 3 *by John Healey, 1963. Wood, plastic, and programed light, 25½" × 38½" × 13". The Walker Art Center, Minneapolis.*

Today's Special *by Chryssa, 1970–1973. Asbestos, acrylic, and neon, 9 × 8 feet. The Denise René Gallery, New York.*

182 Spheres on Two Opposing Planes by Pol Bury, 1965. Wood and motors, 94½″ × 47½″ × 24″. Barely discernible movement is initiated from the motors within the structure. Galerie Maeght, Paris.

25 Eggs on a Platform by Pol Bury, 1969, 20″ × 20″ × 9″. Hidden magnets within the base slowly move the eggs over the surface. Galerie Maeght, Paris.

Measures to be Taken (Overleaf) by Piotr Kowalski, 1972. A game environment is created by the unusual use of electronic generators, antennae within acrylic sheet, and fluorescent tubes. High-frequency electromagnetic fields illuminate the hand-held fluorescent tubes. Documenta 5, Kassel, Germany.

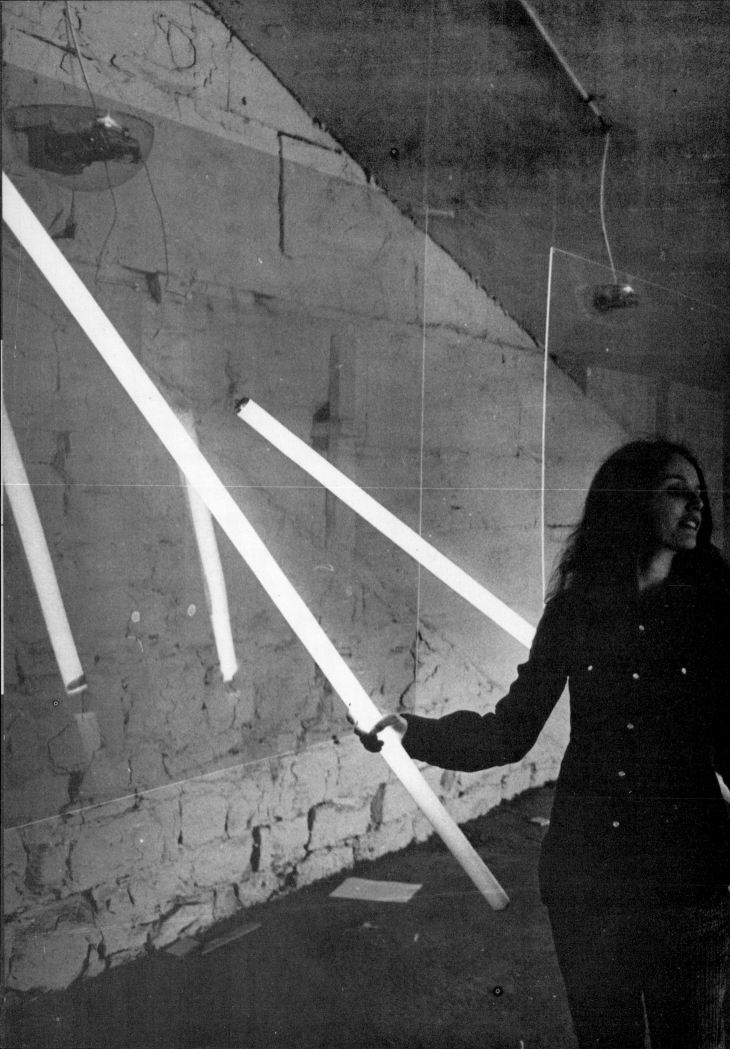

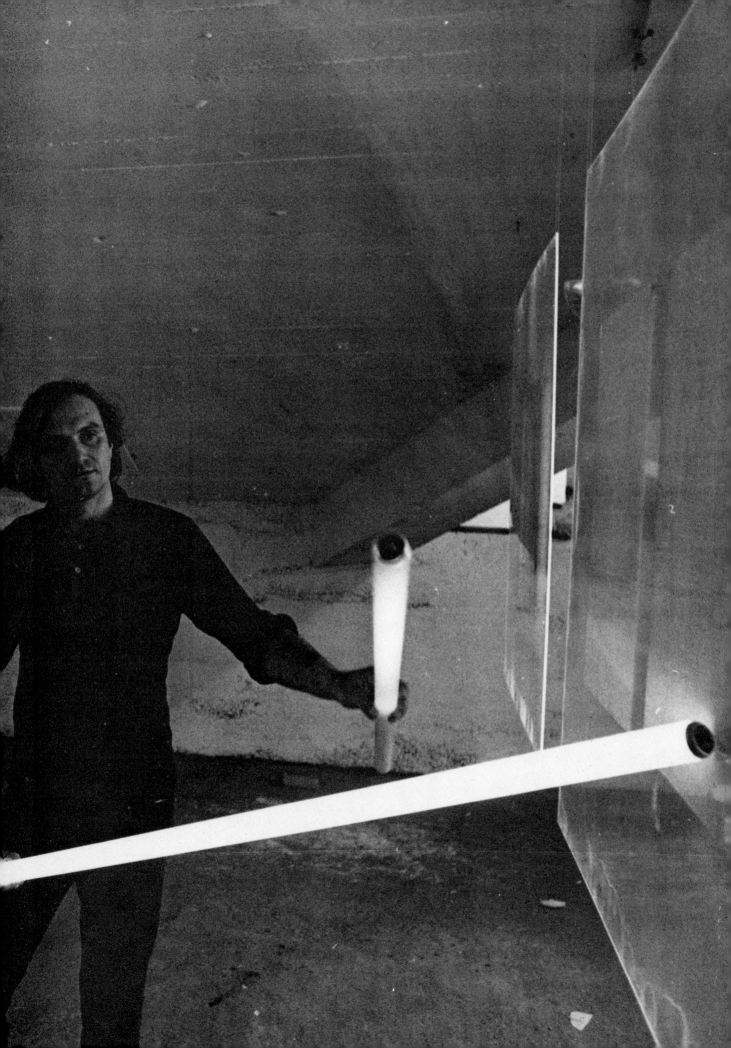

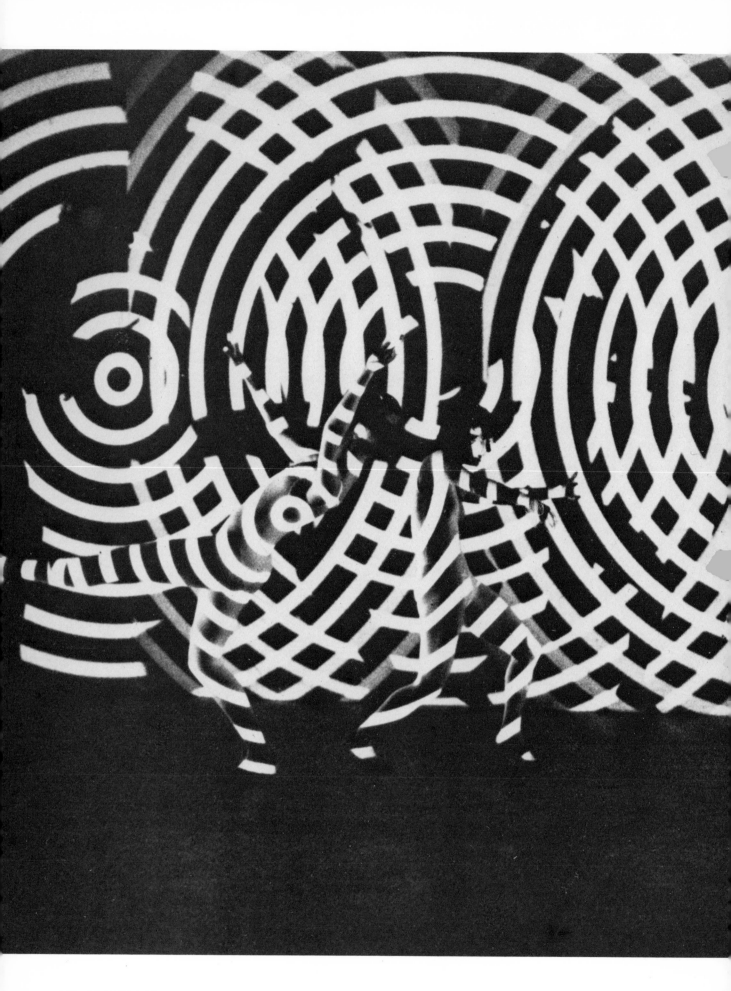

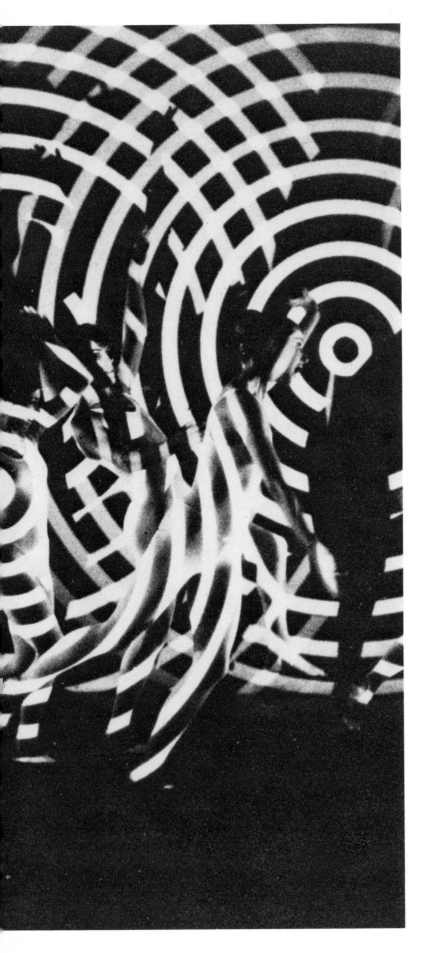

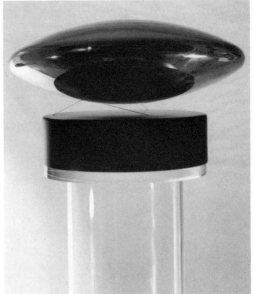

Spatial Absolute #1 by Alberto Collie, 1964. This "anti-gravity" sculpture exploits the push of magnetic forces. Tethered to its base by nylon lines, the saucer-shaped disc is made of non-magnetic titanium and is repelled by the electro-magnetic forces. Collection of the Johnson Wax Company. Photo, Lee Nordness Galleries, New York.

Cyclostrobo #1571 by Michael Ashford Cooper, 1971, about 6 feet high. This photo shows the front of the piece in motion. A combination of strobe light and a spinning disc (at times aligned and misaligned) creates illusions of virtual motion.

Dance Choreography (Left) "de-personifies" participants, exploits abstract design approaches and kinetic continuity.

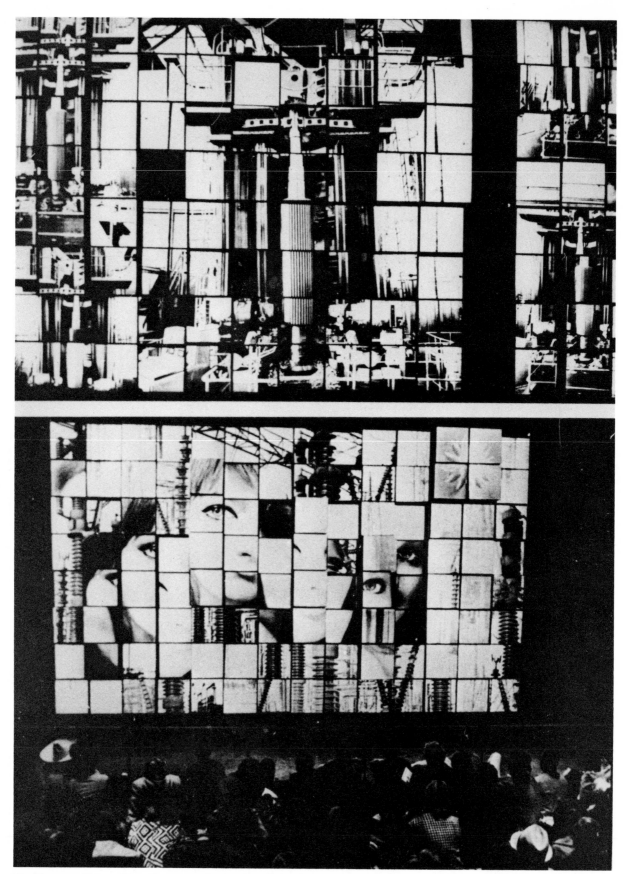

Diapolyecran. *This multi-media spectacular involves 224 projectors mounted within 112 cubes processing 15,000 slides every 11 minutes. The Czechoslovakian Pavillion, Expo '67, Montreal.*

Water Walk. *An event structure involving air-inflated tetrahedrons made of transparent P.V.C. plastic. Participants can "walk" on water by progressively revolving the balloon around themselves.*

SUPPLIERS LIST

MANUFACTURERS

Note that some manufacturers sell only large quantities, but you can write to them for the names of local distributors.

Abrasives

Abrasive Products Ltd.
Hare St., Bilston
Staffs, England WV14 7JL

3M Company
St. Paul, Minnesota 55101

Norton Company
Coater Abrasive Division
Troy, New York 12181

Acrylic Scratch Removal Kit

Armitage Plastics
Highlands Road, Shirley
Solihull, Warks., England

Micro-Surface Finishing
Products, Inc., Box 249
Burlington, Iowa 52601

Acrylic Sheet

Altuglas
40 Avenue Kleber
Paris, France

Cast Optics Corp.
1966 S. Newman Street
Hackensack, New Jersey 07602

Imperial Chemicals
Plastics Division
Welwin Garden City
Herts., England

Rohm and Haas Co.
Independence Mall W.
Philadelphia, Pennsylvania 19105

Shinkolite, Mitsubishi Rayon Co.
No. 8, 2-Chome
Kyobashi, Chuo-ku, Tokyo

Acrylic Monomers

DuPont Company
Plastics Division
Wilmington, Delaware
(also, 18 Bream's Buildings
Fetter Lane, London EC4A 1HT

Anti-Static Negator

Chemetron Corp., Cee-Bee Chemical
P.O. Box 400
Downey, California 92041

Paul Rice and Co. Ltd.
2 Fernwood, Marple Bridge
Stockport, Cheshire, England SK6 5BE

Anti-Static Solutions

Bayer Chemicals Ltd.
Kingsway House, 18-24 Paradise Road
Richmond, Surrey TW9 ISJ

Chemical Development Co.
Danvers, Massachusetts

Fisons Scientific Apparatus
Bishops Meadow Road
Loughborough, Leics., England LE11 ORG

Functional Products
Div. Playtime Products, Inc.
442 N. Detroit Street
Warsaw, Indiana

Anti-Static Wax

S.C. Johnson and Son Inc.
Racine, Wisconsin 53403

Buffing Equipment

Canning and Co., Ltd.
P.O. Box 288, Great Hampton St.
Birmingham, England B18 6AS

Dunmore Company
1323 Seventeenth Street
Racine, Wisconsin 53403

Buffs

Ferro Ltd.
Ounsdale Road, Wombourne
Wolverhampton, Staffs., England

Jackson Buff Corporation
P.O. Box 398
Conover, North Carolina 28613

Catalysts

ABM Industrial Products Ltd.
Poleacre Lane, Woodley
Stockport, Cheshire, England

Apogee Chemical Inc.
DeCarlo Avenue
Richmond, California

McKesson and Robbins, Chemical Dept.
155 East 44 Street
New York, N.Y. 10017

Cements

Industrial Polychemical Service
P.O. Box 471, 17116 South Broadway
Gardena, California, 92047

Cadillac Plastic Company
15111 Second Avenue
Detroit, Michigan 48203

Tuckers (North Midlands)
Queens Drive Industrial Estate
Gateshead Road, Nottingham, England NG2 1LJ

Colorants

American Hoechst Corp.
Cabric Color Division
Mountainside, New Jersey

BASF, Pigments Division
P.O. Box 4, Earl Road
Cheshire, England

Ferro Ltd.
Ounsdale Road, Wombourne
Wolverhampton, Staffs., England

Ferro Corp., Color Division
Cleveland, Ohio 44105

Plastics Color, Division of
Crompton and Knowles Corp.
22 Commerce Street
Chatham, New Jersey 08928

Ridgway Color and Chemical
75 Front St.
Ridgway, Pennsylvania 15853

Electrical Equipment

Allied Radio
100 N. Western Avenue
Chicago, Illinois 60680

Brookhirst Igranic Ltd.
Elstow Road
Bedford, England

Heathkit Electronic Center
35 W. 45th Street
New York, N.Y. 10036

Lafayette Radio
111 Jericho Turnpike
Syosset, New York 11791

Radio Shack
730 Commonwealth Avenue
Boston, Massachusetts

Heaters

Electric Elements Co.
Tokenhouse Yard, Bridlesmith Gate
Nottingham, England 1VG1 2HH

Elmatic Ltd.
Wentlog Road, Rumney
Cardiff, England

General Electric
1 Progress Road
Shelbyville, Indiana 46176

Hydor Therme Corp. (strip heater)
7155 Airport Highway
Pennsauken, New Jersey

Laramy Products Co. (heat gun)
Route 3A, Cohasset, Massachusetts

Lamp Parts
Atlas Plastics Ltd.
Brook Road, Wood Green
London, England N22 6TS

Lamp Products
P.O. Box 34
Elma, New York

Lamps
Crompton Parkinson Ltd.
P.O. Box 72
Crompton House
Aldwych, London, England WC1B 4JH

Edmunds Scientific Company
402 Edscorp Building
Barrington, N.J. 08007

General Electric
219 E. 42nd Street
New York, New York 10017

Metal Polish
Matchless Metal Polish Co.
Glen Ridge, New Jersey 07028

Mirrors
American Science Center
5700 Northwest Highway
Chicago, Illinois 60646

Arinor Ltd.
Stockbury House
Church St., Storrington
Sussex, England

Bakelite Xylonite Ltd.
Enford House, 139 Marylebone Road
London, England NW1

Edmunds Scientific Company
Edscorp Building
Barrington, New Jersey 08007

Multi-lensed Plastic Sheet
Edmunds Scientific Company
Edscorp Building
Barrington, New Jersey 08007

Neon Supplies
Ford Signs Ltd.
12015 Preston Street
Exeter, Devon, England EX1 1DJ

N. Glantz and Sons
437 Central Avenue
Newark, New Jersey 07107

Optical Supplies
Bausch and Lomb, Inc.
Rochester, New York 14602

Birchware Ltd.
North Farm Estate
Royal Turnbridge Wells, Kent, England

Klinger Scientific Apparatus
83-45 Parsons Blvd.
Jamaica, New York 11432

Optics Technology Inc.
901 California Avenue
Palo Alto, California 94304

Paint
Ball Displays Ltd., Kennel Lane
Billericay, Essex, England

Keystone Refining Company
4821-31 Garden Street
Philadelphia, Pa. 19137

Severn Plastics Ltd.
Stonehouse, Glos., England GL10 2QD

Plastic Film
Archway Plastics Ltd.
Causton Road, London, England N6 5PQ

3M Company
Reflective Materials Div.
15 Henderson Drive
West Caldwell, N.J.

E.I. DuPont, Wilmington, Delaware
Mirro-Brite Coating Products, Inc.
580 Sylvan Ave.
Englewood Cliffs, N.J.

Plastic Sheet (Uvex)
Eastman Chemical Production Inc.
Plastics Div., 4200 Dempston St.
Skokie, Illinois
(also, 164 Eglinton Ave.
East Toronto 12, Ontario, Canada)

Paper Sales Corp.
(silver-plated butyrate)
140 Sunrise Avenue
3300 Montreal, Quebec, Canada

Plastic Tubes, Rods
Commercial Plastics and Supply
630 Broadway, New York, N.Y. 10012

Richard Dalerian Ltd.
325 Latimer Road
London, England W10 6RE

Polishing Compounds
Lea Manufacturing Co.
237 East Aurora St.
Waterbury, Connecticut

Mirror Bright Polish Co.
Irvine Industrial Complex
P.O. Box CT
Irvine, California 92664

Polyester Resin
Bakelite Xylonite Ltd.
Enford, 139 Marylebone Road
London, England NW1

Reichhold Chemicals Inc.
RC1 Building, White Plains, New York

Shell Chemicals, Plastics Division
110 West 51, New York, N.Y. 10020

Taylor and Art Inc.
1710 East 12th St.
Oakland, California 94606

Waldor Enterprises
2580 Wharton Glen Avenue
Mississauga, Ontario, Canada

Rear Screen Projection Material
Pola-Coat Inc.
9750 Concklin Street
Blue Ash, Ohio 45242

Safety Masks
Acme Protection Equipment Corp.
1201 Kalamazoo St.
South Haven, Michigan

Spray Equipment
Binks Manufacturing Co.
3114-44 Carrol Avenue
Chicago, Illinois

Automatic Equipment Ltd.
Auteq Works, Daleside Road
Nottingham, England NG2 4DN

Timers
Bayside Timers Inc.
43-69 162nd St.
Flushing, New York 11358

National Time and Signal
21800 Wyoming Avenue
Oak Park, Michigan

National Electronic Indicator, Inc.
P.O. Box 2365
Fresno, California

Time-O-Matic
1106 Bahl Street
Danville, Illinois

RETAIL SUPPLIERS

Sculpture Supplies
Craftool Company
Wood-Ridge, New Jersey 07075

Sculpture Associates
101 St. Marks Place
New York, N.Y.

Plastics
The Plastics Factory
119 Avenue D
New York, N.Y. 10019

BIBLIOGRAPHY

Books

Albers, Josef. *Interaction of Color*. New Haven, Connecticut: Yale University Press, 1963.

Arnheim, Rudolf. *Art and Visual Perception*. Berkeley, California: University of California Press, 1969. London: Faber, 1967.

Arnheim, Rudolf. *Visual Thinking*. Berkeley, California: University of California Press, 1971. London: Faber, 1970.

Barret, Cyril. *An Introduction to Optical Art*. London: Studio Vista, 1971.

Barret, Cyril. *Op Art*. New York: Viking Press, 1970. London: Studio Vista, 1970.

Benthall, Jonathan. *Science and Technology in Art Today*. New York: Praeger, 1972.

Brett, Guy. *Kinetic Art, the Language of Movement*. New York: Van Nostrand Reinhold Co., 1968. London: Studio Vista, 1968.

Burnham, Jack. *Beyond Modern Sculpture*. New York: George Braziller Inc., 1967.

Carraher, Ronald G. & Thurston, Jacqueline B. *Optical Illusions and the Visual Arts*. New York: Van Nostrand Reinhold Co., 1966. London: Studio Vista, 1967.

Cook, J. Gordon. *The Miracle of Plastics*. New York: Dial Press, 1964.

DeDani, A. *Glass Fiber Reinforced Plastics*. New York: Interscience, 1961.

Escher, M. C. *The Graphic Works of M. C. Escher*. New York: Hawthorn Books, 1969. London: Macdonald, 1969.

Fuchs, N. H. *Mechanics of Aerosols*. Elmsford, New York: Pergamon Press, 1964.

Gordon, William J. J. *Synectics*. New York: Harper & Row, 1961.

Gregory, R. L. *The Intelligent Eye*. New Jersey: Weidenfeld & Nicolson, 1970.

Gregory, R. L. *Eye and Brain*. New York: World University Library, McGraw-Hill Book Company, 1966. London: Weidenfeld and Nicolson, 1966.

Itten, Johannes. *The Art of Color*. New York: Van Nostrand Reinhold, 1961.

Jenkins, F. A. and H. E. White. *Fundamentals of Optics*. Third Edition. New York. McGraw-Hill Book Company, 1956.

Julez, Bela. *Foundations of Cyclopean Perception*. Chicago: University of Chicago Press, 1971.

Kepes, Gyorgy. *The Nature and Art of Motion*. New York: George Braziller, 1965.

Klüver, Billy. Julie Martin, and Barbara Rose, editors. *Pavillion. By Experiments in Art and Technology*. New York: E. P. Dutton & Co., Inc., 1972.

Kostelanetz, Richard. *The Theatre of Mixed Means*. London: Pitman Publishing Company, 1970.

Lawrence, J. R. *Polyester Resins*. New York: Van Nostrand Reinhold, 1960.

Lee, H. and Neville, K. *Epoxy Resins. Their Application and Technology*. New York: McGraw-Hill, 1957.

Luckiestt, M. *Visual Illusions*. New York: Dover Publications, 1965.

Moholy-Nagy. *Vision in Motion*. Chicago: Paul Theobald, 1947.

Moholy-Nagy. *The New Vision*. New York: Genge Wittenborn, Inc., 1947.

Modern Plastics Encyclopedia. New York: McGraw-Hill, 1972.

Newman, Thelma R. *Plastics as an Art Form*. Radnor, Pennsylvania: Chilton, 1964. London: Pitman Publishing Co., 1973.

Oleesky, Samuel, and Mohr, Gilbert. *Handbook of Reinforced Plastics of the S.P.I.* New York: Van Nostrand Reinhold, 1964.

Oster, G. and Nishijima, Y. *Moiré Patterns*. Scientific American, 1963 (reprints available from W. H. Freeman, Publishers, San Francisco).

Oster, Gerald. *The Science of Moiré Pattern*. Edmund Scientific Co., 1969.

Painting, John. *Sculpture in Fiberglass*. New York: Watson-Guptill Publications, 1972.

Percy, H. M. *New Materials in Sculpture*. London: Alex Tiranti, 1962.

Popper, Frank. *Origins and Development of Kinetic Art*. Connecticut: N.Y. Graphic Society Ltd. 1968. London: Studio Vista, 1968.

Rickey, George. *Constructivism, Origins, and Evolution:* New York: George Braziller Inc., 1967.

Roddam, T. *Everyday Electronics*. Mystic, Connecticut: Lawrence Verry, Inc., 1966. London: Harrap, 1966.

Seitz, William C. *The Responsive Eye*. New York: The Museum of Modern Art.

Selz, Peter. *Directions in Kinetic Art*. Berkeley, California: University of California Press, 1966.

Seuphor, Michel. *The Sculpture of this Century*. New York: George Braziller, 1960.

Simonds, Herbert R. and Church, James M. *Concise Guide to Plastics*. New York: Van Nostrand Reinhold, 1963.

Smale, Claude. *Creative Plastics Techniques*. New York: Van Nostrand Reinhold, 1973.

Society of Plastics Industry. *Plastics Engineering Handbook*. Third Edition. New York: Van Nostrand Reinhold, 1960.

Tolansky, W. *Curiosities of Light Rays and Waves*. New York: Veneda Publishing Co., Inc., 1965.

Tovey, John. *The Technique of Kinetic Art*. New York: Van Nostrand Reinhold, 1971. London: Batsford, 1971.

Vernon, M. D. *The Psychology of Perception*. New Orleans: Pelican Publishing Co. Inc., 1962. University of London Press, 1965. Penquin, 1970.

Wilman, C. W. *Seeing and Perceiving*. Elmsford, New York and London: The Commonwealth and International Library and Pergammon Publishing Co. Ltd.

Article

Siedlecki, Jerome T. MS. *Potential Hazards of Plastics Used in Sculpture*. Art Education (Journal of the National Art Education Assoc.) Feb. 1972. Volume 25, #2.

INDEX

Edited by Jennifer Place
Designed by Robert Fillie
Set in 10 pt Times Roman by Gerard Associates/Graphic Arts, Inc.
Printed and bound by Halliday Lithograph Corp., Inc.
Color printed in Japan by Toppan Printing Company Ltd.